D0601272

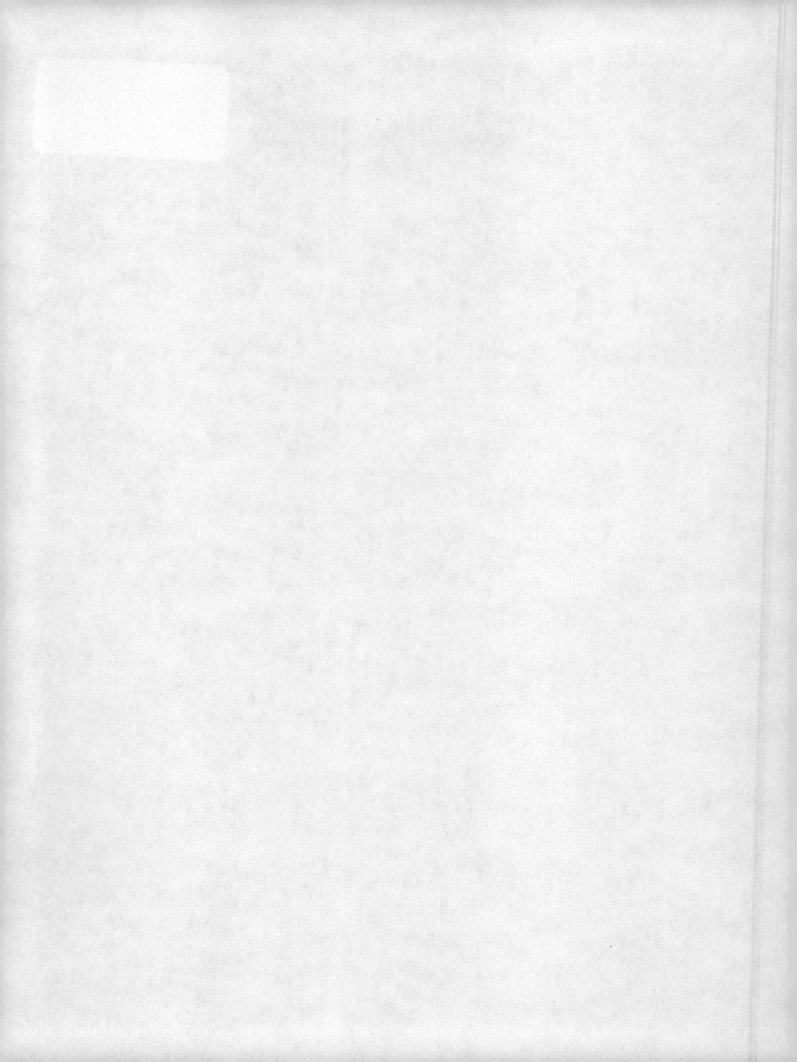

Discovering Drawing

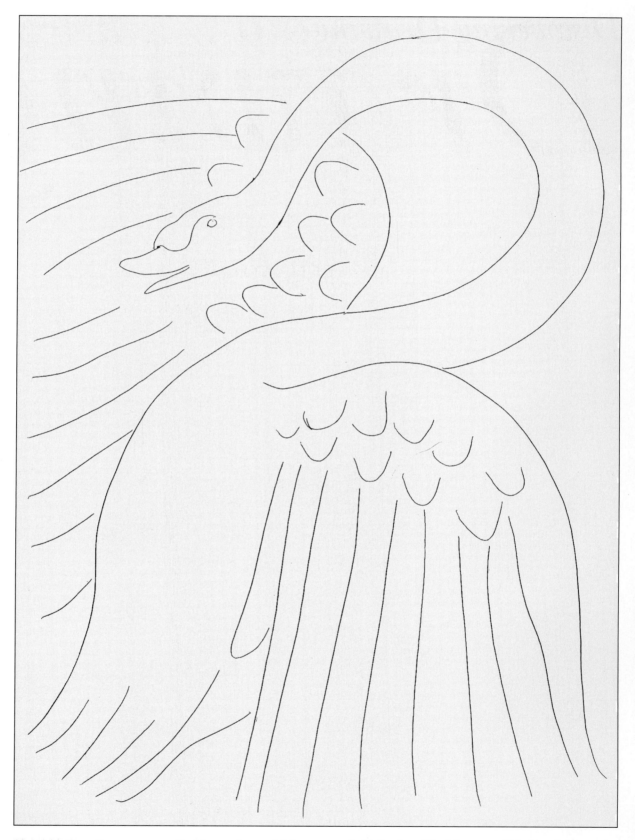

Henri Matisse, *Swan*, 1930-32. Etching, 13" x 9 3/4" (33 x 25 cm). Collection, The Museum of Modern Art, New York (Mrs. John D. Rockefeller, Jr., Purchase Fund).

DISCOVERING
Drawing

Ted Rose

Davis Publications, Inc. Worcester, Massachusetts

The Author

Ted Rose has fifteen years of high school and university teaching experience. His students have won national, regional and state competitions. These awards include First Place in the Texas Collegiate Competition and a Gold Medal in Scholastic Magazine's Art Competition in New York. Rose has taught in the Tennessee Governor's School for the Arts and The Tennessee Arts Academy and is active in numerous art education organizations.

He has also worked as a full-time artist, and has over 100 works in corporate collections and twenty-one solo exhibits in seven states and four foreign countries. His artwork is represented in galleries in Tennessee, Texas, Missouri, Mississippi and Georgia.

Ted currently serves as Chairman of the Art Department at William Carey College on the Coast of Gulfport, Mississippi. He holds the Master of Fine Arts degree from the University of Tennessee at Knoxville and the Master of Education degree from Edinboro University, Edinboro, Pennsylvania. He lives with his wife Kathy, son Mason, and daughter Anna in Long Beach, Mississippi.

© 1995 Davis Publications, Inc.
Worcester, Massachusetts, U.S.A.

All rights reserved. No part of this publication may be reproduced or transmitted in any form or by any means, electronic or mechanical, including photocopying, recording, or any storage and retrieval system now known or to be invented, except by a reviewer who wishes to quote brief passages in connection with a review written for inclusion in a magazine, newspaper or broadcast.

Cover credit: Student work (detail) by Steven Beal, Boston College High School, Dorchester, Massachusetts.

Editorial Consultants:

Leigh Backstrom, North High School, Worcester, Massachusetts

David McIntyre, El Paso Independent School District, El Paso, Texas

Kaye Passmore, Notre Dame Academy, Worcester, Massachusetts

Connie Pirtle, Tennessee State Department of Education, Nashville, Tennessee

Barbara Pratt, Richardson Independent School District, Richardson, Texas

Richard Shilale, Holy Name High School, Worcester, Massachusetts

Diana Woodruff, Forest Avenue Elementary School, Hudson, Massachusetts

Faith Zajicek, Temple High School, Temple, Texas

Managing Editor: Wyatt Wade
Associate Editor: Claire Mowbray Golding
Production Editor: Nancy Burnett
Production: Steven Vogelsang
Copyeditor: Janet Stone
Photo Research: Ewa Jurkowska
Editorial Assistance: Holly Hanson, Amee Bergin, Denise Nephew
Design and Electronic Page Make-up: Tong-Mei Chang, Cathleen Damplo, Constance Jacobson, Douglass Scott, WGBH Design
Design Advisor: Karen Durlach

Printed in U.S.A.
Library of Congress Catalog Card Number: 93–074646
ISBN: 87192–281–9
10 9 8 7 6 5 4 3 2 1

Contents

Umberto Boccioni, study for *The City Rises*, 1910. Crayon, chalk and charcoal, 23 1/8" x 34 1/8" (23.1 x 34.1 cm). The Museum of Modern Art, New York. Mrs. Solomon Guggenheim Fund.

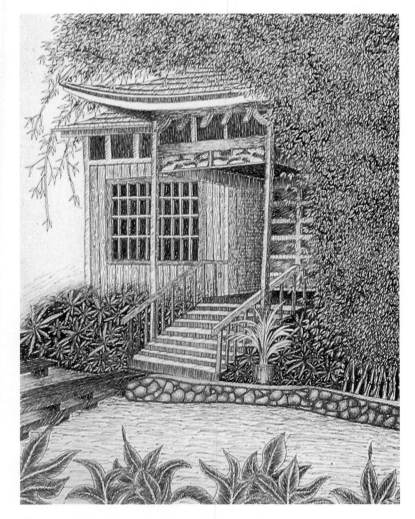

Student work by Kyung-Eui Kim, Honolulu, Hawaii.

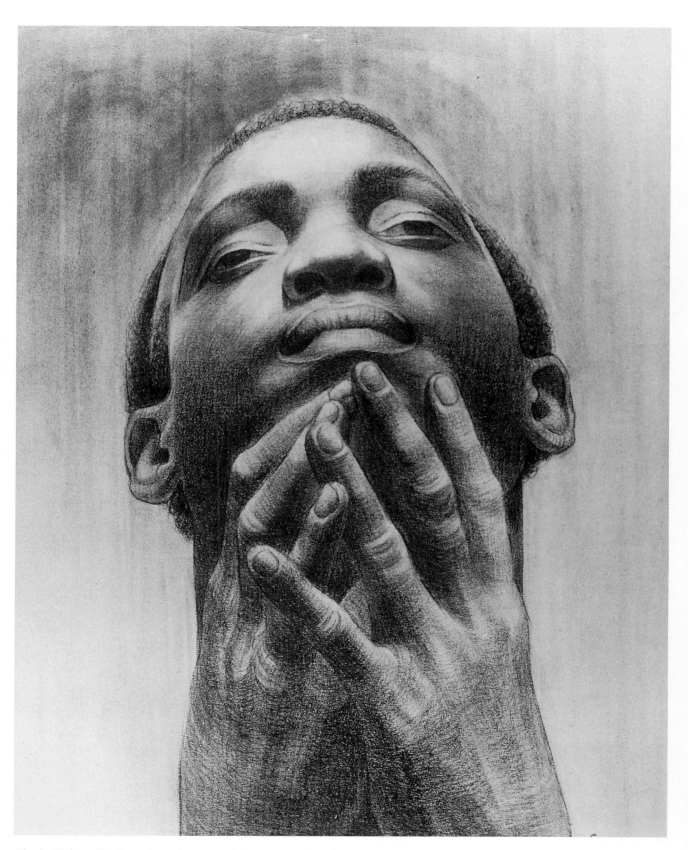

Charles White, *I Believe*. One of a series of drawings used on the "Harry Bellafonte Special" television program, NBC, 1960. Original in the collection of Mr. and Mrs. Harry Bellafonte. Courtesy Heritage Gallery, Los Angeles.

Part I

Vizualizing

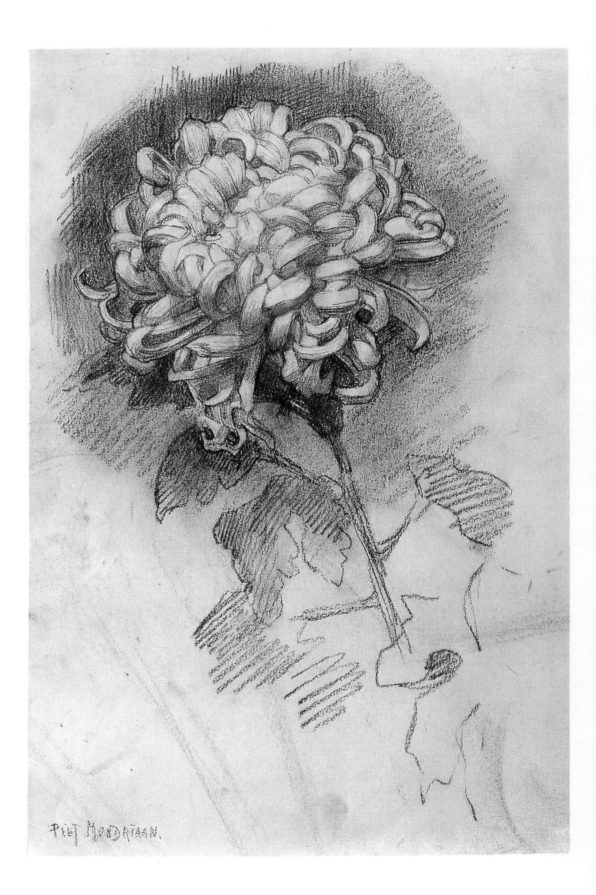

PIET MONDRIAAN.

1 Goals of Drawing

Drawing is both a mental and physical act. The physical aspect—what your hand records—is a reflection of what your eyes see and your mind thinks. Drawing is a type of language all its own. Throughout this book, you will be exploring drawing as a form of communication.

Vocabulary
sketch
sketchbook
thumbnail
 sketches
doodling

In this chapter, you will explore the interrelationship of drawing to everyday life. There are

many types of drawing, some of which have practical uses in the business world. Other types of drawing are expressions of a culture. How do you see drawing in your own life?

This chapter explains the importance of using a sketchbook and gives you some suggestions on how to use it as a tool for drawing.

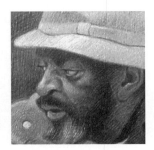

In the last section of the chapter are some guidelines you can follow to make your drawings—and the drawing experience—meaningful and satisfying.

Key Chapter Points

- Drawing is communicating.
- Drawing is a skill that anyone can develop.
- Drawing has a practical value in today's world.
- There is no right or wrong way to draw.
- The best way to learn is by trial and error.

When you draw something, you make it important. The way you draw it shows others what it means to you. What do you think this flower meant to the artist? Why did it catch his eye? Piet Mondrian, *Chrysanthemum*, 1906. Pencil, 14 1/4" x 9 5/8" (36 x 25 cm). The Museum of Modern Art, New York. Gift of Mr. and Mrs. Armand P. Bartos.

What Is Drawing?

People throughout time have searched for ways to leave their mark on this earth. Since the beginning of time, people have communicated significant ideas and recorded valuable information through drawings. Drawings have been found on rocks, skins, clay, fabric, paper, bones and the earth itself. The unique aspect of drawing is that we can creatively express what is within and immediately translate life experiences.

The process of drawing helps us interpret our world physically, emotionally and aesthetically. Cultures throughout the world have approached drawing from a variety of perspectives. Essentially, drawing involves imagining, investigating, translating, responding and expressing our ideas, values and beliefs.

Learning to draw is learning to see. The process of drawing reflects our own evolution. In our first experiences, we learn to touch and then to see. Gradually, we learn how to sense lights, darks, textures, patterns and edges. Learning to draw involves basically the same type of evolution. Drawing is a skill that can be developed just as reading, counting or playing basketball. Looking, analyzing, discovering, responding and acting are all necessary in the process of drawing.

Speaking of Art ...

"Did you ever have something to say and feel as if the whole side of the wall wouldn't be big enough to say it on and then sit down on the floor and try to get it onto a sheet of charcoal paper—and when you had it down, look at it and try to put into words what you have been trying to say with just marks—and then wonder what it all is anyway."
—*Georgia O'Keeffe,*1915

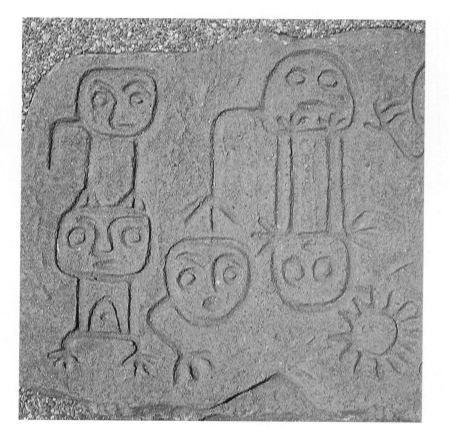

If you had only a rock to draw with, how would your drawings look? Would you try to create detail? Would you work only in straight lines? These ancient rock carvings may have been used to record important events, or to serve as boundary markers or magical symbols. Petroglyphs. Nootka, Sproat Lake, Canada. Werner Forman Archive/Art Resource, NY.

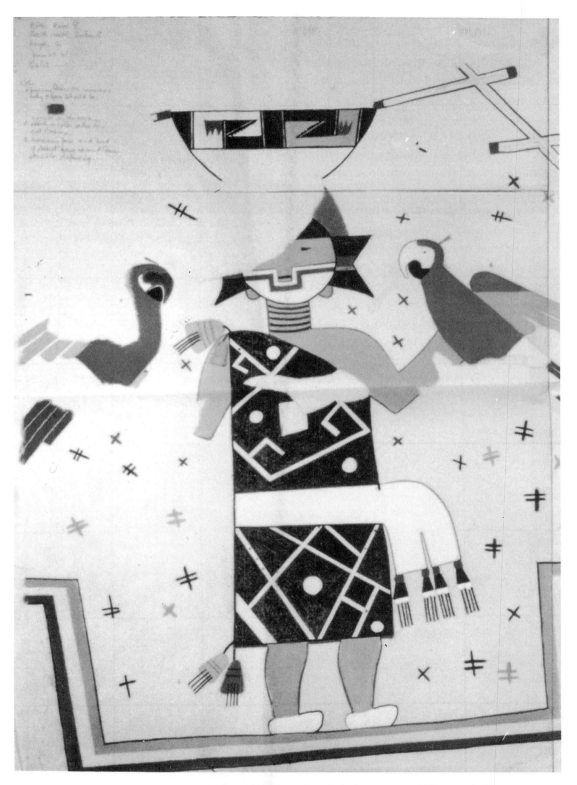

Many American Indian tribes use symbols to show how they feel about events. What symbols appear in this drawing? How would you express some of your beliefs with symbols? Drawing of a kiva mural from pottery mound, Pueblo, New Mexico, ca. 1350-1450. Courtesy Maxwell Museum, Albuquerque, New Mexico.

Drawing As Language

In the same way that a poem or a piece of music expresses a person's thoughts and feelings in a tangible form, a drawing is a way for you to express yourself through a visual format.

The process of drawing enables you to see more accurately by studying the objects around you. If you have ever drawn an object, you already understand this concept. Consider how the drawing process has made you more aware and more sensitive to the world around you.

Just as each of us has our own unique style of handwriting, an artist should strive to have a unique style of expression. Experiment with ideas and search for your own special style of drawing. Explore new directions in your art. Use ideas from other artists and from other times and build upon them.

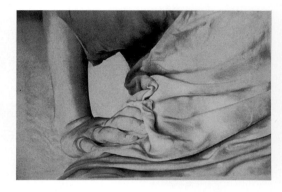

What drawing style will you develop? Will it be realistic, like this artwork, showing every detail as clearly as the eye sees it? Susan Avishai, 1993. Colored pencil. Courtesy of the artist.

How will you express your ideas in your drawing? Will you find new ways to describe ordinary objects through drawing? Student work by Rafael Vasquez, El Paso, Texas.

What kind of subject matter will you explore through drawing? Will you draw what you imagine? Student work by Jeff Broderick, Santa Fe, New Mexico.

Sketchbooks

A sketchbook is a necessary tool for the beginning drawing student. Perhaps you have already begun using a sketchbook. Would you describe it as a visual diary, a personal journal, or perhaps a movable studio? You should view the sketchbook as a companion. In a sketchbook, you can:

1. try out ideas and experiment with different materials and drawing techniques;
2. record and save visual information;
3. capture images from your imagination;
4. develop quick sketches (thumbnail sketches);
5. experiment with problem solving and developing compositions.

Speaking of Art...

In 1944, James Lord was a gutsy young soldier in Paris. After knocking on Picasso's door on several different visits, he finally met Picasso and persuaded him to sketch his portrait. However, Picasso had not focused his complete attention on the drawing, and Lord was disappointed with the quick pencil sketch. He boldly returned to Picasso and asked him to sketch him again. Picasso complied.

"Clearly, Picasso had seen in me that morning a being very different from the one who had come unbidden to ring at his door several months before. This drawing looked like me, was adequately large, and was in no way a disappointment. I tried to express some awkward manner of thanks, but he dismissed this gently."
—*James Lord*

Use your sketchbook to practice the drawing topics you find most challenging. When you look back through its pages, you'll be able to see the progress you've made. Student work by Carissa Renteria, El Paso, Texas.

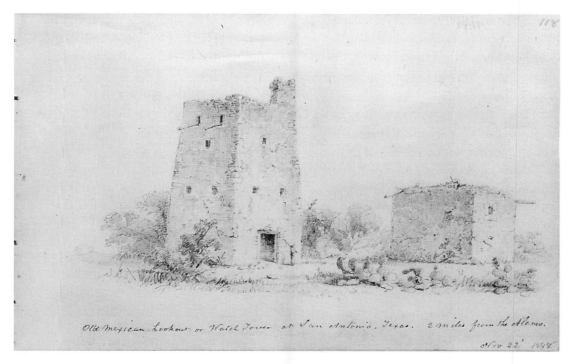

This drawing was done by a nineteenth century soldier who kept a sketchbook as he traveled through Texas. If you found yourself in an unfamiliar place, how would you record what you saw? How is a sketch different from a photograph? Seth Eastman, *Old Mexican Lookout or Watch Tower at San Antonio, Texas, two miles from the Alamo*, November 22, 1848. Graphite on paper, from sketchbook. McNay Art Museum, gift of Pearl Brewing Company.

Sketchbooks

useful sizes: 9" x 12", 11" x 14"

materials: pencil, ink, markers, ballpoint pen, conté crayon, light washes, photographs, collage, graphite

spiral-bound: opens flat, has easy-to-remove pages

hardbound: two pages, more permanent

Use your sketchbook to do sketches of major art projects, thumbnail sketches or just doodling. All of these approaches can expand your drawing opportunities and capabilities.

Thumbnail sketches have value in letting you quickly record various kinds of visual information in a series of drawings.

Doodling provides a chance for you to let your marks wander with your mind.

Doodling is valuable because it allows you to relax and develop very personal and unique drawings without any preconceived plan.

The sketchbook is not used just by beginning drawing students. Leonardo da Vinci recorded his ideas, plans and inventions in numerous sketchbooks. Pablo Picasso used his sketchbook as a valuable resource material for his growth as an artist.

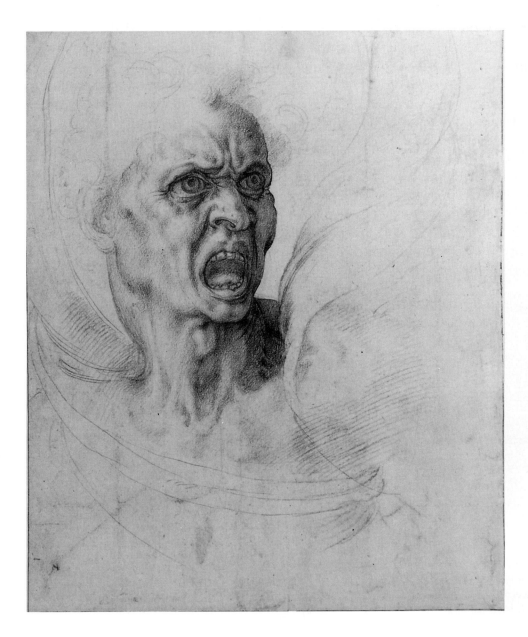

Pablo Picasso

1881–1973

The oldest son of painter Jose Ruiz Blasco, Pablo Picasso began to draw at an early age. Among his first works were portraits of his parents and his sister, as well as sketches of his native Malaga, Spain. When he was ten years old, Picasso was allowed to fill in the details of his father's paintings. At eleven, he was sent to the School of Fine Arts in La Coruna, Spain. Picasso said about his school days, "For being a bad student, I was banished to the 'calaboose'—a bare cell with white-washed walls and a bench to sit on. I liked it there, because I took along a sketch pad and drew incessantly."

When Picasso died in 1973, he left 175 sketchbooks containing over 7,000 drawings that had never been exhibited. Those sketchbooks are not only a type of diary containing carica-tures of friends and cartoon-style sketches from trips, but also a unique record of Picasso's artistic develop-ment.

Picasso began his career as a Realist, but he soon turned away from natural vision to search for new possi-bilities of expression. Inspired by African sculpture and prehistoric art, he created a style known as Cubism,

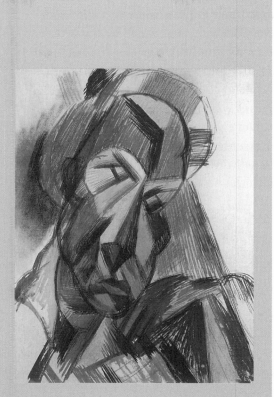

Pablo Picasso, *Head of a Woman*, 1909. Gouache over black chalk, 24" x 19" (61.8 x 47.8 cm). The Art Institute of Chicago, Charles L. Hutchinson Memorial Collection.

in which the object is depicted from several vantage points at the same time. The natural forms are reduced to geometric shapes. Picasso's *Head of a Woman* is an example of a Cubist drawing. The form of the head is not completely lost but is broken into an angular composition. Instead of facial features, there are sharply cut, tilting geometric planes.

You don't have to produce finished drawings in your sketchbook. It can be used for doodling, for small sketches of ideas for larger works, and for concentrating—as this artist has done—on the details you are most concerned with. Unknown artist, after Michelangelo, *A Damned Soul*. Courtesy Royal Library, Windsor Castle.

Establishing Attitudes and Directions

Establish a healthy attitude when approaching drawing. Try to approach every drawing as if it will be the best drawing you have ever done. This is a positive and aggressive direction. Equally important is working with the subject matter with a positive attitude.

Developing good work habits is another essential part of the drawing process. Good work habits include being prepared with the proper materials, equipment and lighting. Set up a comfortable working space. Drawings often fail not because of technical ability, but from poor work habits or lack of planning.

As you experiment in drawing, learn from your mistakes. What are your strengths and weaknesses in your technical abilities and observational skills? Look at each drawing you complete as a learning experience, not as a success or a failure. Incorporate new information you are learning in the drawing process into your next drawing to overcome what you think are your weaknesses.

Today's technologies have provided more media that can be used for art than ever before. Become familiar with these media. Go to art museums and galleries to see how other artists are developing new directions in art. Throughout this book, you will have opportunities to learn how to use the current materials that are available for drawing.

You may discover that by developing your own style, philosophy and form of expression in drawing, you may find yourself as well.

It might seem difficult at first to find ideas for your drawings. Start by jotting down things you think about during the day—your math homework, a video game, the weather. You may find that your thoughts bring new images to your mind. Student work by Stephen Gist, Temple, Texas.

Have you ever tried drawing in white on black paper? Or with a feather dipped in ink? Can you make a drawing with the sole of your shoe? Sometimes you'll get surprising results from an unusual medium or technique. Student work by Ginger Urick, East Detroit, Michigan.

The Role of Drawing Today

Consider how art has enriched your life. Have you drawn pictures of friends and family or scenery? Perhaps you have photographed them. What makes you want to record what you see? Why is the process of drawing an important method of communication?

In a unique way, drawing promotes human understanding, achievement and self-improvement. Drawing serves as a means of making lives fuller and richer, enriching whole societies and cultures.

Fashion designers use drawing to show others their ideas.

Graphic artists produce illustrations for many different clients. This illustration was created on a computer for an advertisement. Courtesy Commercial Graphics, Worcester, Massachusetts.

Our society benefits from a better educated and aesthetically aware public. One measure of the strength of a culture is its art, through which the culture expresses its values and beliefs. Through art, we gain understanding and valuable knowledge of cultures past and present.

On a practical level, drawing provides a means of solving problems and developing ideas. Drawing is a quick, flexible and direct method for putting together information. Designers use the sketching process to visualize ideas and concepts for new products. Fashion designers use drawings to develop ideas for jewelry. Graphic designers create logos, symbols and layouts for the corporate world. Illustrators, architects and cartoonists all use drawing as a vehicle for visual and creative thinking and to communicate their ideas.

All of these areas require an understanding of basic drawing and visual communication skills.

Perhaps you have already grasped how your drawings reflect your personal responses to life. Can you also understand how your drawings relate to your culture? Your drawings have value. They express not only your feelings, but also some of the feelings that are unique to your time in history. Be willing to examine the direction and value of your work. Here are some guidelines to help you grow as an artist.

1. Create artwork that expresses your personal philosophy. What do you think about? What do you feel is important? Do you wish for a peaceful world? A world without pollution, without illness, without poverty? How might your drawings reflect what you feel?

People-watching is good preparation for sensitive drawing. How do people's faces look on a bus or train, or when they're telling a joke or yawning? Yetti Frenkel, *Orange Line #1*, 1987. Pastel and conté, 32" x 54" (81 x 137 cm). Courtesy of the artist.

2. Produce drawings that have originality. All artists get ideas from other artwork, or from things they have seen, but they add ideas or techniques that are completely their own. Listen to your imagination: where does it take you? How would you like to change the things you see? Apply ideas like those to your drawings.

3. Develop drawings that use a variety of approaches, themes and subject matter. The more you explore new ways of doing things, the more confident you'll become. Confidence will allow you to take risks and seek new challenges.

4. Produce drawings that communicate important ideas and challenge the viewer to see a subject in a new way. You have

insights that no one else has; you see things as no one else does. When you draw, try to remember that other people don't necessarily think the way you do—about anything. That may inspire you to tell them, through your drawings, how you view life, the world, yourself.

5. Create artwork that reflects our current society but demonstrates a thorough understanding of a previous culture's achievements in art.

6. Develop an in-depth understanding of other artists' styles and work in order to develop your own individual approach to drawing.

William Blake

1757-1827

William Blake's passion for art began with his fascination with drawing. As a child, he was constantly sketching from nature and copying copper prints. He was also an avid reader. Stories from the Bible, Shakespeare and Milton fascinated the young artist and inspired his first poems and pictures. It was the world beyond empirical evidence that always appealed to him the most.

At age fourteen Blake began his apprenticeship to James Basire, a London engraver. After seven years of learning his craft, Blake became a certified printmaker himself. He became an engraver of other artists' works, as well as a creative artist in his own right.

In 1779, Blake decided to continue his education at the London Royal Art Academy. Although he enjoyed his classes in figure drawing, Blake was more interested in drawing from imagination rather than from life. Blake believed that "the artist has to put before the viewer forms and poses which hitherto have existed only in the darkness and confusion of an irrational mind or one beset with uncontrolled passions."

Blake often claimed that his fantastic imagery originated in his visions. Once he told his neighbor that a ghost of a flea appeared to him. As his friend watched, Blake began to draw the monster. It had a tongue like a lizard and its head was covered with green and gold skin. In its hand was cup to hold blood.

Blake is known for his watercolor illustrations. This sketch shows his fascination with other-worldly images. William Blake, *The Head of a Ghost of a Flea*, 1819. On paper, 7" x 6" (19 x 15 cm). The Tate Gallery, London. Art Resource, NY.

Speaking of Art...

Jean-Auguste Ingres was one of David's students. In 1801, he won the French Academy's Prix de Rome, a scholarship to study art in Rome. He remained in Italy after his year of study and supported his family by drawing pencil portraits. Before he began a painted portrait, he would make hundreds of pencil sketches. In 1824, he returned to Paris, where he lead the French Academy for over forty years.

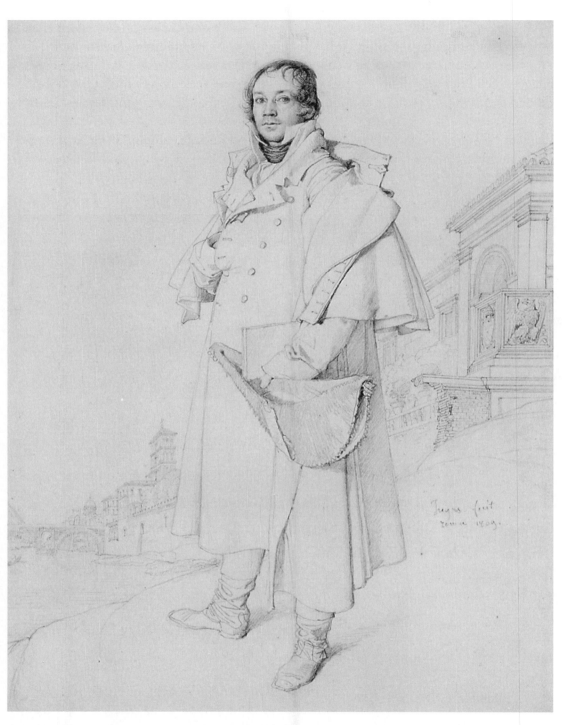

Drawing effective portraits means working to master the proportions of the face and body, showing the folds of clothing and the textures of skin and hair, and capturing small personal details. Jean-Auguste-Dominique Ingres, *Charles François Mallet, Civil Engineer*, 1809. Graphite on cream wove paper, 11" x 8" (26.8 x 21.1 cm). The Art Institute of Chicago, Charles Deering Collection.

Summary

You have learned in this chapter how drawing can be a language all its own. Drawing is communicating. It is a language which can cross all boundaries around the world and still be enjoyed and understood. As you progress through this book, consider how drawing is an integral part of our society.

Successful drawing, like any other art form, depends a great deal on establishing a positive attitude. Learning how to plan and seek directions in your drawing is critical to getting good results. Learning how to express your concerns and emotions in a complex and ever-changing world can be a joy and a challenge.

Your best drawings will probably be of things you care about or find visually interesting. If they don't come out as you'd imagined them, try again. It takes time and practice to develop good drawing skills. Melissa Gill, *Untitled*, 1993. Charcoal on paper. Courtesy of the artist.

Some drawings suggest feelings rather than show you things you've already seen. What feeling does this drawing give you? Georgia O'Keeffe, *Special No. 9*, 1915. Charcoal on paper, 25" x 19 1/8" (64 x 49 cm). The Menil Collection, Houston. Photograph: Paul Hester.

Activities

Sketchbooks

a Select a subject that interests you and develop it in ten different ways. Begin with a simple contour drawing. Try different techniques such as blending, crosshatching and stippling to add value. Try drawing the subject from a different viewpoint. Draw the subject as though it were fading away. Search for new creative methods as you complete this exercise.

b Write down a dream you have had. Record as many details as you can remember. How did you feel during your dream? Illustrate your dream. Try to capture the mood.

c Select an object. Imagine how it would look if it were collapsed, melted, exploded or in some other unusual state. Draw one of your mental images.

d Select a familiar object or item of food. Create a series of sequential sketches in which the object gradually transforms into something else.

Style

Compare and contrast the work of three artists who have very different styles. In a short essay, identify the main characteristics of each style. What makes each style different from the others?

Create your own composition. How would each of the artists approach it? Try drawing your composition in each of the three styles.

Images and the Written Word

Make a list of descriptive words in a journal. Record quotations you have heard or read that have made an impression on you. Are there specific details of experiences, dreams, sights and sounds that you could record in your journal? Use your journal writing as a source for drawings in your sketchbook. Think of how you can create a visual representation of written expression.

Design Elements in the Environment

Can you find design elements and principles of art in your everyday environment? Consider the shapes and patterns in buildings, the colors and lines in automobiles, as well as the designs you find in the natural world. Each day for a week, record some images and patterns you see. At the end of the week, write a paragraph about what you have seen. Reflect on how important these elements are to your everyday life. Consider how your life would be affected without their presence.

Careers

Research a career in art that interests you. How are drawing skills used in that career? If possible, visit a workplace and talk to an employee. Write a brief report about this career. Include a job description, training required, responsibilities, opportunities and salary.

Drawing on Scratchboard

Using a scratchboard that has not been inked, randomly paint colored inks over its surface. You may want to leave a few places white. When the colored ink has dried, cover the scratchboard with black ink. Let the ink dry. Now draw a design on the scratchboard.

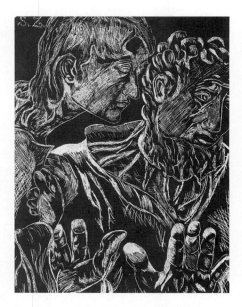

Student work by Sebastian Zapisek.

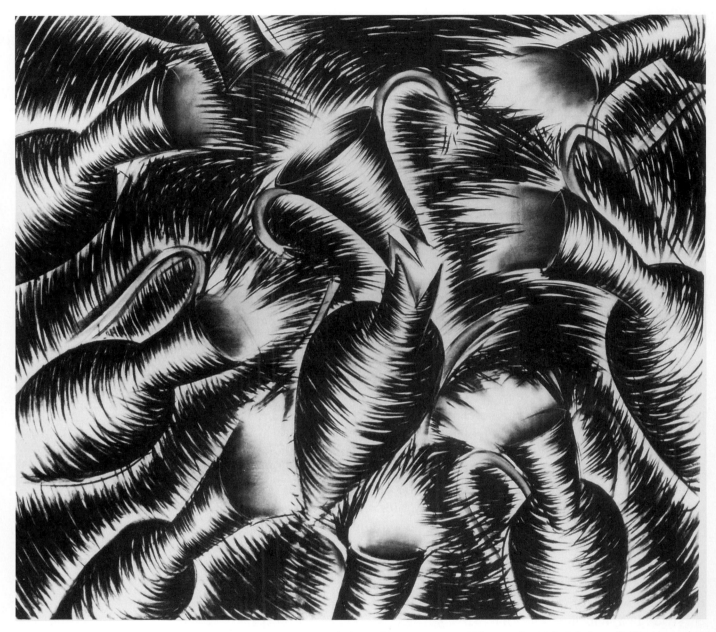

Strong, confident lines and stark contrasts give this drawing a feeling of intense energy. What unifies it? Is it balanced? Have you ever imagined giving everyday objects lives of their own? Susan Chrysler White, *Untitled 2*, 1981. Dayglow, gouache, charcoal, 48" x 42 1/2" (121.9 x 108 cm). Courtesy Stedman Art Gallery/Rutgers-Camden Collection of Art.

2 Establishing a Composition

This chapter covers the basic vocabulary of art, the fundamentals on which artworks are created. The vocabulary may not be new to you. You have probably used these terms to describe many things in your environment. Apply what you already know as you discover how the vocabulary is used in the context of art.

Vocabulary
line
shape
texture
value
color
balance
emphasis
harmony
variety
movement
proportion

This chapter explores the principles of art that enable the artist to organize the elements of a

composition into a unified whole. The objective of this chapter is to explain how each element of design—line, shape, texture, value and color—can be successfully blended with the principles of art to produce interesting and successful compositions.

The principles of art include balance, emphasis, harmony, variety, movement and proportion. Any successful composition includes at least some of them. These fundamental principles can also help you analyze an artwork and discover the idea or concept the artist has attempted to communicate.

Key Chapter Points

- The elements of design are line, shape, texture, value and color.
- The principles of art are balance, emphasis, harmony, variety, movement and proportion.
- Texture is simulated in a drawing.
- Value is the gradation of shades between black and white.
- Unity is a principle of design that relates to a sense of wholeness in a composition.

Glossary of Drawing Materials

Pen and Ink
1. broad tip marker
2. fine tip marker
3. brush tip marker
4. chisel tip calligraphy pen
5. extra fine point marker
6. 0.5 mm point felt pen
7. technical drawing pen with interchangeable nibs
8. fountain pen
9. pen holder and nibs
10. black drawing ink
11. reed pen
12. bamboo brush
13. bamboo brush
14. Sumi-ink ink stick and grinding stone

Charcoal
1. stick charcoal
2. stick charcoal
3. compressed charcoal square
4. compressed charcoal round
5. charcoal pencil extra soft
6. charcoal pencil medium/2B
7. charcoal pencil hard/HB
8. powdered charcoal

Graphite
1. flat sketching pencil 6B
2. ebony pencil
3. sketching pencil 4B
4. drawing pencil 9B
5. drawing pencil HB
6. drawing pencil H
7. drawing pencil 8H
8. graphite woodless pencil
9. graphite stick 4B

Conté/Grease
1. crayon
2. oil pastel
3. conté stick
4. conté pencil white
5. conté pencil black 2B
6. conté pencil black 3B
7. china marker
8. lithographic crayon

Rubbing and Blending Tools
1. rolled paper stump
2. tortillon
3. rolled paper stump
4. chamois
5. erasers
6. cotton balls
7. cotton swabs

Pen and Ink

The earliest pens were reed pens made from bamboo cane, and quill pens from feathers. Today artists have a wide range of pens available to use, from those that need to be dipped in ink to those that carry their own supply of ink in the barrel in refillable or disposable cartridges.

Ballpoint pens, fountain pens with a refillable or disposable cartridge and felt-tipped markers are good tools for continuous line drawing of consistent thickness, since they carry their own ink supply. The best and most expensive tool with a continuous flow of ink is the technical drawing pen. Technical pens are refillable and are available with a variety of interchangeable nibs that produce lines that range from thin (.13 mm nib) to thick (2.00 mm nib).

The blackest and most permanent ink is India ink. It has been in use since about 2,500 BC. The solid form (Sumi-e sticks) is ground on a grinding stone and mixed with water, generally used for washes. Liquid India ink is used with reed pens, quills and brushes. Additional types of ink are those for fountain pens and technical pens.

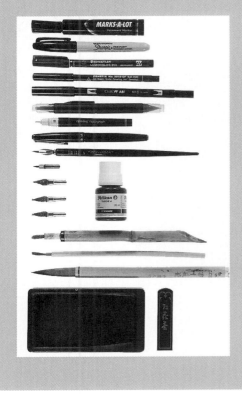

Charcoal

Charcoal was used as a drawing medium by the Greeks and Romans, by artists in the Middle Ages and Renaissance and is still used today. Until the sixteenth century, when fixatives were discovered, charcoal drawings could not be kept. Charcoal can be erased with kneaded rubber erasers and worked with a chamois, rolled paper stumps, cotton swabs and fingertips.

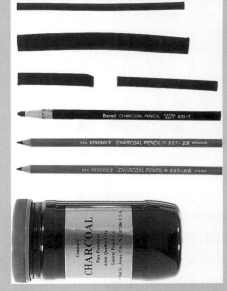

The two types of charcoal are stick and compressed. Stick charcoal is carbonized wood or vines and can be purchased in varying thicknesses. Compressed charcoal is ground carbon mixed with clay or binding substances. Compressed charcoal produces a richer, blacker line than stick charcoal and is more difficult to erase. Charcoal pencils are compressed charcoal encased in wood, in a variety of gradations such as extra soft, soft, medium, hard. Letters and numbers may indicate the gradation, such as H (hard), 2B (soft).

Powdered or dust charcoal can be purchased in jars or made by scraping the stick form down with a knife. Charcoal powder is worked with stumps or fingertips.

Charcoal's thickness and the difficulty in keeping the point sharp make it a medium suited to large, free drawing rather than small, precise work. Since charcoal smudges easily, finished drawings must be fixed to preserve them.

Graphite

Graphite, the most commonly used drawing material, comes in stick and pencil form and in a great variety of hardnesses (from 8B, the softest, to 9H, the hardest). Graphite pencils are generally called lead pencils, although they are actually made of graphite mixed with clay. Soft lead pencils contain less clay and produce a darker line, while hard pencils contain more clay and produce a lighter line. Graphite has a shiny, metallic quality and even at its darkest is not a true black.

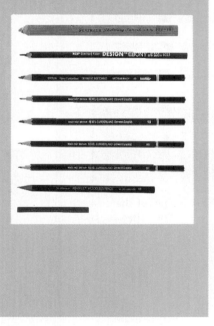

Conté/Grease

Conté is a finely textured, semi-hard, oily material in pencil and stick forms, in several degrees of hardness. It comes in colors, including sanguine, sepia, white and black. Conté is smoother and more permanent than charcoal.

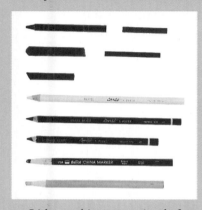

Lithographic crayons (made for drawing on lithographic stones for printmaking) and oil pastels are greasier than conté. Lithographic crayons come in several degrees of hardness. China pencils, similar to lithographic crayons, may be used on concrete for preliminary drawings for murals.

Wax crayons are inexpensive, round or square, wrapped in paper or unwrapped. Remove the wrapper to use the sides for broad strokes.

Rubbing and Blending Tools

Stumps/tortillons for rubbing and blending are made of tightly rolled paper, felt or chamois. Use pointed ends for rubbing small areas, blunt ends for larger areas. Tear away a layer to get a clean point. You can make your own by tightly rolling a triangle of paper.

Alternative tools for rubbing and blending are cotton swabs for small areas and cottons balls for large. Chamois is a soft leather used for smoothing areas of charcoal and pastel drawing.

The fingertips and lower palm of your hand can also be used for rubbing and blending.

Blending with erasers is discussed on page 90.

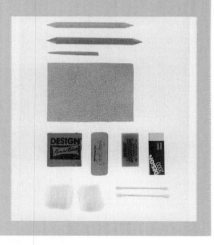

Computers

There are many paint/drawing software programs available. Most offer a choice of tools such as pencil, brush, airbrush to create lines of varying texture and thickness; a choice of closed or open shapes, with thick or thin borders; and a variety of patterns that can be used to fill shapes to show shading and texture. The drawing may be done using a stylus on a graphics tablet or a mouse. Scanners can be used to transfer photographs to the computer screen where they can be manipulated, distorted or replicated.

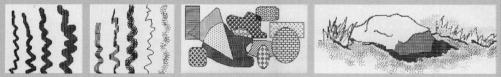

The great advantage to using a computer as a drawing tool is that you can save your drawings at different stages of development and recall them later.

Looking at Drawings

How can you judge whether an artwork is good? The quality of an artwork is not judged solely on whether or not you like it. Nor does subject matter alone make a drawing successful. A drawing that is a literal translation of an image is not necessarily a successful drawing.

Good artwork is successful when subject matter, technique, originality and proper use of the elements of design work together for a well-balanced composition. When each of these elements reinforces the others, the composition is strong and structured.

THINK ABOUT IT
As you work to create a balanced composition, you are analyzing the separate elements and synthesizing them, or figuring out how they all fit together. Thus, as your drawings get stronger, so does your ability to reason and to think!

Speaking of Art ...

When Giotto was about ten years old, Cimabue, a great Florentine painter, discovered him drawing a picture of a sheep on a rock. Cimabue was so impressed with the boy's drawing ability that he asked him to become his apprentice. Under Cimabue's guidance, Giotto learned to draw accurately from life.

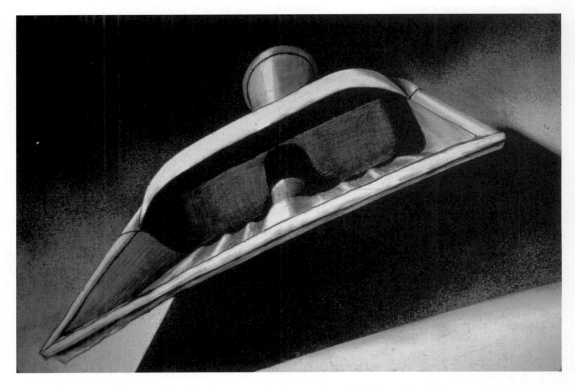

Even a dustpan can have an air of excitement and mystery about it, if the artist finds a way to communicate his or her own excitement. Notice how the dustpan's angled position and deep shadows make it seem to move toward you. Student work by Gladys Cosby, Abilene, Texas.

Originality

Artwork that captures your attention tends to be strong in originality. Think of originality as something that is intriguing and thought-provoking. Developing originality in your artworks is an on-going process. Start by choosing subject matter that you find interesting. Experiment with different materials that can best express your subject matter and your feelings about it.

Many beginning drawing students rely on photographs for their compositions. Working from photographs, particularly those you have composed yourself, is a valid approach to organizing a composition. However, the benefits from drawing directly from the subject matter cannot be stressed enough. Working directly will produce fresh, more informed and spontaneous compositions.

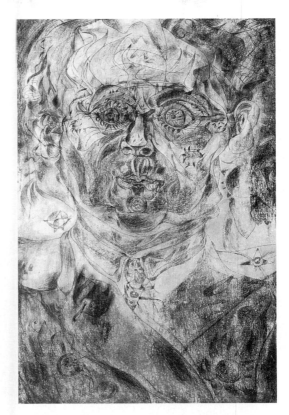

How do you think this artist felt about himself the day he drew this self-portrait? Do you think it shows originality? What face would you like to show to those around you? How would you reveal your personality? Joan Miró, *Self-Portrait, I*, 1937. Pencil, crayon and oil on canvas, 57 1/2" x 38 1/4" (146.1 x 97.2 cm). The Museum of Modern Art, New York. James Thrall Soby Bequest.

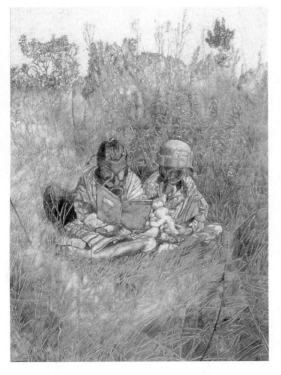

Surprise is a good way to catch a viewer's attention and hold it. Here, a pleasant-looking scene is soured by the presence of gas masks. What message is the artist sending? Student work by Elizabeth Buscemi, Livonia, New York.

Elements of Design

The elements of design are the armature on which a composition is built. Examining how each element of design is used in the composition will help you better understand how a work is structured and composed.

Line Line can be described as a continuous mark on a surface. The line is the oldest and most direct form of communication. It can be drawn quickly with expression, defining space with dramatic rhythms. With little effort the line can be drawn heavily to show more volume or drawn faintly to denote the delicate.

Scratchboard

In scratchboard drawings, a clay-coated cardboard that has been painted with black ink is scratched with a sharp tool, resulting in a white line on black. Almost any kind of sharp tool can be used to scratch the board. The most common scratchers for scratchboard are sgraffito nibs, which fit into drawing pen holders. Pre-inked scratchboards now are available with silver or colors under the black coating. The scratched lines on these boards are colored.

This sharp nib is best for fine lines.

This curved spade-shaped scraper can make wider lines.

Try a ruler with an X-acto knife to scratch straight lines.

Stipples or dots can add texture.

Needles can scratch fine lines.

Pre-inked black scratchboard is easy to use, or you can paint India ink on all or part of white scratchboard.

The values become lighter as the crosshatched lines come closer together. The crosshatching on the left is freehand, but a ruler was used on the right.

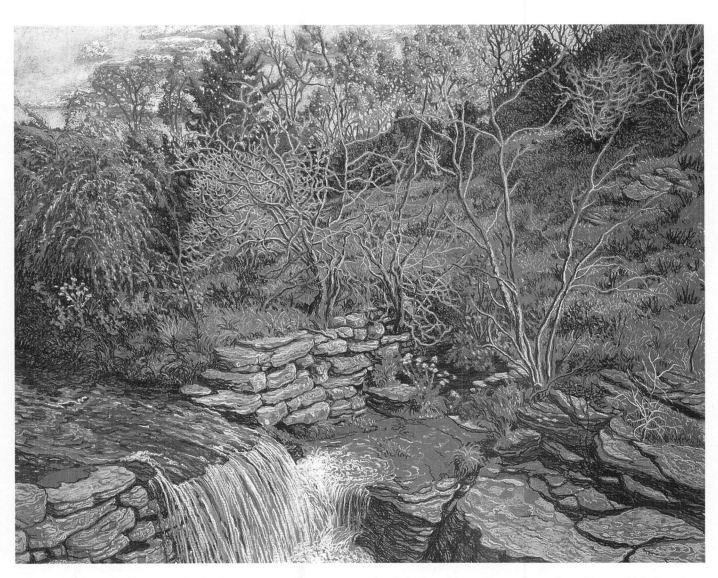

White lines create highlights in this landscape, giving the impression that light is striking only certain surfaces. From which direction is the light coming? Jack Beal, *Untitled Landscape*, 1979. Pastel on paper, 47 1/2" x 47 1/2" (120.7 x 120.7 cm). Courtesy Frumkin/Adams Gallery, New York.

Developing a line composition which causes the flat surface of the paper to appear three-dimensional is one way to explore the line as an element of design. Try repeating lines to create a pattern and then varying the thickness of the lines. Focus on getting a sense of how a composition is organized. Can you see the value of using repetition and variation in your lines?

Shape The closing of a line creates a shape. A shape is two-dimensional with a recognizable boundary. The shape of an object in a drawing is often called the figure and the surrounding space is called the ground. The relationship between the figure and the ground is called the figure-ground relationship.

Figure and ground are often referred to as positive and negative space. The positive space is created by solid objects in the composition. The negative space is the area around the solid objects.

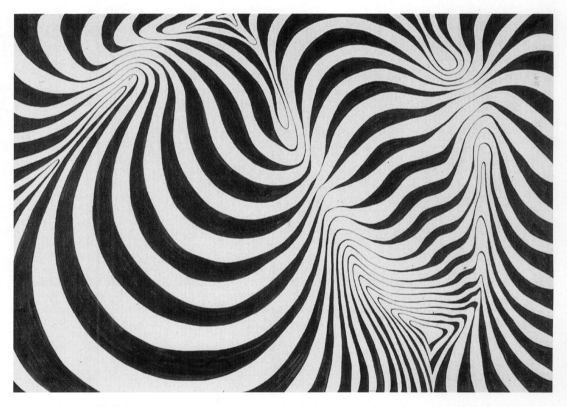

Varying line width helps create movement. Does it also help suggest three-dimensionality here? Student work by Geinene Haynes, Nashville, Tennessee.

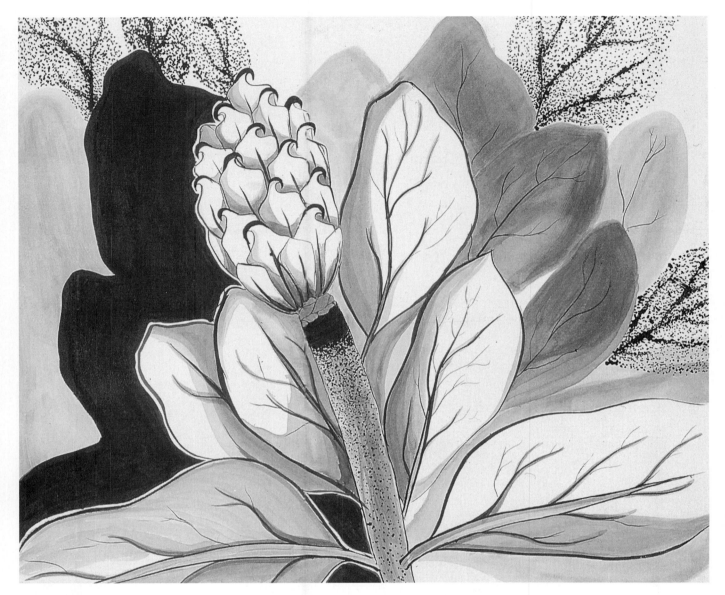

The solid areas of ink in this drawing make the negative space stand out more than the positive space. Student work by Tara White, Temple, Texas.

In his book Six Thinking Hats, *Edward de Bono shows that there are many approaches to any given situation. The more approaches we use, the wider the range of solutions we have. Try to explore different approaches to drawing shapes and the space around them. How can the shapes and spaces work together?*

Try repeating letters and numbers throughout a composition, changing the value and the direction of each. This exercise will help you better understand the concept of positive and negative space. It will also improve your ability to use variety, value and organization in your composition.

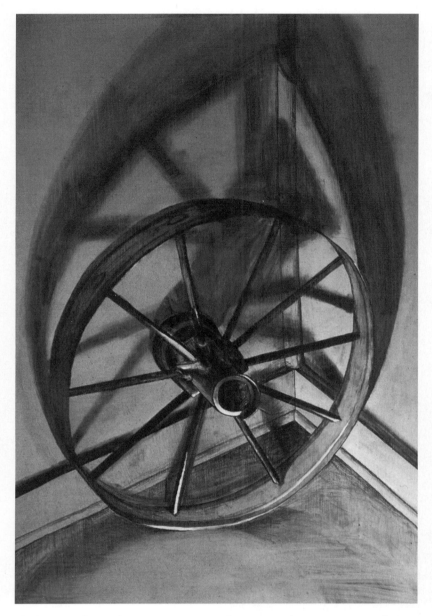

Shadows can be used to create two sets of positive and negative space relationships. Student work by Jim Hale, Commerce, Texas.

Choose a letter of the alphabet. Repeat it throughout a composition, changing the position of the letter and the values of both positive and negative space. Notice how the negative space stands out clearly from the composition in some cases, and appears neutral or insignificant in others.

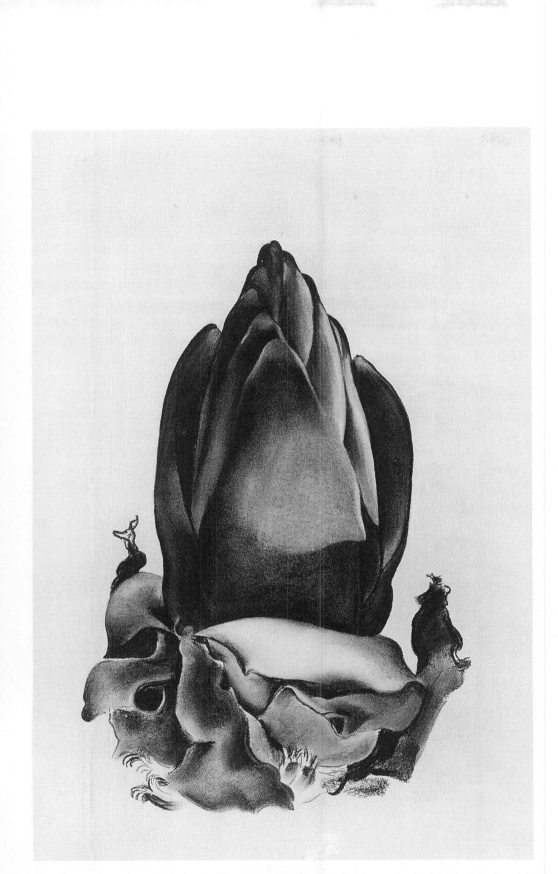

Positive space is created here by the blossom of the flower. You can see negative space in the air around the flower. Can you see how showing only the flower, without background or the rest of the plant, makes the flower look powerful? Georgia O'Keeffe, *Banana Flower*, 1933. Charcoal, 21 3/4" x 14 3/4" (55.2 x 37.5 cm). The Museum of Modern Art, New York. Given Anonymously (by exchange).

Texture Texture refers to the sense of touch. This element describes the surface quality of an object. For example, rust on metal is a texture you can see and feel; the grain in a piece of wood is a texture you can see. Texture can add valuable visual information and create intrigue in drawing.

A drawing that suggests or duplicates various kinds of textures in a composition has simulated texture. A drawing that actually includes pieces of paper, cloth, wood or other materials has actual texture.

To develop a feeling for various textures, try making a rubbing. Lay a piece of typing paper on top of a textured surface and rub a soft lead pencil back and forth across it. The image that comes up will give you an accurate transfer of the object's surface. To fully explore a range of textures, collect up to one hundred rubbings that are three to four inches square. Select the best twenty-four rubbings and glue them on a large sheet of paper. Choose rubbings based on uniqueness, strength of image, and range of value.

Did this exercise make you more aware of surface textures? Notice the different marking systems you created in each rubbing. The rubbings are a way to record visual information. You can use this information to learn to draw simulated texture.

THINK ABOUT IT
Making a rubbing that records visual information is a simple task that can bring you one step further to the more complex task of drawing simulated texture. Learning to transfer what you have learned in one task to a new, more challenging task is a valuable thinking skill.

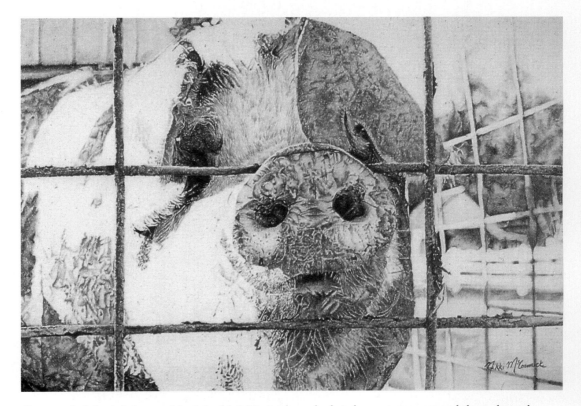

Can you feel the bristles on this pig's chin? Notice how the bristly areas are scattered throughout the composition, rather than used all over the pig's body. How does that help create visual interest? Student work by Nicole McCormick, Indianapolis, Indiana.

How would you describe the textures in this composition? Rough? Gritty? Oily? Worn smooth? Student work by Megan Boehm, Macedonia, Ohio.

Smooth, solid areas are placed next to patterned ones in this montage. Student work by Katy Kaufman, York, Pennsylvania.

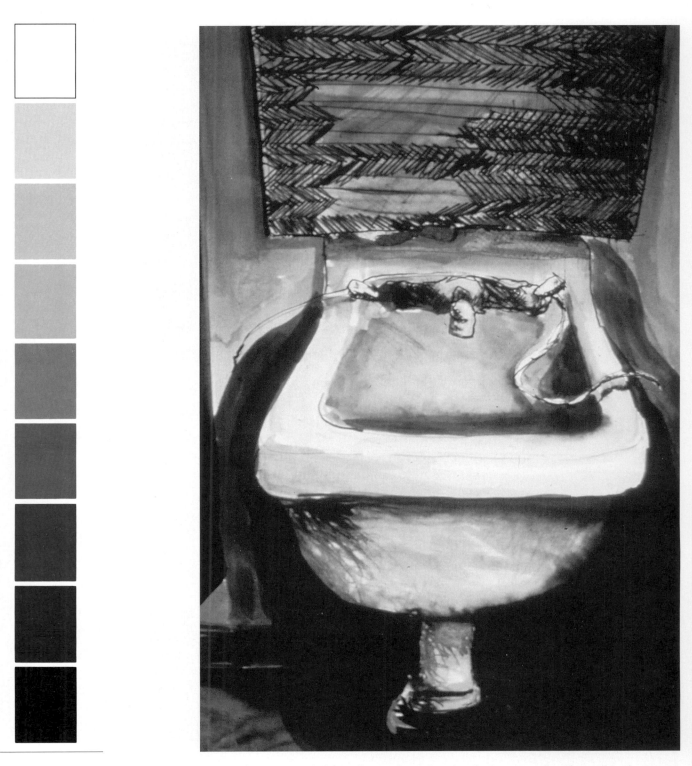

Value scale.

Sharp value contrasts help emphasize the sink and make it seem to leap forward in the composition. Student work by Bryan Lipscomb, San Antonio, Texas.

Value Value refers to the properties of darks and lights used in a composition. The range of value depends on how much light is reflected on the surface of the objects.

Value gradation is used to create the illusion of three-dimensional space on a two-dimensional plane. Value gradation shows the gradual change of lights to darks. Values are usually shown on a value scale, with white at one extreme and black at the other. Try creating your own six-step value scale. Leave the first square white and gradually darken the value in each square until the sixth square is entirely black. After completing the scale, step back at least ten feet and see if your scale shows a good gradual change in value gradation.

The following exercise explores how value can create drama and visual strength in a composition. Tear, wrinkle and fold some pieces of paper. Use a spotlight on them to create dramatic shadows. Next, draw in the shapes created by light and those created by shadows. Using the value scale, translate the shapes into six different value ranges.

THINK ABOUT IT
Using value to create the illusion of a three-dimensional object is a form of problem solving. The more problems you solve, the more problems you can solve.

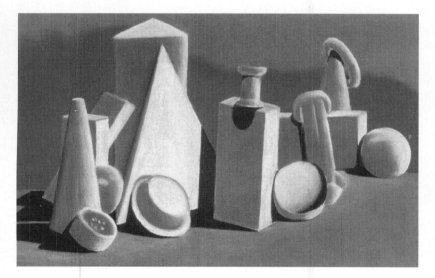

Top of page: There are many ways to create value in a drawing. In this exercise, the student used the same basic shapes in three different compositions. He then created a range of values by using tones (second row), dots (third row) and hatching (bottom row). Student work by Oscar Tovar, El Paso, Texas. Above: Brightly lit still lifes can help you see value changes. Notice how areas that receive the most light are clean white, while those receiving less light are gray or black. Student work by Jaime Behrens, Rosemount, Minnesota.

Käthe Kollwitz

1867–1945

The art of Käthe Kollwitz, a German printmaker and sculptor, is usually discussed in connection with the art movement called German Expressionism. For Käthe Kollwitz, like many of her contemporaries, art became a way of dealing with social and political issues. Unemployed workers, strikes and political assassinations were frequent themes in her works.

World War I brought new imagery into her art. Mourning parents and corpses dominated her famous series of woodcuts entitled *War*. Through art, Käthe Kollwitz expressed her grief over the loss of her son Peter, who was killed in battle.

Following Hitler's rise to power in 1933, she was expelled from the Art Academy of Berlin, where she had taught in the Graphic Arts Department. Unable to teach and no longer allowed to exhibit her works, she withdrew from public life. However, she did not stop creating. She died in 1945, leaving a large collection of prints and drawings, as well as numerous self-portraits, she had drawn over the years.

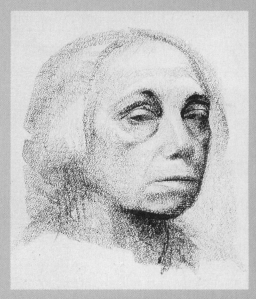

Käthe Kollwitz, *Self-Portrait*, 1919–20. Lithographic crayon, pen and ink. Courtesy The Galerie St. Etienne, New York.

The lithograph is an example of skillful use of value. Kollwitz marked the features of her face with the pointed end of the crayon. She used the flat side of the crayon to indicate areas of light and shadow with broad, sculpting strokes. The image that emerges is a sincere likeness of the aging artist. The portrait reveals a face full of dignity but also marked by weariness and sadness.

Color Color can be effectively used in drawings. You can draw with colored pencils, pastel chalks and even wax crayons. Although color is not essential in drawings, it can provide additional character, interest and effects in a composition. The function and structure of color should be understood by all beginning art students.

The following characteristics of color can be beneficial in understanding how color functions.

1. Light is the presence of all color.

2. Objects in space reflect different wavelengths of light to create color.

3. White is the presence of all light.

4. Black is the absence of all light.

5. The spectrum of color as you view a color wheel is the diffusion of the wavelengths of light.

The following terms are essential in developing an understanding of the concepts of color.

1. *Hue* is the common name of a color on the color wheel (See page 154).

2. *Value* conveys the lightness and darkness of a color.

3. *Complementary colors* are colors that are opposite each other on the color wheel.

4. *Analogous colors* are colors that are next to each other on the color wheel.

5. *Primary colors* are red, yellow and blue. These three colors in the spectrum cannot be produced by mixing pigments.

6. *Secondary colors* are green, orange and violet. They are created by mixing any two primary colors.

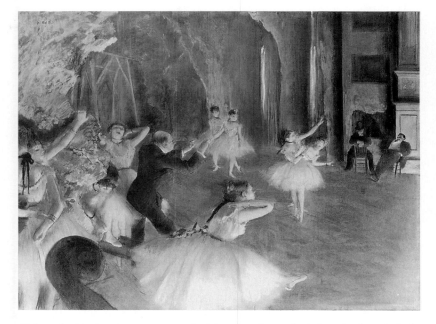

Although this drawing was created with colored pastels, it has depth and vitality in black-and-white as well. Here you can see that its wide range of values gives the composition visual interest. Turn to page 167 to see it in color. Do you think the work is more effective—that is, catches your attention, makes you want to look more closely—in color or in black-and-white? Why? Edgar Hilaire Germain Degas, *Rehearsal on the Stage*. Pastel, 21" x 28 1/2" (53.3 x 72.3 cm). The Metropolitan Museum of Art, New York, Bequest of Mrs. H. O. Havemeyer, 1929. The H. O. Havemeyer Collection.

7. *Neutrals* are white, gray and black.

8. Colors can be divided into *cool colors* and *warm colors*. Cool colors are greens, blues and violets. Warm colors are yellows, oranges and reds.

For more about color in drawing, see the section on color in Chapter 6.

THINK ABOUT IT
Of all the visual elements, color is the most fascinating. Explore the many different color schemes. Analyze and evaluate the many options open to you. Then, narrow all these possibilities into the one you wish to use.

Dividing the Picture Plane

Before you begin drawing on a surface, think first about how you will compose on the picture plane. Never skip the crucial step of planning your composition in your rush to draw an image.

THINK ABOUT IT
Facing a blank drawing space forces you to use higher-order thinking skills. You can't avoid complex thinking in the visual arts!

The picture plane is the illusionary flat surface on stretched canvas, illustration board or drawing paper on which you will create a drawing. A picture plane that is predominantly vertical tends to be more dynamic and grand in scale. The picture plane that is horizontal reflects a more stable and restful attitude.

Understanding how compositional structure interacts with your subject matter is a very important consideration in making your drawing. First consider your subject matter, which has its own shape. How will that shape impact your composition? How will you arrange and interpret the visual information?

Dividing your picture plane can help you see what is happening structurally in your drawing. Break the composition into equal parts to see how the positive forms and negative spaces have to be handled. Recall the elements of design covered at the beginning of this chapter. How will you incorporate these elements into your drawing?

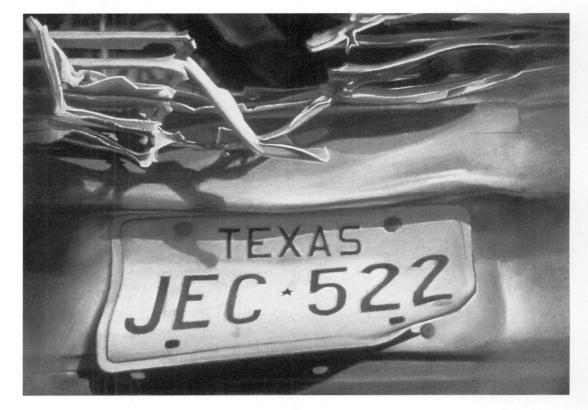

Horizontal compositions can seem calmer than vertical ones. But this artist creates some tension and mystery by showing us only part of what may—or may not—be a car. Why do you think he chose to show only this section? Author, *Texas Plates*, 1983. Charcoal, 18" x 24" (45.7 x 61 cm). Private collection, Nashville, Tennessee.

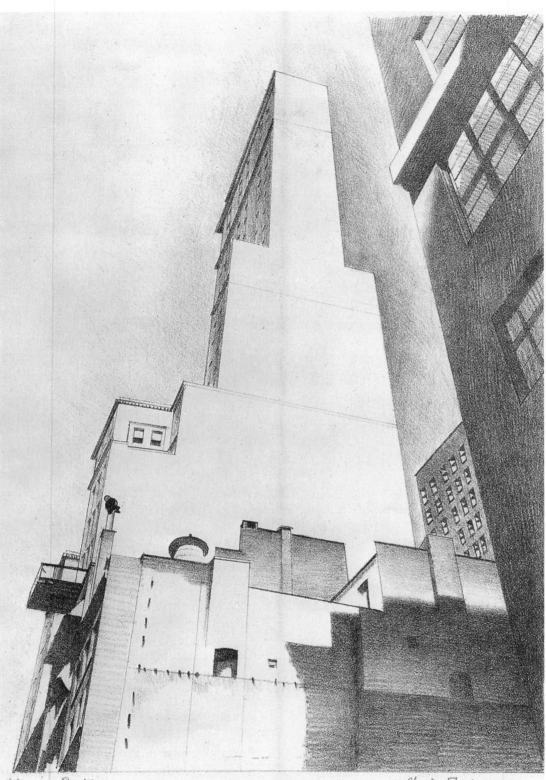

Delmonico Building

Charles Sheeler

If you've ever looked straight up into the sky in a city full of skyscrapers, you'll know how dizzy it can make you feel, and how far away the sky seems. Here, the artist gives the building stature by allowing it to take up all but a fraction of the vertical paper. Its whiteness makes it look pure and dazzling. Charles Sheeler, *Delmonico Building*. Lithograph, printed in black, 9 3/4" x 6 11/16" (24.8 x 17 cm). Collection, The Musuem of Modern Art, New York. Gift of Abby Aldrich Rockefeller.

Principles of Art

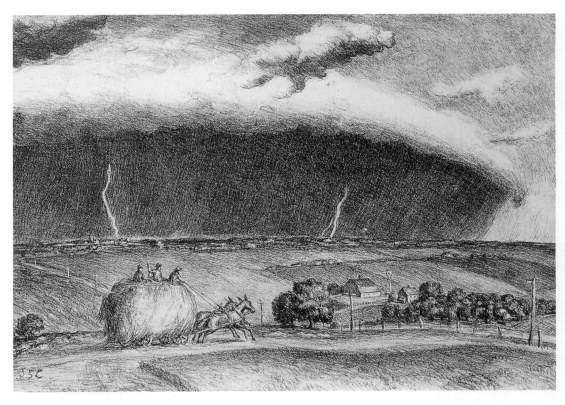

You can show emphasis in drawings in a number of ways. Here, dark clouds and lightning bolts combine to focus attention on the brightly-lit hay wagon. John Steuart Curry, *The Line Storm*, 1933. Lithograph. The Philadelphia Museum of Art. Purchased: The Harrison Fund.

The principles of art help determine the organization of compositions and provide solutions to compositional problems. By studying the principles of emphasis, balance, harmony, variety, movement, rhythm and proportion, you will develop a sense of unity in your drawings. The processes work together to enhance the qualities of all compositions.

Emphasis in a composition refers to developing points of visual interest to direct the viewer's eyes to the most important parts of the composition. Emphasis is achieved mainly through some type of contrast. Contrast can be achieved through dominance in shape and value or variation of edges. How else might dominance be achieved?

Balance is a sense of stability in a composition. Balance can be created by repeating similar shapes throughout a work, or by creating a feeling of equal weight among the shapes.

Informal balance or asymmetrical balance is based on the weight of the objects in the drawing. The weight can be shown or emphasized by varying the shapes, sizes, values and colors of the objects. Formal balance or symmetrical balance is a repetition of similar shapes that mirror each other.

Harmony is achieved in a composition by combining similar elements of drawing. Harmony gives an uncomplicated look to the overall composition.

Would you say this work shows balance? Consider balance among light and dark areas, balance of the visual "weight" of objects in the composition, and balance from top to bottom. Student work by Camilla Fancher, Columbus, Ohio.

Variety refers to differences and can provide complexity to the composition. Variety is achieved by using different or contrasting values, shapes and textures in a composition to create interest and uniqueness. Variety can act as a counterbalance to harmony in a drawing. Variety helps an artwork from being boring.

Movement adds energy and excitement to a composition. It is a way of recording and showing action in a drawing. Movement also directs the viewer's eye through the work. Drawings that successfully use movement have a feeling of strong direction.

Rhythm is a type of movement in a drawing. It can be conveyed by repetition of shapes or colors. Alternating areas of darks and lights can also produce a sense of rhythm.

Proportion refers to relationships in size between objects or between the parts of a single object. Proportion also reflects the size relationships of the parts to the whole drawing. Proportion gives the artist a way to stress or emphasize areas by enlarging, distorting or exaggerating them to create strong visual effects.

Unity is achieved when all the parts of the composition relate to each other. Unity gives the drawing a feeling of oneness. It gives a sense of strength that keeps the work from being confusing.

Is there much movement in this drawing? How about harmony? How many of the principles of design can you use to describe it? Notice how the artist's use of line gives the image a simple, clean look. Student work by Ron Bastyr, Slippery Rock, Pennsylvania.

Learning to combine and use the elements and principles of design takes time. Analyze your own drawings to see how well you have incorporated these elements. Try the following methods to help you evaluate your work.

1. Divide your composition into four equal quarters, and analyze how well the positive and negative space is varied.

2. Look at how well the edges in your composition are varied.

3. Examine carefully how well your range of value carries from a distance. Is the overall design visually exciting from a variety of distances?

4. Make sure you have a focal point and enough variety in your composition to hold the viewer's attention.

5. Try to have a variety of textures or surface qualities in your drawings.

6. If color is used, make sure the color scheme is effectively used and blended into the composition.

7. Reexamine any areas in the composition that appear to be confusing or misdirected. Consider ways to bring unity to the composition.

THINK ABOUT IT

To develop a sense for unity in your drawing, think about what you did and how you did it. How can you apply what you learned to your next drawing?

Far from being boring or static, this work gives you so much to look at that you might not know where to start. What sort of mood do you think the artist was in when he created it? Student work by David Berger, Cincinnati, Ohio.

Could this drawing have been made from one very nervous, continuous line? Try something similar yourself. Does your drawing show as much movement as this one does? Student work by Donna Bailey, Adel, Iowa.

Summary

The elements of design and the principles of art provide the fundamental foundation for good drawing compositions. This chapter has helped you examine the properties of design that serve as a foundation for successful compositions.

Too many beginning students become fascinated with capturing the likeness of an object rather than thinking of the overall composition. Understanding how to incorporate the elements of design and principles of art in drawing is essential for your growth as an artist. Once you become comfortable with these elements, you will begin to apply them almost intuitively in your drawing. Consistently improving the design qualities in your drawings will help you produce powerful compositions.

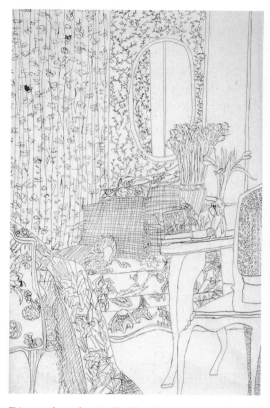

Diagonal strokes (called hatching) and strokes that cross each other (crosshatching) are the only ways this artist created shadow areas. Is there much variation in line width here? Student work by Carmen DePina, Brockton, Massachusetts.

The lines in this work are lighter and more open in the foreground, darker and denser in the background. Is the same true in an actual forest? Has the artist given you enough visual information to tell what this urban forest is made of? Linda Murray, *The Urban Forest Marches On.* Carbon pencil, 22 1/2" x 30" (57 x 76 cm). Courtesy of the artist.

Activities

Pattern Drawing

Draw outlines of shapes to create a composition. Then create at least five different patterns, and fill in the outlines with these patterns.

Texture Rubbings

Use a pencil on white paper to draw outlines of several different objects. Leaving the objects white, fill in the background, or negative space around the objects, with texture rubbings. Experiment with wax crayons or ebony pencils. Create as many different black textures as you can.

Leaf Composition

Arrange fall leaves on a piece of paper, considering design: emphasis, balance, repetition, line and rhythm. Lightly draw the leaves. Add color with pencils or watercolors.

Student work by Nicole Nicas.

Positive and Negative Space

Stack chairs or stools on top of one another to create an interesting arrangement. Use markers to color in the negative spaces between and around the chairs. Do not draw outlines of the chairs. Instead, concentrate on accurately developing the negative spaces.

Analyzing Movement

Look at some traditional drawings and paintings by artists such as Degas, Homer, Constable and David. On photocopies of these works circle the center of interest in red, trace the movement of the eye through the picture in blue, and mark any recurring rhythms in green.

Art Criticism

Select a famous artwork that genuinely appeals to you. What one thing do you notice when you look at this artwork? Does it convey a particular mood? What qualities in the work contribute to that mood? Label four columns in your journal *description, analysis, interpretation* and *judgment*. Spend no more than fifteen minutes filling in the columns with a description of what you see, the elements and principles used in the work, what you think the work means, and your feelings and personal response to the work.

Value

Create a line design on a piece of paper by drawing lines that begin on one side of the paper and go off the other side of the paper. Use curved or angled lines to create an interesting design with a center of interest. Allow lines to cross each other, dividing the paper into small sections. Choose one section to shade. Include values from black to totally white.

Continue shading adjacent sections. However, in these adjacent areas, make the black of the first section adjacent to the white of the next section. Continue shading in this manner so that black will always be adjacent to white, and middle values will be next to each other.

Drawing with Music

Wassily Kandinsky said, "Art is music. Music is art." Listen to a piece of music. Create a composition that reflects feelings and thoughts you experienced as you listened to it. You might create an abstract composition based on the expressive qualities of lines, shapes and colors. Or you could create a realistic drawing of something in your life that the music reminded you of.

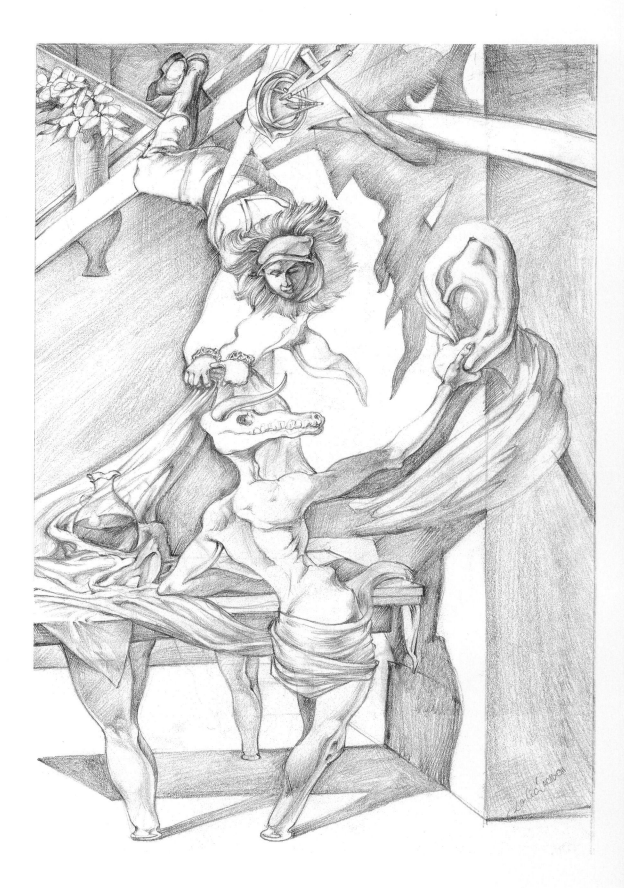

Part 2
The Process
of Drawing

Student work by Boris Zakic, Yugoslavia.

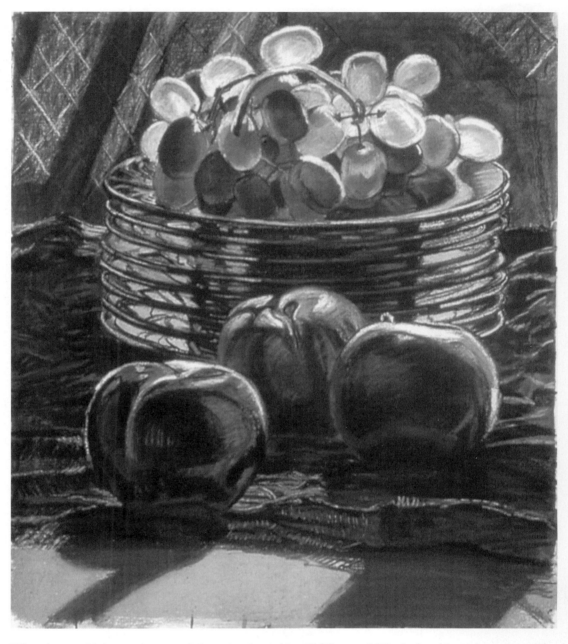

What do you think most interested the artist about this still life setup? Was it the objects themselves? The way the light made them look? Janet Fish, *Green Grapes*, 1979. Pastel on paper, 28 1/2" x 25 1/4" (72.4 x 64.1 cm). Photograph courtesy of the artist.

3 Drawing from Objects

Throughout time, artists have used still lifes as a way to learn to see and to draw from objects. The term *still life* refers to an arrangement of stationary objects used by the artist for a composition. Still lifes allow the artist to study and draw the arrangements for varied lengths of time with controlled lighting.

In this chapter, you will learn how to arrange objects and plan an interesting composition. You will learn to simplify visual information and interpret it. The goal of this chapter is to teach you to approach still lifes with direction and confidence.

To draw still lifes, you need to learn the basics of value, modeling and overlapping. You will learn to use line, stroke and tone to create edges, structure and shadows. This chapter concludes by giving you some possibilities for exploring light in your varied environment.

Vocabulary
line, stroke and tone
value
figure–ground relationship
positive space
negative space
modeling
overlapping
transparency
hatching

Key Chapter Points

- A still life is an arrangement of inanimate objects to draw.
- Value is the relative lightness or darkness of a color or shade.
- Figure-ground refers to the relationship between images and background.
- Positive space refers to objects or enclosed areas. Negative space refers to space around the objects.

Drawing Still Lifes

Drawing is a way of teaching yourself to see. You are transferring visual information—what you see—into meaningful marks. This process is not easy, and you cannot learn it in a few quick steps. There is no one unique drawing method. The key to successful drawing is allowing yourself to make mistakes and learn from them.

Drawing a still life helps you really look at the form of an object. Consider the possibilities in the arrangement of the objects. How can you use spaces in between objects? What relationships can you establish between objects and the surrounding space? Still lifes give you freedom in moving and placing objects, in interpreting the shapes and forms in your composition. Use the following suggestions to organize a still life. While you

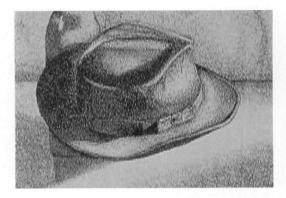

How well do you know your hat? Can you draw its softness, its worn places? Can you make it look mysterious, comical, devilish? Student work by Jennifer Little, Mechanicsburg, Pennsylvania.

may not be able to control all the conditions in your classroom, these tips will be especially helpful if you set up compositions at home.

1. Set up a good working space. Allow yourself enough work space for your tools and materials. Make sure you have room to step back and look at your drawing.

2. Make sure you have a clear and interesting view of the still life.

3. Use strong lighting to emphasize the objects. Create strong shadows through spotlights and the arrangement of the objects.

Sometimes even random shapes in a heap can be turned into interesting compositions.

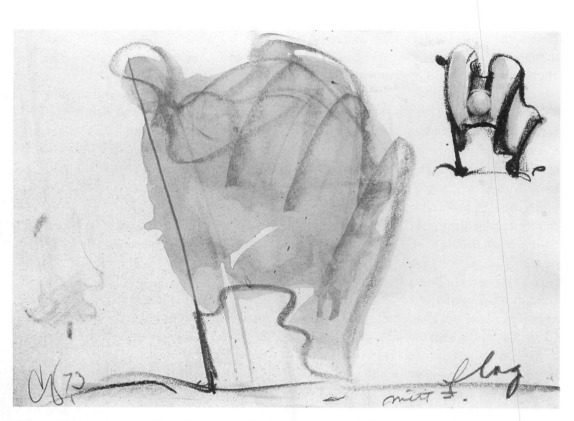

What might have inspired this artist to make the visual connection between mitt and flag? Was it an accident that led to a drawing? Was the artist thinking on paper? Claes Oldenburg, *Mitt Compared to Flag*, 1973. Crayon and watercolor on paper, 9 1/2" x 13 7/8" (24.1 x 35.2 cm). Courtesy The Pace Gallery. Photograph courtesy Leo Castelli.

THINK ABOUT IT
In the planning stage, you are identifying, interpreting and making abstract connections.

Be open to making changes in a composition as you draw. During the drawing process, new ideas may come to you; you may even *have* to change your plans. For example, one student had almost finished carving a stone when it broke into three pieces. The student felt she could not make the piece work and that it was completely lost. However, the instructor encouraged the student to reexamine the possibilities of the composition. Because the broken pieces had come from one large stone, the new existing forms had strong relationships. After careful observation of the work, the student was able to do a better, stronger composition using multiple pieces.

THINK ABOUT IT
Being open to change is part of a process which author Edward de Bono calls lateral thinking. Lateral thinking *is a process of thinking around a problem and generating new ideas.*

Learning to adapt, change and rework areas is a fundamental part of the learning and drawing process. The following concepts and problems are designed to help you become more knowledgeable in examining and discovering still lifes.

Line, Stroke and Tone

Line, stroke and tone are tools of a marking system that enable the artist to approach any drawing with a wider range of techniques.

The **line** helps establish the edges found in the composition. Make this mark by using the corner edge of a charcoal, graphite or conté stick. You can also control the line's *weight* (thickness), *speed* (does the line make sharp, jagged movements or lazy, slow ones?) and *sharpness* (is it a crisp, lean line or a fuzzy, blurry one?).

The **stroke** is a heavy line that gives weight, structure and strength to the drawing. Make this mark by using the blunt end of the charcoal or conté stick. The stroke effectively accomplishes the same results as a line, but with more emphasis.

Tone allows you to establish negative space (the space around objects) and shadows quickly. By laying the charcoal or conté stick on its side and pulling it across the paper, you can develop large areas of tone. Tone can help you create the shadows that make an object look three-dimensional. Using shading to make objects look three-dimensional is called *modeling*.

Each of these marks can be varied in pressure, weight, speed and rhythm to capture the essence of the subject matter. Paper bags are a good subject to use in developing line, tone and stroke. The bags provide sharp creases, varied edges and deep shadows for making the necessary variety of marks.

Now that you have some understanding of line, stroke and tone, a review of negative space and figure-ground relationships may be helpful. If you're having trouble remembering the difference between negative and positive space, try imagining a furnished room without a ceiling. Imagine pouring three tons of JELL-O™ into the room. Where the JELL-O™ gels is the *negative space*; the furniture or other objects in the room can be considered the *positive space*.

THINK ABOUT IT
Working with positive and negative space is similar to fitting together the pieces of a puzzle. Every piece is important; all the pieces work together.

Experimenting with line, stroke and tone will help you become familiar with the effects you can create.

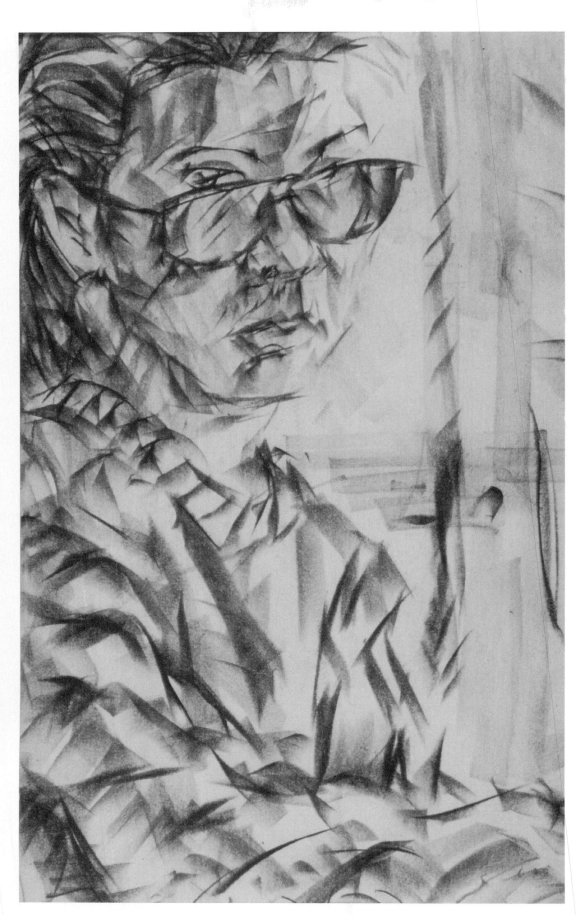

This artist used the side of her drawing tool to create a portrait almost entirely of tone. What mood does the work project? Student work by Shawn Alexander, Elmont, New York.

Charcoal, Conté and Graphite

Charcoal is a dry drawing material that has been used since prehistoric times. It comes in a variety of forms: vine, compressed charcoal, charcoal pencil and powdered charcoal.

Vine charcoal is thin, soft and delicate. It is available in six-inch lengths, different thicknesses and different degrees of softness (or blackness). It can be easily smudged, smoothed or erased. Drawings must be sprayed with a workable fixative to avoid unwanted smudging and keep the image intact. Vine charcoal works best on rough textured paper.

Compressed charcoal is made from ground-up powdered charcoal that has been compressed into sticks with a binding medium. The sticks are available in square or round shapes. Compressed charcoal, like pencils, is numbered to designate the degree of softness (or blackness) and is graded from oo (very soft) through 5 (hard).

Charcoal pencils are thin sticks of compressed carbon encased in wood. Pencils have four standard degrees of hardness: 6B (extra soft), 4B (soft), 2B (medium) and HB (hard). Charcoal pencils are clean and very convenient to use. They are more suitable for smaller, detailed types of artwork.

Powdered charcoal may be sprinkled onto the desired surface and then erased or rubbed to shade areas and create special effects.

Conté crayons are available in five colors as well as black, gray and white. They are manufactured in three degrees of hardness: HB, B and 2B. Conté crayons create a smooth hard texture that is not powdery. The point, edge and side can be used to create interesting effects and build up tones gradually.

Graphite sticks are three-inch square sticks made of graphite and clay. The degrees of hardness range from 2B, 4B and 6B.

Fixative is a matte or glossy aerosol spray that is used to protect charcoal, pencil and pastel drawings from smudging. *Workable fixative* means that the drawing may be worked on even after it has been fixed. **WARNING: Do not use fixative spray except in a well-ventilated area or outside. It can be harmful to your health.**

Newsprint is an inexpensive paper made of wood pulp. Newsprint is available in rough or smooth textures and in pads up to 24" x 36".

Chamois is a small, soft leather cloth used to blend and smooth pastels or charcoal.

Charcoal paper is highly textured paper designed to hold dry pigment.

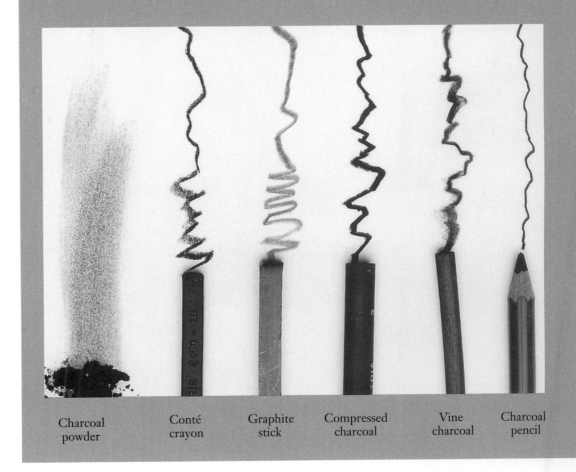

| Charcoal powder | Conté crayon | Graphite stick | Compressed charcoal | Vine charcoal | Charcoal pencil |

Techniques

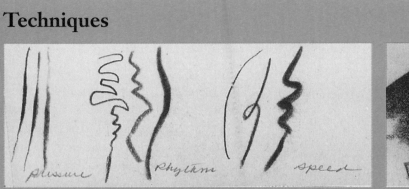

These lines illustrate changes in pressure, rhythm and speed.

Use a stump or tortillon to draw with or smooth and soften areas.

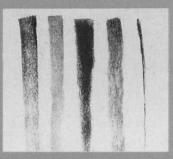

Line, stroke, tone

Use your finger, a paper towel or a chamois to smudge and blur areas.

Use tissue, cotton or a kneaded eraser to soften, clean and create highlights.

Supplies

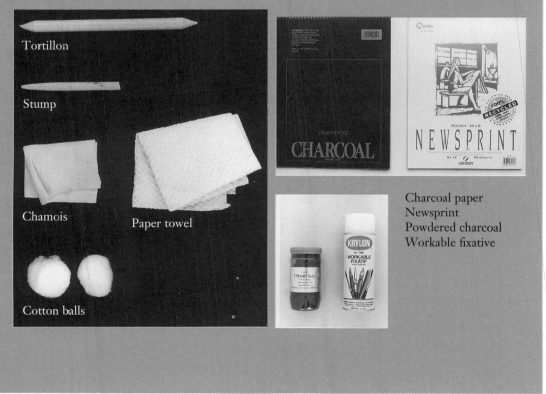

Tortillon

Stump

Chamois

Paper towel

Cotton balls

Charcoal paper
Newsprint
Powdered charcoal
Workable fixative

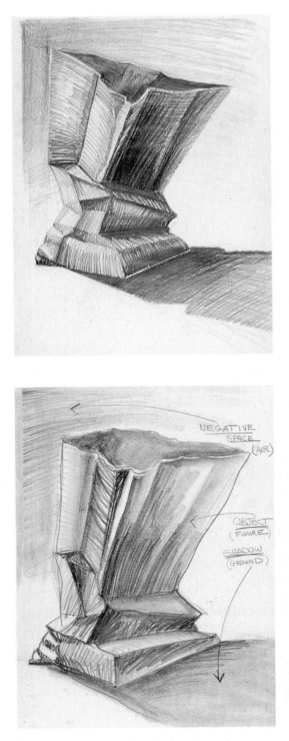

The *figure* in the figure-ground relationship is generally an object or a dominant shape. The *ground* is what the object stands on, or, if there is no obvious surface, it is the "air" or space around the object, the horizon line, or the shadow cast by the object.

The following suggestions can help you translate visual information into a workable drawing.

1. Reduce the forms to simple terms. Express as much as you can in the drawing with a minimal amount of work.

2. Lay out the subject matter with confident marks.

3. Pay attention to negative space. Use areas of tone to reinforce the feeling of space you want to create around the objects in your drawing.

4. Establish forms by exploring edges both inside and outside the subject matter.

5. Carefully establish relationships between the object and the ground using shadows. Use marks consistently to define object and ground.

THINK ABOUT IT
Completing the above steps can help you establish order in your drawing. Develop your ability to arrange objects in relation to each other; think of each part in your drawing as a part of the whole.

Drawings of a bag and its shadow show the figure-ground relationship and positive/negative space relationships clearly. Student work by Gina Miller, Abilene, Texas.

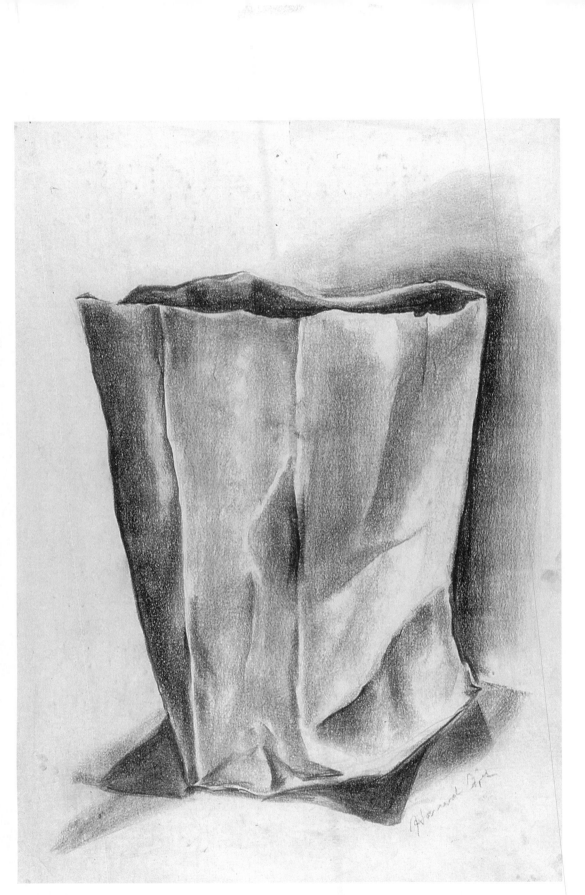

Careful use of shadows helps establish the ground beneath the bag, its creases and dark interior. Notice how edges are created with shadows and highlights rather than with line. Student work by Hannah Cofer, Knoxville, Tennessee.

Pencil Modeling Techniques

gesture sketch

straight lines

contour lines

crosshatching

stipples or dots

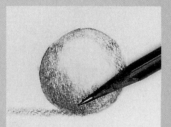

side of the pencil

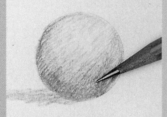

back and forth marks, which gradually build up darker

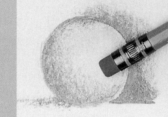

side of the pencil; blended, eraser highlight

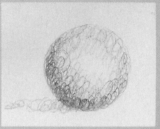

round scribbles

Ink Modeling Techniques

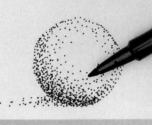

stipples or dots

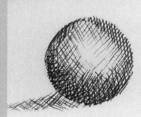

crosshatching

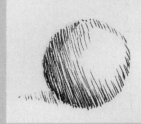

straight lines

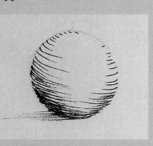

contour lines

scribbles

combined crosshatching, scribbles and stipples

Rhythm, Speed and Pressure

Changing the rhythm, speed and pressure of your mark-making is essential in creating interest in your drawing. Suppose you could translate your marks into music. If you made each mark with the same rhythm, speed and pressure, the marks would sound monotonous, like a single note of music. Just as songs have varied notes, a good composition requires varied lines, strokes and tones to create space, variation and compositional intrigue.

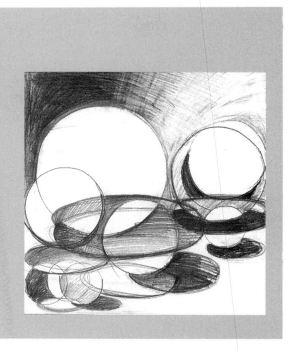

Drawing with Both Hands

Drawing lines, strokes and tones with both hands is one way to increase your sensitivity and develop a greater range of marks. By using both hands, you prevent your marks from going all the same direction.

The immediate response by most students to this suggestion is "I can't." In fact, you can draw with both hands if you practice and are persistent. This drawing method will help you develop speed. You will also benefit by becoming aware of the many possibilities there are for making marks.

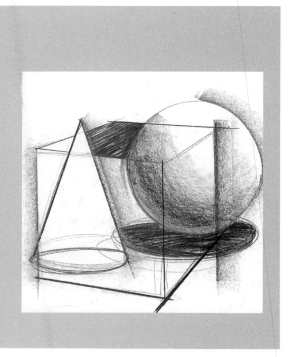

Defining Forms

Perhaps you have had difficulty in correctly drawing the proportions of an object. To find the correct proportions, draw the object as though you could see through it. This is called *drawing through* the object; it means making an object look transparent. Suppose you want to locate the true proportions and shape of a box. By drawing through the box, as though you could see both the inside and outside, you can see the correct planes of the box.

Try this exercise. Sketch light lines of the box as shown. Lightly sketch the lines

behind the face of the box that cannot be seen. Look carefully at the lines for the correct proportions. Can you find relationships between the planes of the box? When you draw multiple boxes, notice the space relationships that the boxes have with each other.

Your experiments in drawing a paper bag introduced you to the uses of line, stroke and tone to create a variety of edges. Apply these concepts to drawing boxes. Study how you can show the boxes' position in space by changing the thickness and speed of the lines. Make edges that are close to the foreground sharper and heavier. Make edges that are farther away lighter, softer and less distinct. To set up shadows on the ground and on the box itself, use tone. Tone also defines areas of negative space.

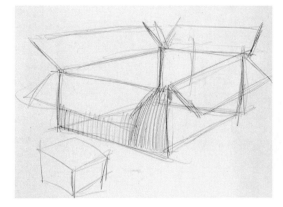

Sketching a box as if you can see through it helps you get a feel for its forms. Student work by Oona Elliot, St. Ann's Bay, Jamaica.

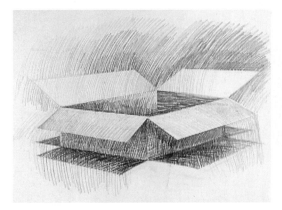

Using line, stroke and hatching, the artist defines the box's forms more precisely. Student work by Oona Eliot, St. Ann's Bay, Jamaica.

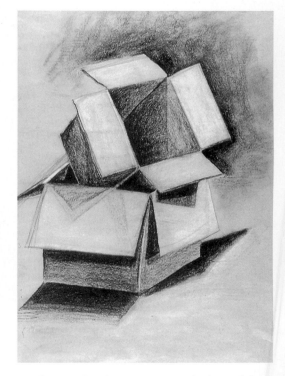

Working on box-brown paper, with charcoal for shadows and white chalk for highlights, this artist has given her composition a three-dimensional look and plenty of visual interest. Student work by Hannah Cofer, Knoxville, Tennessee.

Transparency and Overlapping

Transparency and overlapping are two tools that can help you improve your skills in drawing objects and establishing a composition.

Use *transparency* to find the structure of an object. Imagine that you can see through the object, that you can see all its internal edges. Draw those invisible parts; really try to "feel" the object's structure. When drawing more than one object, use transparency to draw through all the objects and get a sense of how they relate to one another.

Overlapping is an important principle in design that helps achieve unity in your compositions. The placing of one object partially in front of another is an excellent visual device to give the illusion of depth. Making the edges of the forms in front sharper than the edges of forms in back will strengthen the illusion of depth.

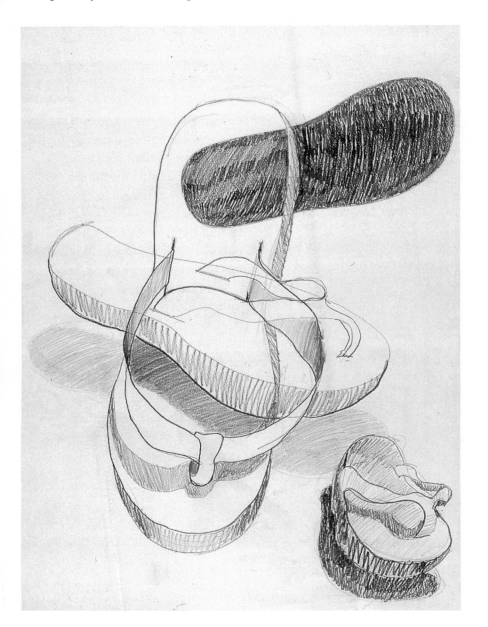

When drawing more than one object in a composition, it can be helpful to sketch the objects as if they were transparent. You'll see relationships between objects more clearly, and be able to sense how well the shapes fit together. Student work by Bill Meyer, Springfield, Illinois.

Exploring the Line

Do you have a favorite pair of shoes— perhaps a pair that is almost worn out? Could you capture the personality of the shoes just by drawing an outline? Certainly a coloring-book type outline would not suggest much personality. To draw the character and age of your shoes, as well as express your feelings toward them, you would need to use variety in your line. You'd need to use descriptive lines.

Try drawing a shoe to explore the wide range of edges and spaces you can draw with lines. How old is the shoe? Is it

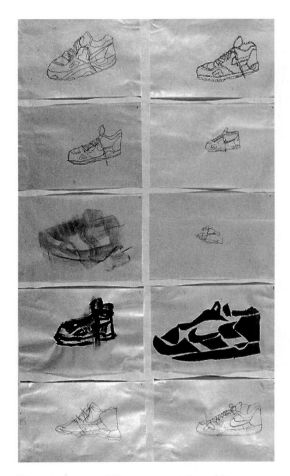

Try using many different materials and line weights to draw your shoe. How does its character change when you draw it with a different tool? Student work by Jennifer Griener and Mary Ann Gemme, Worcester, Massachusetts.

creased or worn? Illustrate its unique personality by changing the rhythm, speed and pressure of the line. Capture the weight of the shoe to define its structure. Use a marking system that describes both the object and its personality.

Then, draw a pair of shoes in a composition. Arrange the shoes in a variety of ways. Draw them from different angles. Vary their sizes. Add depth and interest by overlapping the shoes.

Bones are also good subject matter. Bones provide a variety of edges, cracks and crevices not found on shoes. Cow skulls are especially interesting because of their large size and unique surface cracks. The numerous caverns and holes make cow skulls unlike many other bones.

Carefully study the features of different animal bones. Try to see the many different lines visible in the bones, and practice suggesting those lines yourself. Edges found in bones vary a great deal. Try drawing bones with a continuous line. Then, try using short lines, close together and parallel (called *hatching*) to create the edges of the bones, and the value and texture within the bones.

Continue to build upon the line work you have already explored by drawing the bones from different angles. This time, overlap the images. To develop a more interesting composition, make sure each image is a different size and angle. Also try varying the amount of space that is overlapped.

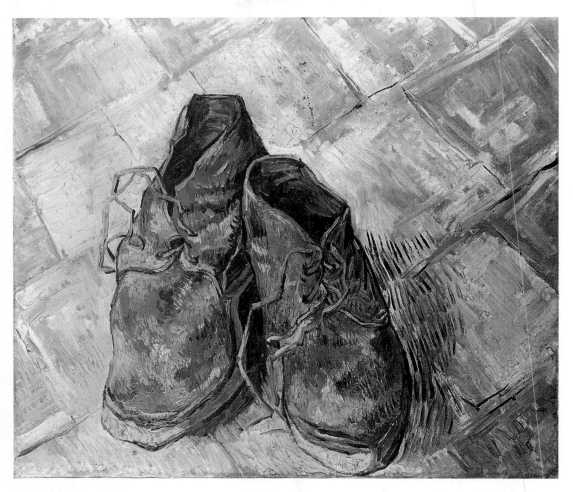

What kind of person do you think might have been wearing these, and for how long? Vincent van Gogh, *Shoes*. Oil on canvas, 17 3/8" x 20 7/8" (44.1 x 53 cm). The Metropolitan Museum of Art, Purchase, The Annenberg Foundation Gift, 1992.

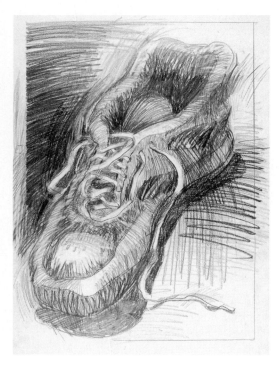

What kind of "personality" does your shoe have? Would you use active lines like these to express that personality? Student work by Karl Selden, Dothan, Alabama.

Line

Line is a mark made by using a tool, such as a pen or pencil, and pushing, pulling and dragging it across the surface. Lines can be made with many different tools and methods.

Materials

(a)
(b)
(c)
(d)
(e)
(f)
(g)
(h)
(i)
(j)
(k)
(l)
(m)

Methods

(n)
(o)
(p)
(q)
(r)
(s)

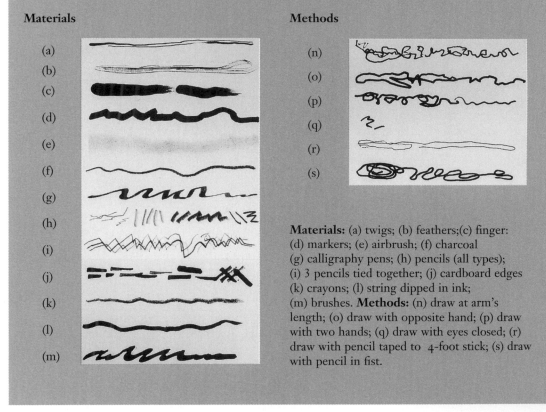

Materials: (a) twigs; (b) feathers;(c) finger: (d) markers; (e) airbrush; (f) charcoal (g) calligraphy pens; (h) pencils (all types); (i) 3 pencils tied together; (j) cardboard edges (k) crayons; (l) string dipped in ink; (m) brushes. **Methods:** (n) draw at arm's length; (o) draw with opposite hand; (p) draw with two hands; (q) draw with eyes closed; (r) draw with pencil taped to 4-foot stick; (s) draw with pencil in fist.

When drawing a more complex bone, like a fish bone, remember to vary the direction, rhythm, speed and pressure of the line. One beginning art student intuitively grasped this concept by applying something he learned playing football! He found that when he varied his running speed on the football field, his movements became less predictable and more productive. In the same way, when he varied the speed of his lines in drawing, his lines became more interesting.

THINK ABOUT IT
Making connections between different areas and subjects can bring unexpected results!

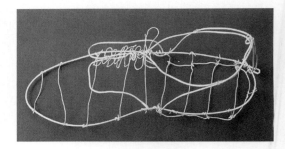

Another way to explore lines is to "draw" with wire. Student work by Patrick Terrien, Worcester, Massachusetts.

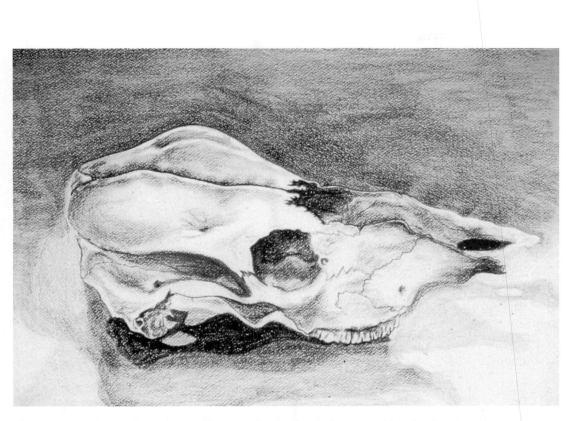

The crevices and irregular surfaces of bones make them a challenging subject for drawing. Try capturing the overall shape of a skull or bone with one continuous line. Then, as this artist did, use line, stroke and tone to create a more detailed composition. Student work by Marquita Stearman, Commerce, Texas.

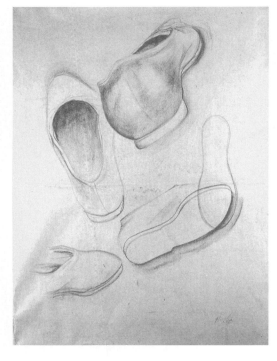

Student work by Hannah Cofer, Knoxville, Tennessee.

Speaking of Art...

" I was the sort of child that ate around the hole in the doughnut, saving the hole for last and best. So, not having changed much, when I painted the bones, I was most interested in the holes."
—*Georgia O'Keeffe*, 1915

Organizing Space

There is an important relationship between space and design. Learning how to plan the entire composition before you begin drawing is an essential step in the drawing process.

Here is one easy method to set up a composition of a still life. Place a sheet of paper flat on the table. Draw two pencil lines that divide the paper into four equal parts. Next, take a second sheet of paper and tear it into many pieces of various sizes and edges. Place the torn paper on the four squares. Be sure the positive and negative space in each square differs from that in the other squares. Shine a spotlight on the still life. Look at it from any angle. Is the composition dynamic and challenging?

THINK ABOUT IT
This activity involves the thinking skills of identifying, analyzing and interpreting. Think of how you can apply what you learned in this exercise to your own compositions.

To plan a torn paper sculpture, first divide a piece of paper into four equal sections by drawing one horizontal and one vertical line. Then draw simple lines to show the positive and negative space within each section. Make sure the use of space is different in every section.

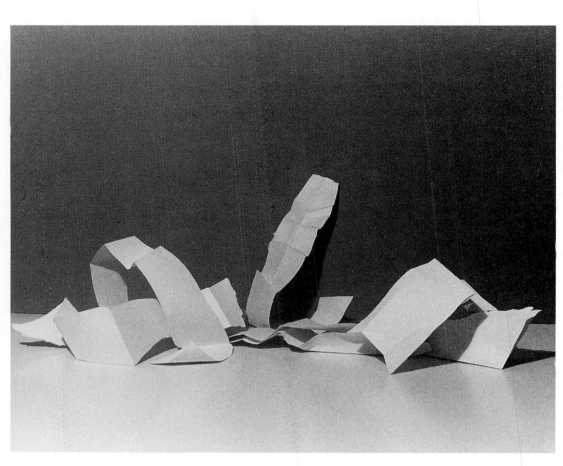

Using your simple line drawing as a guide, construct a torn paper sculpture. Is positive and negative space still different in every section? Are interesting highlights and shadows created when you shine a bright light on your sculpture?

Unification of Space

Washes unify a drawing, develop contrast, produce patterns and create form. Try pen-and-ink washes on Bristol, railroad or illustration board. Experiment with heavy drawing paper, charcoal, bond, mimeograph or craft papers.

Try watermedia washes on watercolor, charcoal or heavy drawing papers. Experiment with tagboard, oatmeal and bond papers.

Hint: To wipe out or blot wash areas, use a paper towel.

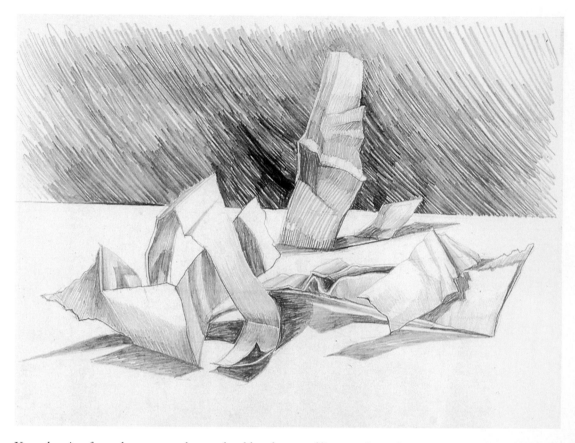

Your drawing from the paper sculpture should make use of line, stroke and tone to create edges, establish forms and suggest three-dimensionality. Have you used a wide range of values? Student work by Ramona Sartoro, Gulfport, Mississippi.

Paper Sculpture Still Life

What makes a sculpture successful? Does a sculpture share the same design concepts of a drawing? To find answers to these questions, construct a paper sculpture and use the work as the basis for a still-life drawing. This experience is an excellent way to learn about space and form. It will also help you understand the similarities and differences between two- and three-dimensional work.

A Paper Wall Relief

Create a paper wall relief from paper strips woven together. Use the various elements of design to create interest. Layering the paper at different heights will cast unusual shadows and increase the relief's complexities and sculptural qualities. Use a strong light source to cast shadows. Notice how important shadows are in a sculpture. How do they create interest? Explore overlapping. Practice "pushing and pulling space"—making objects farther away recede; making objects closer to the viewer come forward. To do this, make background objects look grayer and softer than foreground objects. Give foreground objects sharp edges, and stronger darks and lights.

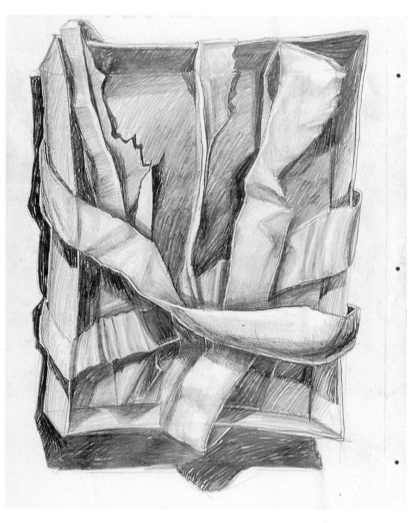

Can you tell which areas are closest to you and which are farthest away in this wall relief? How has the artist suggested distance? Student work by Ramona Sartoro, Gulfport, Mississippi.

Interrelating Darks and Lights

Understanding how to interrelate darks and lights in a composition is an important drawing concept. Many beginning drawing students isolate their subject matter by confining their darks to just the form or background. This isolation causes the subject matter and its environment to appear unrelated. To avoid this problem and make objects visually interesting, look for lights that are found inside the subject matter and lights found in the ground. Then, develop the composition by filling in the dark areas within the forms and the surrounding space. Be sure to develop shadows and negative areas of space to accent the highlights found in the composition.

Plants are a good subject to use when studying the relationship between darks and lights in a composition. The play of light on leaves, interesting shadows and the plant's many layers give the artist much to work with. Sondra Freckelton, *Ball and Begonia*, 1993. Watercolor, 38 1/2" x 33" (97.8 x 83.8 cm). Courtesy Maxwell Davidson Gallery.

Subject matter and environment are closely related—perhaps a bit too closely for the subject's comfort?—in this comic/horrific ink drawing. How has the artist used dark areas to create an obvious focus? Student work by Pamela Zernia, Kenosha, Wisconsin.

Janet Fish

1938 –

Still life painting has a long tradition in the history of art. The most famous still life compositions come from seventeenth century Holland. Executed in warm, rich colors, the Dutch paintings convey the beauty of ripe fruit, richly ornamented fabrics and gold-trimmed goblets. Still lifes remain a popular subject with Realists like Janet Fish, who paints contemporary household objects. A simple glass bowl of fruit placed on a sunbathed table is a modern version of an old theme.

Although Janet Fish is a Realist, her art is more about perception than representation of objects. She has a special interest in depicting the properties of light as it moves through glass goblets and creates intricate designs on casually arranged fruit and candy. Reflections and shadows significantly enrich the visual texture of her paintings and drawings.

The treatment of light is important in conveying the mood of an artwork. In *Green Grapes* (see page 48), homely objects bathed in patterns of light and shadow provide a sense of joy and serenity. Janet Fish captures in her art something that is easily missed in reality—moments of beauty of common things.

Explore darks and lights and positive and negative space by drawing a still life of a dark plant on a white ground. Use a strong spotlight to create a wide range of values and interesting shadows. Develop areas of darks within the positive and negative space. Notice how the darks define the underlying structure of the composition.

Negative space dominates this charcoal drawing. Its strong value contrasts give the image power and presence. Melissa Gill, *Untitled*. Charcoal on paper. Courtesy of the artist.

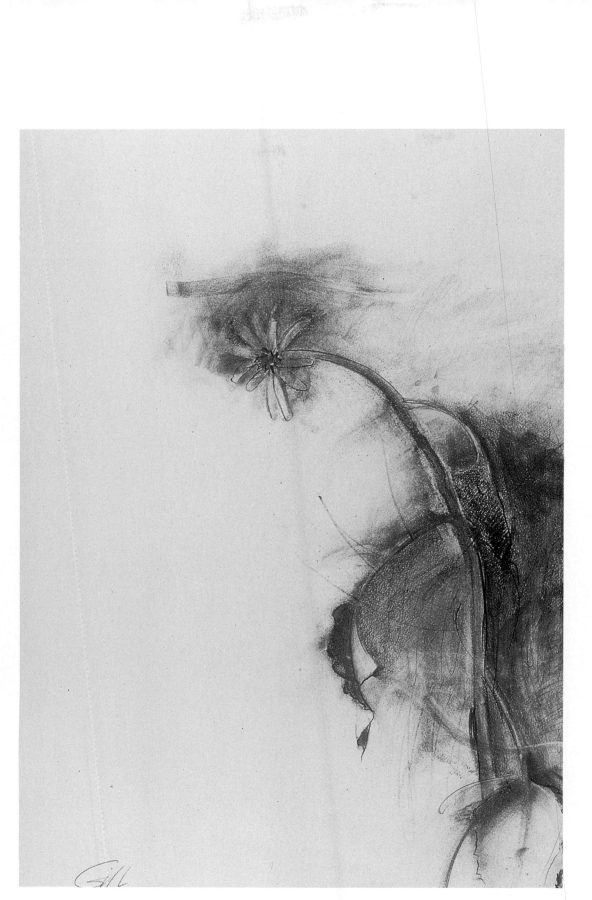

What gives this drawing its feeling of fragility? Melissa Gill, *Untitled*. Charcoal on paper. Courtesy of the artist.

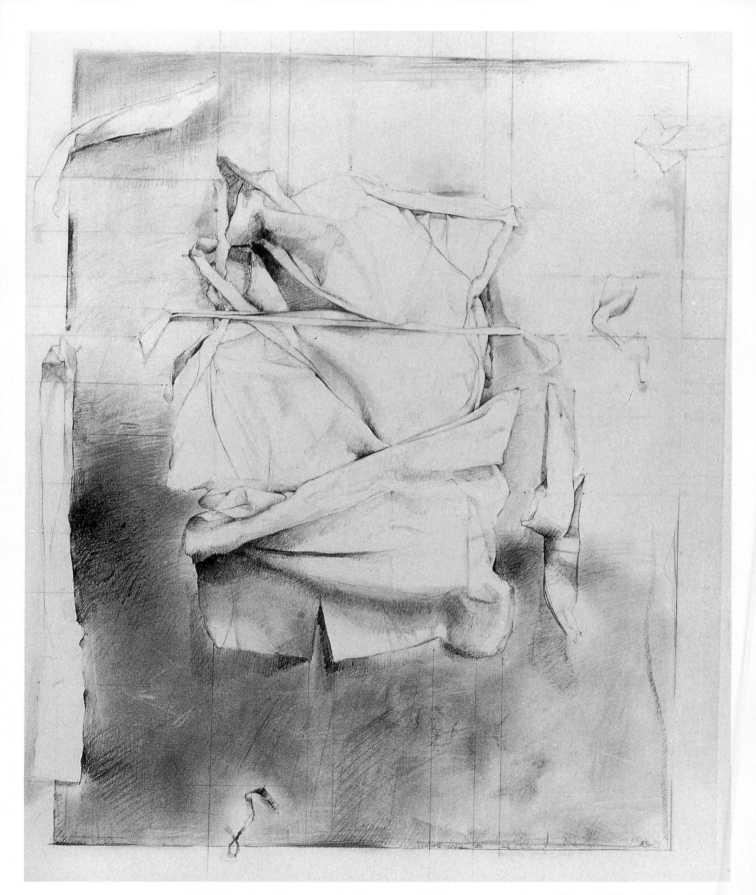

In this drawing, the artist explored a variety of values to suggest the wrinkles and folds in fabric and paper. Stephen Posen, *Untitled*, 1973. Graphite on paper, 40" x 32" (101.6 x 81.3 cm). Collection of Louis and Susan Meisel.

When developing darks and lights, work the entire composition equally rather than trying to finish one part of the drawing at a time. Push and pull the dark and light areas in order to develop a relationship between the forms and the surrounding space. Layer values over the forms to achieve a rich sense of depth.

Carefully study the value changes in a single shadow. Be sure to include these changes in the drawing. Be sensitive to variations in the shadow edges.

Gradually build value throughout a composition to find the correct relationship within the composition. Use a full range of value changes to achieve as much contrast as possible. Dramatic variation in value and intriguing arrangement of composition create strong impressions.

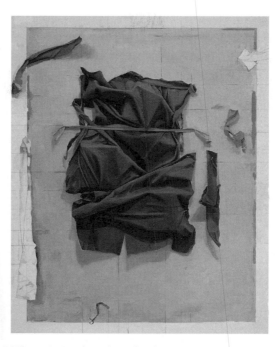

The painting based on the drawing (opposite) uses a narrower range of dark values to suggest folds. Which work do you think is more interesting? Stephen Posen, *Untitled*, 1973. Oil, acrylic, graphite on canvas, 40" x 32" (101.6 x 81.3 cm). Collection of Louis and Susan Meisel.

Value

Value scale using hatching strokes.

Value scale using pressure strokes.

Graphite Pencils

hard: 8H, 7H, 6H, 5H, 3H, 2H, H
soft: HB, F, B, 2B, 3B, 4B, 5B, 6B, 7B, 8B
Weights of graphite pencils are made in several grades ranging from 8H (very hard) to 8B (very soft). The specific grade is printed on each pencil. Various tonal effects can be created by using short dabbing strokes, crosshatching and dots, and by mixing different grades of pencils.

Exploring Possibilities with Light

Throughout this book, you are encouraged to look for ways to create strong and unusual compositions. Dramatic shadows provide one source of fresh and interesting subject matter. Consider the interplay of natural light and shadow in your environment. The sun casts different shadows throughout the day. Compare how a building looks at high noon and in late afternoon. Do you see some unique possibilities with shapes and shadows? Try isolating areas, such as windows, doors and stairs. Do they create interesting designs? Do shadows make them even more interesting?

The most dramatic natural lighting occurs around the hours of sunrise and sunset. The cast shadows at this time are longer and more striking. Notice long shadows cast over areas like stairwells or fire escapes. Subjects like these are not only powerful in darks and lights but also are elegant in their sense of pattern.

Use a viewfinder to help you locate a good composition. To make a viewfinder, cut a small square (2" x 2") out of the center of a piece of paper. Then, look through the square and find interesting design relationships that would otherwise go unnoticed. Hold the viewfinder at unusual angles. By viewing architectural structures from dramatic points of view, you can develop unique and exciting compositions.

THINK ABOUT IT
How do you know when you have found the "right" approach to a composition? Do you solve problems logically or intuitively? Build on what you learn in each drawing to help you plan your next composition.

Look for patterns and interesting shadows all around you. This artist was attracted by the shapes and shadows around a fire escape. Top: Here positive shapes are black, negative shapes white. Middle: Positive shapes are white, negative ones are black, and the whole image has been turned backward. Bottom: A more realistic rendering of the scene is still rich with pattern and shadow. Student work by Chad Brown, Memphis, Tennessee.

Light reveals details that you may not always notice. A strongly lit subject viewed from below can appear quite dramatic. Author, *Column*, 1989. 20" x 40" (51 x 102 cm).

Summary

Drawing from still lifes is a natural way to learn the basics of the drawing process. Still lifes can train your eyes to see the shapes of real objects and explore their three-dimensionality. This chapter gave you opportunities to explore the elements of shape, form and space in a still life. In addition, you learned the importance of positive and negative space in a composition.

Reflect for a moment on your developing skills in using line, stroke and tone. Are you gaining more confidence in translating visual information from a still life?

Still lifes also allow you great freedom in arranging a composition. When you isolate areas, use striking shadows and approach the subject matter from unusual angles, you will produce powerful compositions. This makes your work fresh, challenging and more creative.

From which direction is the light coming in this work? Why might the artist have chosen to show us only this part of her subject? Susan Avishai, *Terra Cotta Silk*. Colored pencil, 15 3/8" x 15 3/8" (39.1 x 39.1 cm). Courtesy of the artist.

Strong vertical lines in the background help unify this still life. Student work by Joo-Hyun Lee, El Paso, Texas.

Activities

Drawing What You See

In working with familiar objects and subject matter, we often attempt to draw what we *know* rather than what we actually *see*. Select a simple line drawing you have done. Turn it upside down and copy it. (Your drawing will also be upside down.) Concentrate on angles, lines and shapes rather than subject matter.

A Partial View of an Insect

Use reference books to find illustrations of common insects such as ants, mosquitoes, flies and spiders. Select one insect to draw. Use a 2-inch viewfinder to isolate one area of the insect's body. Draw that section only on a large scale, as though you were viewing the insect through a microscope. With pencil or charcoal, draw the body by using light and dark value. Do not draw the figure with line.

Inside a Fruit or Vegetable

Bring in different kinds of fruits and vegetables, such as pumpkins, grapefruits, eggplants and red cabbages. Examine the outsides of these organic forms; then cut them in half to examine the insides. Is the inside appearance very different from the outside? Compare the colors, line and textures.

Choose one of the objects and create a pencil sketch. Then fill in the lines and colors with prismacolor pencil. Consider the values of individual colors.

If you have time, repeat the exercise, this time drawing the object from the outside. Did drawing the inside first make you more aware of the outside? Are you becoming more visually aware of the surfaces of objects?

Shading Simple Objects

Draw a series of timed five-minute sketches of fruits and vegetables. Every five minutes, trade fruits with your classmates and create a new charcoal drawing, making each fruit seem very important by drawing it large. Concentrate first on the form and shading and then on the texture. Try shading by using the side of the charcoal. Add the shadow on the table under the fruit.

The same timed technique may be used with a collection of bottles and jars to learn to shade reflections.

Student work by Kelly Budzyma.

Drawing Geometric Forms

Construct a geometric form such as a cube, pyramid or octahedron out of paper. Then tape your form to a base of white paper so that the form will remain stationary. Light the form with a light source coming from the right or the left of the form.

To make the exercise more interesting, look at the form as though it were part of a surreal, dreamlike landscape. Perhaps you see the layout as a desert.

Pay close attention to the dark shadows that the form casts on the white paper base. To draw the shadow effects, use pencil or conté values. Consider how crosshatching or stippling could capture the textural qualities. Try to draw sharp contrasts between the shadows and the white areas.

Drawing Reflective Surfaces

Metal cans and containers have reflective surfaces which can be used to create challenging and interesting compositions. Set up a still life of three or four different-sized tin cans and other metallic containers. Remove any labels so that all the surfaces will reflect light.

Set up a light source from behind you. The surfaces of the cans should reflect areas of very light value as well as dark. Do the containers have ribs or seams that create surface variations? Notice any shadows cast by the objects.

Take some time to study the shape of a cylinder before you begin to draw. Consider how to draw the inner volume of the can. Does the intensity of the light source create contrasting, darker values inside the can?

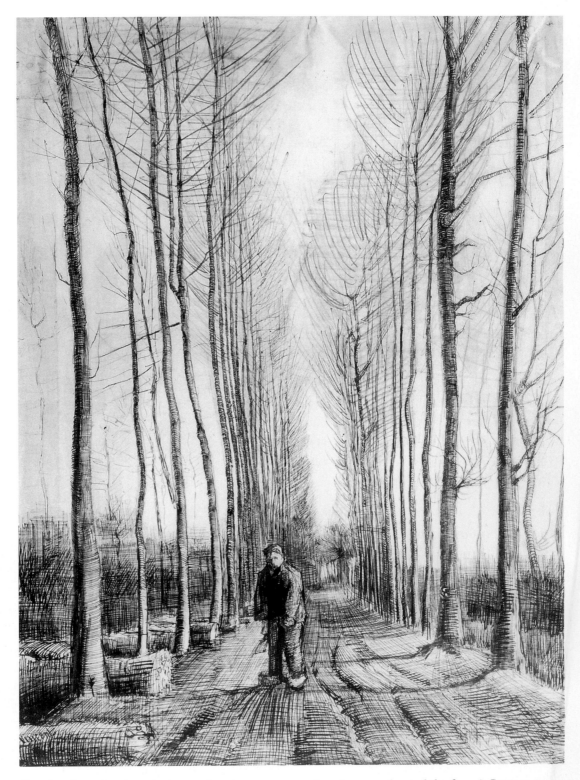

How has the artist given the impression that you can see for a long way beyond the figure? Can you see how he has used line skillfully to broaden some areas, make others look narrow, and create shadows? Vincent van Gogh, *Lane of Poplars*. Courtesy Foto Marburg/Art Resource, NY.

4 Structures and Landscapes

This chapter introduces you to the concept of perspective and how you can apply it to create depth in your drawings. Perspective allows you to overcome problems you may have in drawing objects that are in the distance. Objects that are far away appear smaller than they are in reality. How do the measurements of a box change when you view the box at an angle? Learning to draw using one-, two- and three-point perspective sharpens your observational skills by allowing you to draw what you *actually* see.

Landscape drawing has always fascinated artists. By first drawing objects from nature, you will research a variety of shapes and structures before you deal with nature on a larger scale. This chapter explores different approaches to drawing landscapes. You will learn how to create interest in landscapes by using various design concepts.

The last section investigates drawing the urban environment, or the manufactured objects and structures that surround us. The urban environment offers a tremendous range of subject matter. You will also be introduced to ways to incorporate various atmospheric effects in your compositions.

Vocabulary
perspective
vanishing point
horizon line
exaggeration
foreshortening
distortion
foreground
middle ground
background

Key Chapter Points
- Perspective gives the illusion of depth.
- A landscape drawing shows the natural environment, such as trees, mountains, flowers and lakes.
- An urban landscape shows architecture and objects in the human-made environment.

Perspective

Perspective is the visual technique in drawing that creates the illusion of three-dimensional space on a two-dimensional plane. The use of perspective originated during the Italian Renaissance in the fifteenth century. Leon Battista Alberti and Filippo Brunelleschi developed rules for the foundation of perspective. Artists such as Donatello, Leonardo da Vinci and Piero della Francesca further refined the development. With the introduction of perspective came other ways to create depth in a drawing. The concepts of linear perspective, overlapping forms, objects receding in space and use of a vanishing point became essential parts of drawing.

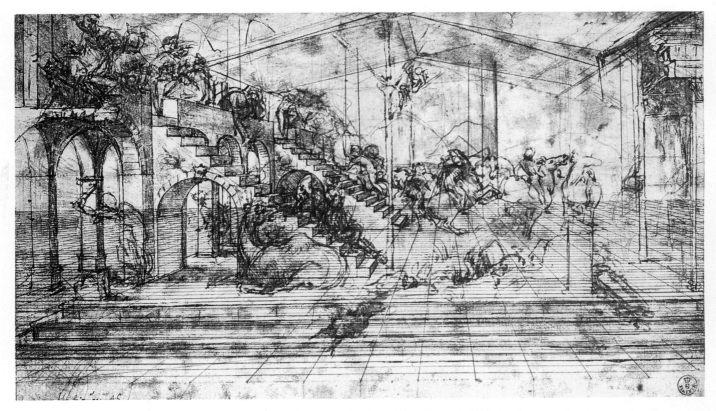

Notice the fine horizontal and vertical lines in this study, especially those in the lower half of the drawing. Can you see that the horizontal lines gradually move closer together as they recede in space? What do the vertical lines do? How has the artist used these lines as guides elsewhere in the drawing? Leonardo da Vinci, *Study of Stairs and Horses*. Alinari/Art Resource, NY.

One-point Perspective

One-point perspective refers to a point converging on a plane. If you look down a railroad track, the parallel sides of the track seem to meet, or converge, at a point in the distance. This point on the horizon line is called the *vanishing point*. In the same way, the painted marker lines on the road appear to become progressively smaller as they recede in the distance. This change in scale gives the viewer a feeling for distance as the lines meet at the vanishing point.

To grasp the concept of one-point perspective, try drawing a box that is in the middle of the road. First, draw a line across the paper to establish the horizon line. Next, put a vanishing point in the middle of the horizon line. Then, draw two lines from the vanishing point to the opposite bottom edges of the paper to create a "road." Finally, construct a box in the middle of the road by using a ruler to line up the edges of the box with the vanishing point. The top, bottom and sides of the box should be drawn parallel to the edges of the paper. This simple exercise conveys the theory of one-point perspective while showing how an object recedes in space.

THINK ABOUT IT

Using perspective requires you to recall your mental picture of what the subject looks like, compare that image with what you actually see, form conclusions based on this information and select the right way to present the subject.

A railroad track in flat, open countryside is an excellent example of one-point perspective. The point on the horizon where the parallel tracks appear to meet is called the vanishing point.

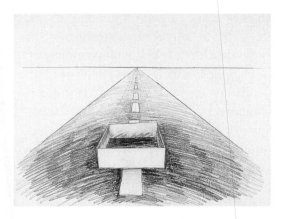

To discover how objects are affected by perspective, use the lines of a road or railroad track to help you establish the sides of a box in the middle of that road or track. If you use a ruler to align the vanishing point with the sides of the box, you'll see how a right-angled shape seems to get narrower as it recedes in space.

Speaking of Art...

The Renaissance painter Paolo Uccello was so excited about drawing perspectives that his wife complained that he would not rest.

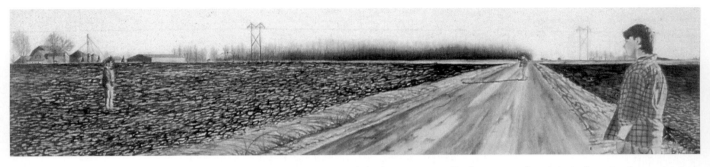

A wide, narrow format makes this landscape appear even flatter, and the horizon even farther away, than it is in fact. Student work by David Hicks, Russiaville, Indiana.

Another good exercise for beginners is drawing a long hallway. How do the lines of the hallway change when you see them at different eye levels? Try standing on a chair or ladder, or lie on the floor to see the differing angles of perspective.

To develop a better understanding of how one-point perspective can enhance your drawing, look at a cardboard box from several viewpoints. Draw the box straight on with the horizon line in the middle of the box. Then, draw the box as you view it above your head. How does

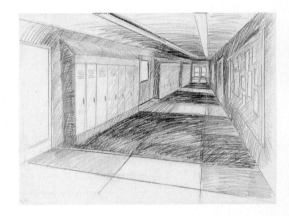

Sketching hallways in your school will give you good practice in one-point perspective.

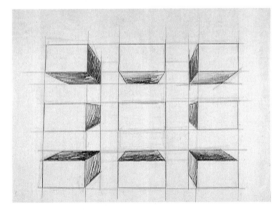

Draw boxes from slightly above and below, from slightly to one side or the other, and from straight on. Are you beginning to get a feel for how perspective can affect objects?

the box look when you look down on it? Try drawing it from the left or right as well to expand your capabilities in using perspective.

Using boxes to develop other objects is another good exercise in perspective. Draw letters, numbers and other simple objects inside boxes. Draw them at different angles and make them different sizes. How do the forms change as they recede in space? The more unusual the angle of the boxes is, the stronger the composition will be.

Here the vanishing point has vanished around the corner. What leads your eye into the picture? Student work by Mark Ferencik, Durham, North Carolina.

The use of perspective is more subtle here. Can you see how the large letter recedes in space? Why do you think the artist chose to show only part of a much larger word? Robert Cottingham, *S*. Courtesy of the artist.

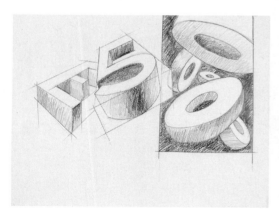

Try making letters and numbers appear three-dimensional. Setting them at unusual angles or on their sides will give you good perspective practice.

Getting dizzy? Don't worry—it's only perspective at work. Ronnie Naizer, *Help Me, I'm Falling*. Ink, 20 1/2" x 15" (52.1 x 38.1 cm).

Two-point Perspective

To draw a box from a three-quarter viewpoint, you need to use two-point perspective. In two-point perspective, there are two vanishing points on the horizon. To draw a box realistically in two-point perspective, simply draw lines from the two vanishing points to establish the sides of the box.

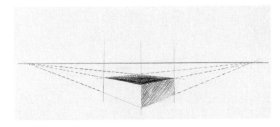

Two-point perspective makes use of two vanishing points rather than one, and allows you to depict more complex objects and scenes.

Try to draw a city block in two-point perspective. This exercise will challenge your creativity and technical ability. Architecture poses interesting problems for the artist. How will you approach the subject matter? Can you draw the street where you live? Can you draw your street, your city block, your neighborhood as it may have looked in 1900? Do some research; find some old photographs of your area, and note how things have changed since they were taken. Then, imagine what a photograph taken in 2900 AD might show. Draw what you imagine.

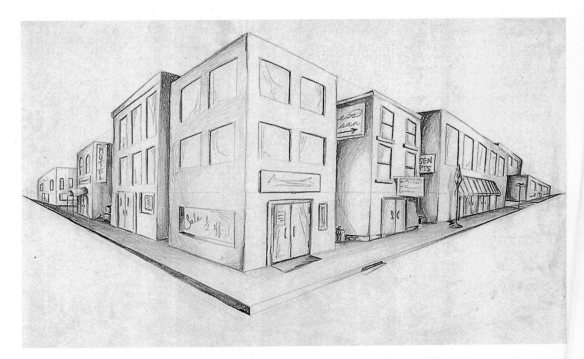

What do streets in cities or towns near you look like? Is the architecture like this? Using two-point perspective, you can draw a familiar street corner—and then change it to suit your own tastes. Don't forget to note where sunlight or moonlight is coming from, to create shadows and highlights. Student work by Andrea Katarakis, Red Lion, Pennsylvania.

Although the train station is presently unused and falling down, this artist found old photographs and restored it, through drawing, to its former glory. Student work by Todd Cahill, Grafton, Massachusetts.

Selective use of detail gives this simple line drawing depth and feeling. Student work by Jen Townsend, Grafton, Massachusetts.

Two-point perspective is applicable to any shape, not merely buildings and boxes. Abstract and nonobjective works, too, can be given three-dimensional qualities through its use. Student work by Ernesto Arriola, El Paso, Texas.

Three-point Perspective

Three-point perspective allows the artist to enhance the perspective of very long objects. In three-point perspective, the vanishing point is placed at the extreme bottom or top of the drawing.

In addition to perspective, the illusion of depth can be created and strengthened through techniques, such as exaggeration, foreshortening and distortion. Exaggeration means overstating or magnifying—making things larger than they are in reality. Foreshortening is the compression of a form's natural proportions (See Mantegna's *Dead Christ*, chapter 1, as an example). Distortion occurs when an artist changes the size or position of a form, making it appear unrealistic.

Three-point perspective allows you to exaggerate forms. Notice how, in this diagram, the side vanishing points are close together, the lower vanishing point is far down the page, and the resulting box form is extremely elongated. What would happen if you moved the side vanishing points farther apart?

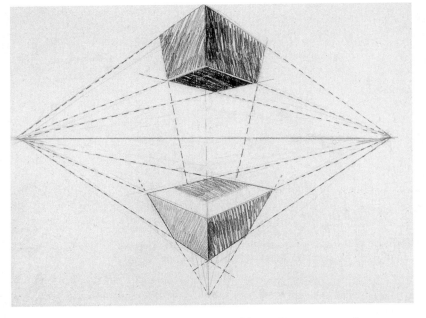

In three-point perspective, the primary vanishing point appears at the extreme top or bottom of the composition. Two secondary vanishing points—like those used in two-point perspective—are used at the sides.

A pencil work showing three-point perspective. Its counterpart in ink is shown on page 89.

When you foreshorten an object or figure, you change its proportions. How does this figure differ from a figure seen from straight on? What has the artist exaggerated or emphasized? Why? Salvador Dali, *Christ in Perpective*, 1950. Sanguine, 30" x 40" (76.2 x 101.6 cm). Collection of the Salvador Dali Museum, St. Petersburg, Florida. ©1993 Salvador Dali Museum, Inc.

A similiar version, in ink, of the work on page 88. Which shows more detail? Which has more visual energy? Student work by Boris Zakic, Yugoslavia.

Erasers

The basic function of an eraser is to eradicate undesirable marks. An eraser can also be used as a "drawing tool" to soften, blur or blend areas. In shaded areas, the eraser can be manipulated to create lines and highlights. There are four basic types of erasers.

Art gum is a block-shaped, dry rubber eraser that is especially good for removing pencil and charcoal. It can be used on all papers without harming or smearing the surface. It crumbles easily, and you must be careful the small bits of eraser do not cause unwanted smudging.

A *kneaded eraser* is soft, flat and extremely pliable. It absorbs erased material easily and must be systematically kneaded with the fingers to expose a clean surface. The eraser can be shaped into different forms to soften areas, erase details or create highlights. It is a versatile material that will not damage the surface of the paper.

A *vinyl eraser* is a newly developed elongated eraser that is excellent for removing marks on paper or film. It is made with a low abrasive material that does minimal damage to the surface of the paper.

A *pink pearl eraser* is wedge-shaped, firm and beveled on both ends. Its sharp edges and flat surfaces are very effective for blending and softening lines and shadow areas. It can be used on all drawing surfaces but does not clean as thoroughly as the other three types.

Esther Pullen, *Parcel for Paul*. Pencil on paper. Courtesy of the artist.

Create highlights

Lighten and soften; change value

Smudge to create distance or depth

Create texture, distort, blend

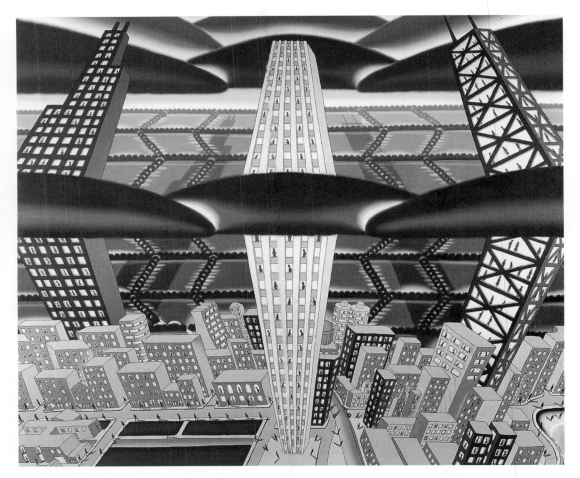

Look carefully at this work, especially at the small, lower buildings. Can you find the vanishing points? How has the artist played with the rules of perspective? Roger Brown, *Land of Lincoln*, 1978. Oil on canvas, 71 1/2" x 84" (181.6 x 213.4 cm). Courtesy Phyllis Kind Gallery, NY.

Does this drawing show exaggeration, foreshortening or distortion? Student work by Nicole Pupillo, Worcester, Massachusetts.

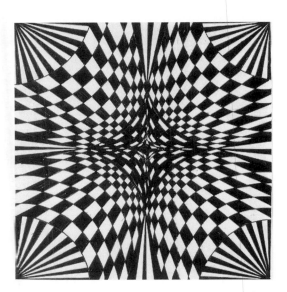

Optical illusions can show perspective, too. What kind of perspective has this artist used? Student work by Keira Olivas, El Paso, Texas.

A Perspective Gallery

Can you tell whether the mountains in this landscape are in the foreground or background? Would you say this work has much depth or little depth? Why? *Twelve Views of Landscape*, Chinese, ca. 1180–1224. Handscroll, ink on silk, 10 3/4" x 99 3/4" (27.3 x 253.4 cm). Courtesy The Nelson-Atkins Museum of Art, Kansas City, Missouri (Purchase: Nelson Trust).

How does the artist show you that some of these warriors are in front of the others? *Scenes from the Kerta Gosa Hall of Justice Ceiling*, Klungkung. Courtesy Ronald Sheridan/Ancient Art and Architecture Collection, London.

How does this artist's use of perspective and light contribute to the work's somewhat mysterious mood? Student work by Ryan Edwards, St. James, New York.

Escher is known for his unusual uses of perspective. Where is the ground? Where is the sky? Are we looking in a window, down from the ceiling or up from the floor? Maurits Cornelis Escher, *Other World*, 1947. Wood engraving. Courtesy Art Resource, NY.

In many non-Western cultures, realistic use of perspective is not important. How would you describe the use of perspective in this work? *Minister Kibi's Trip to China* (detail), Japan, Heian period, 12th century. Ink and color on paper, 12.7" x 961.4" (32.2 x 2442 cm). Courtesy Museum of Fine Arts, Boston. Willima Sturgis Bigelow Collection by Exchange.

Do you think this artist was interested in showing you the warriors' environment? What makes you think so? *Warrior Leaders Canoe on Lake*, Pre-Columbian, Mixtec. Courtesy Ronald Sheridan/Ancient Art and Architecture Collection, London.

Try to imagine or redraw this scene using the perspective techniques you've learned in this chapter.
What would be visible? *Persian Manuscript Illumination*. Courtesy of the Freer Gallery of Art,
Smithsonian Institution, Washington, D.C. 46.12–253b.

Landscape

In art, the natural world can be your greatest source for visual information. Nature provides an incredible range of forms, patterns, textures and designs to explore in drawing. Go for a walk and look around. Collect ideas and items that are visually interesting. Take advantage of what nature has to offer. Studying individual forms, like rocks, twigs, leaves and flowers, will expand your visual vocabulary.

Before you attempt to draw a landscape on a large scale, try drawing close-ups of different objects in nature. Experiment drawing found objects; use a wide variety of media. Each object has its own unique sense of design, texture and shape. Observe the object and select a medium which best captures the essence of the form. Pay attention to developing marks that carve out or reflect the texture and structure of the object. Draw the object from several viewpoints to better explore the structure.

For a more interesting composition, be creative with the angle of placement of the object. Change the scale of the objects in the drawings, and vary the amount of refinement in different areas within a drawing. How can you add interest to your compositions?

THINK ABOUT IT
Drawing objects in the natural environment sharpens your powers of observation and strengthens your ability to compare and contrast objects.

Studying and drawing small natural forms at close range is good practice. Try to capture the object from many different points of view.

Speaking of Art ...

Van Gogh produced a prodigious amount—10,000 drawings and paintings in nine years. At one point in his career, van Gogh showed a change in perception and an enhancement of line and color. Historians now believe that the change in style was partly the result of illness. Dr. Shahram Khoshbin, a neurologist and art authority at Harvard University, studied van Gogh's medical records and concluded that he had epilepsy. Dr. Khoshbin found that his own patients with epilepsy have told him that before a seizure, everything becomes detailed and clear. Van Gogh wrote and talked about this heightened perception.

Line, stroke and tone are visible in this sketch. Can you see how creating a detailed drawing of a thistle might help you draw a whole field of thistles in a larger landscape? Charles Burchfield, *Study of Thistle*, 1961. Crayon, 13 1/4" x 18 7/8" (33.7 x 47.9 cm). Collection of Whitney Museum of American Art, New York.

The shapes and textures of shells have fascinated artists for centuries. As you practice drawing objects, think: How are these shapes like other shapes I've seen? What do these shapes remind me of? What do they mean to me?

After you have drawn objects close up, begin looking at the entire landscape, from the ground to the sky. What do you see? How could you interpret what you see in a landscape drawing? What makes the landscape so compelling that you want to draw it?

The basic structure of a landscape composition consists of the foreground, middle ground and background. The relationships among the sky, earth and foliage are established by these sections.

To develop harmony in landscape, the artist must use the basic principles of design. One key to a successful composi-

tion is variation. Vary the shapes, sizes, textures and values in the drawing so the landscape will gain strength and interest.

Drama in a landscape is created through the use of conflict and variety. Conflict is created in many ways. Placing extremely different textures or values next to one another is one way to create conflict. Approaching the composition from a unique angle or point of view will add excitement to the composition. Andrew Wyeth often deals with ordinary subject matter from a fresh angle. This gives his work strength and interest.

How has this artist used value to create depth and texture? Student work by Angie Evans, Gulfport, Mississippi.

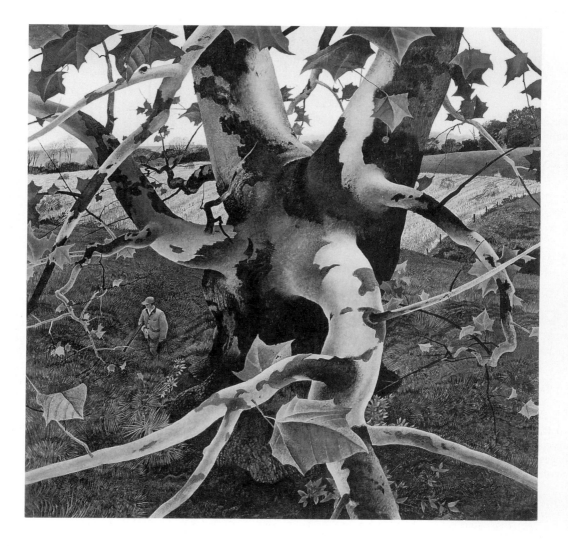

Can you identify foreground, middleground and background in this drawing? Where is the most detail visible? The least? Rembrandt Harmensz van Rijn, *Saint Jerome in Italian Landscape*, 1653. Etching and drypoint, 10 1/4" x 8 1/4" (26 x 21 cm). Courtesy Los Angeles County Museum of Art.

One way to create drama in a work of art is to choose an unusual point of view. Whose might be represented here? Andrew Newell Wyeth, *The Hunter*, 1943. Tempera on panel, 33" x 33 7/8" (83.8 x 86 cm). Courtesy The Toledo Museum of Art. Elizabeth C. Mau Bequest Fund. 46.25.

Strong, dark lines that move in different directions give this drawing drama. Why do you think the artist chose to show this scene? Student work by Anthony Balistreri, Milwaukee, Wisconsin.

Notice the variety of textures in this work. Can you find the focal point? Thomas Riesing, *Cows*, 1991. Charcoal on paper, 27 1/2" x 39" (69.9 x 99.1 cm). Courtesy of the artist.

Here are some points that can help you plan the composition of a landscape.

1. Select a dynamic angle that captures the strength of the landscape.

2. Look for strong directional lines to accent the composition. Use variation within shapes to hold the viewer's attention.

3. Make sure elements, such as color, shape, size, value and texture have sufficient contrast to create interest.

4. Work to achieve harmony and unity in the composition. Unity can be established by using dominance in shape, color or size. Dominance helps to develop an area of emphasis as well.

A powerful landscape is based on the principles of design. Your personal response to the natural environment is no less important. Use the principles of design to help you interpret what you see and feel.

Sometimes a few simple lines and washes communicate your feelings about a scene more effectively than a lot of painstaking detail. Student work by Kirk Lieb, Akron, Ohio.

This artist's lively use of line gives a stand of trees personality and presence. Student work by Ann Lott, Gulfport, Mississippi.

Urban Environment

An urban landscape is based on elements in our human-made environment. In our surrounding world, it is difficult to turn around and not see highways, buildings, planes, cars or other influences of people.

In the 1930s, Charles Sheeler began capturing unique aspects of our industrial environment by developing close-up views of steam engines, machinery and buildings. His compositions emphasized strong design qualities from refreshingly different points of view.

Spend time walking around the manufactured environment to explore all the various possibilities you can use in a composition. Urban environments are full of visual interest. Junkyards, docks, bicycles, fire escapes, fences, cars, trucks, gasoline stations and diners are just a few possibilities you can explore.

Look for areas in the urban environment that have visual complexities that create interest. Search out compositions that are refreshingly different and challenging.

How does a deserted street look in early morning? at night? Study the urban environment you want to draw during different times of the day. Notice how changes in light throw different areas into shadow. How do shadows play on walls of buildings and streets at a corner or an intersection?

How has the artist shown you that some buildings are in the far distance here? Thomas Riesing, *Williamsburg Bridge, East River*. Charcoal on paper, 42 1/2" x 62" (108 x 157.5 cm). Courtesy of the artist.

Try showing your urban landscape at several times of the year, in bad weather, at dusk or midnight. Thomas Riesing, *View From NE: Alcoa Highway Bridge*, 1985. Charcoal on paper, 42 1/2" x 62" (108 x 157.5 cm). Courtesy of the artist.

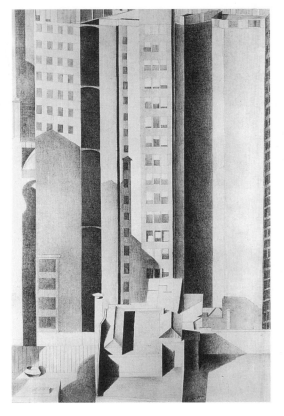

At the same time, look for atmospheric qualities that may add interest to your subject matter. Fog, rain, snow or darkness can often provide intrigue and character.

THINK ABOUT IT
Before you can interpret and evaluate something, you first need to see it.

In spite of the use of shadows and perspective, these buildings look flat. What creates that effect? Do you think that's what the artist intended? Charles Sheeler, *New York*, 1920. Pencil, 19.9" x 13" (50.5 x 33 cm). Courtesy The Art Institute of Chicago.

Can you find a repeated pattern here? How does it help unify this composition? Student work by Todd Alcorn, Delta, Ohio.

Use a viewfinder to find compositions that other people might not notice. Sometimes objects that are damaged or rusty have more visual interest than those that are intact. Student work by Christopher Borkowski, Parma, Ohio.

Try to look at the scenes around you with new eyes, even though you see them every day. Does your neighborhood look exactly the same in the morning as it does in the afternoon? Student work by Ron Milhoan, Knoxville, Tennessee.

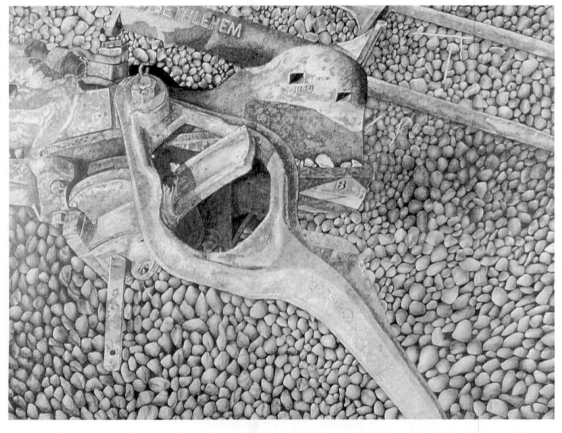

How has this artist made unusual use of negative space? Student work by Janet Zavodsky, Parma, Ohio.

Always look for subject matter you can respond to in the drawing. Your personal interest in the subject matter always makes the drawing more exciting and will be reflected in the end product.

Here are a few suggestions to help you draw the urban environment.

1. Select an environment that provides the best view and strong relationships among the foreground, middle ground and background.

2. Develop exciting, unusual angles and perspectives of the subject matter.

3. Emphasize directional movement and rhythm within the composition.

4. Lay in large areas of shapes and lightly capture the essence of the whole composition.

5. Build up areas of darks, gradually solidifying the shapes and shadows.

6. Use atmospheric perspective. (*Atmospheric perspective* is the illusion, produced in drawing or painting, that objects farther away from the viewer are hazier and less distinct than objects close up.) You can create atmospheric perspective by fading forms and softening their edges as they recede in space.

7. Give forms in the foreground stronger contrast. Use crisper, sharper edges and colors.

8. Develop a strong sense of lighting. Make sure the shadows reinforce the forms.

Above and opposite: In the drawing of this scene, the artist uses hatching and crosshatching to create shadows and define forms. The painting uses flat areas of color. The painting's edges are much sharper than those in the drawing. Which medium do you think works best to give you the "flavor" of a city street? Why? Opposite: Robert Cottingham, *J.C.* Graphite on Vellum, 13" x 20" (33 x 50.8 cm). Above: Robert Cottingham, *J.C.* Acrylic on canvas, 21" x 31" (53.3 x 78.7 cm). Both works courtesy of the artist.

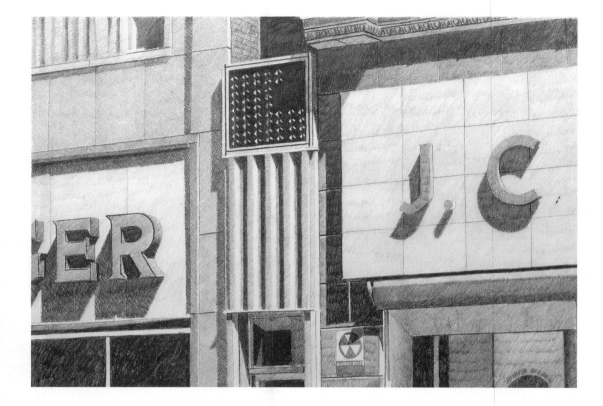

Be sensitive to capturing the time of
day, blowing wind, season of the year or
other elements of nature which can create
interest in the composition. Working
early in the morning or late in the
evening will provide the best long shad-
ows and richest colors. Remember to
work for an unusual point of view in the
composition. Try using a stepladder or
get low on the ground to find a different
point of view. Select a view that offers
freshness and vitality.

Reflections

Reflections can be intriguing to work with in a drawing. Recording the visual information found in reflections requires a lot of investigation and observation.

To understand how to handle reflections, set up a still life that includes a mirror as well as some drapery or household objects. Look closely at the edges of the actual objects. Are the edges of the reflected objects different? Are there other differences between the objects and their reflections? Develop the reflective qualities by using high contrast in darks and lights.

After working successfully with mirrors, try other subject matter to expand your drawing vocabulary with reflections.

By exploring other reflective surfaces, you can come up with some innovative compositions. Some possibilities in subject matter are

1. chrome bumpers,
2. musical instruments (saxophones, tubas, etc.),
3. sheets of mylar,
4. drinking glasses, vases and glass containers filled with water (Incorporate objects in and out of the water.),
5. kitchen utensils and aluminum pots and pans,
6. streams or lakes,
7. side-view mirrors on cars or trucks,
8. glass windows or doors,
9. highly polished surfaces, such as stone, bronze or steel.

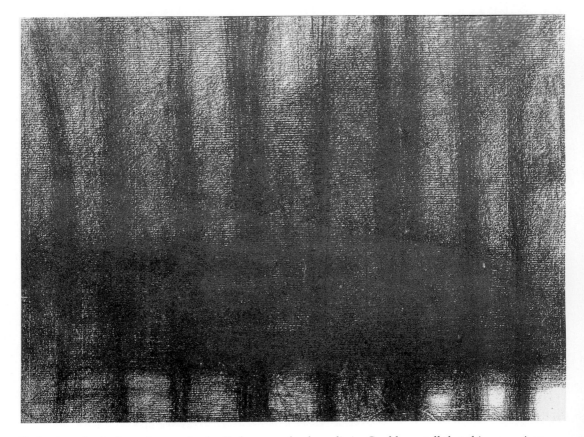

Reflections don't always have to be detailed or completely realistic. Could you tell that this was a river bank before you read the title? Georges Seurat, *Bords de rivière (Banks of the river)*, 1883–1884. Crayon, 8.8" x 11.9" (22.4 x 30.2 cm). Courtesy Art Resource, NY.

Mary Cassatt

1844-1926

When Mary Stevenson Cassatt told her father that she wished to become a painter, he responded that he would rather see her dead. To Mr. Cassatt, a respected Philadelphia banker, painting was not an occupation that even a sensible man would consider as a life work. Mary, however, managed to convince her father, and at the age of seventeen she was admitted to the Philadelphia Art Academy.

Shortly after graduating from the Art Academy, she moved to Paris, where she copied her favorite masterpieces at the museums and made sketching trips to the country. She admired many Renaissance and Baroque painters, but it was the works of Impressionists such as Edgar Degas that had the strongest influence on her.

Cassatt had a special interest in painting women and children. The majority of her work shows women at leisure or engaged with their children. Her subjects always appear natural and absorbed in their activities. By capturing the private moments between a mother and child, she managed to reveal the beauty of domestic life.

Although Mary Cassatt is best known for her oil paintings, she left behind many exceptional drawings and prints. As a painter of people, she always sought perfection in her figure drawing and tried different exercises to improve it. Said one biographer, "She was not satisfied to draw with a pencil. Instead, she chose to use metal and steel point so that the plate could hold every trace of her mistakes and corrections." This method, which required tremendous self-discipline and effort, allowed Mary Cassatt to achieve the beautiful line she desired.

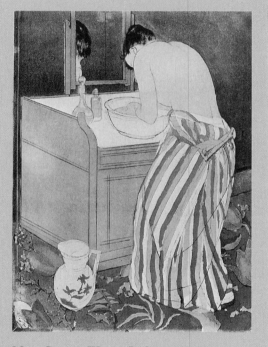

Mary Cassatt, *Woman Bathing*, ca. 1891. Drypoint and aquatint in color, 14 5/16" x 10 9/16" (36.4 x 26.8 cm). Courtesy the Metropolitan Museum of Art, Gift of Paul J. Sachs, 1916. (16.2.2).

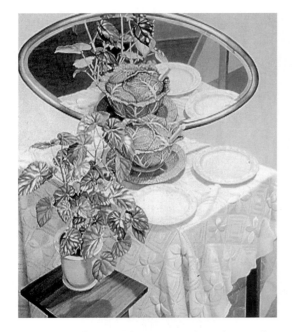

Artists like Richard Estes, Janet Fish and Charles Bell have created some intriguing compositions using reflections. Richard Estes generally uses the highly polished surfaces and windows found in New York City as a point of development for his compositions. Janet Fish's still lifes often incorporate glasses or glass containers that capture the unusual qualities of reflective light (See chapter 3.). Charles Bell's work explores the reflective qualities found in pinball machines and marbles.

Look at reflections as a valuable learning experience. They provide challenges and a way to increase your drawing skills.

Look carefully at reflections. Are the colors in the mirror the same as the colors of the object itself? Sondra Freckleton, *Mirror Image*, 1992. Watercolor, 46" x 38 3/4" (116.8 x 98.4 cm). Courtesy of the artist.

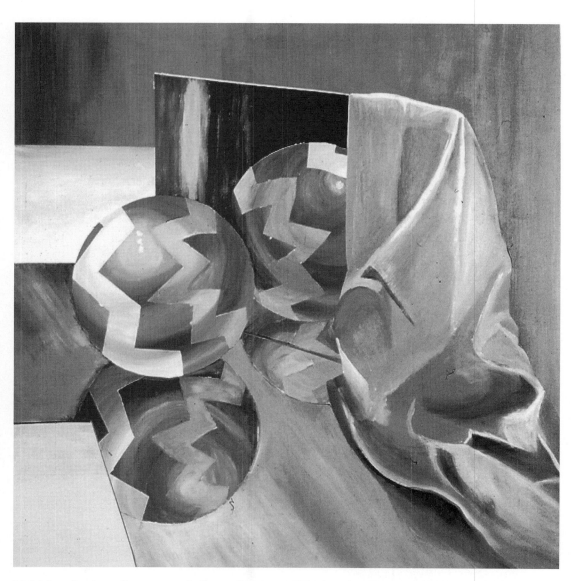

Multiple reflections allow you to challenge the viewer: Which is the object and which is the reflection?
Student work by Chad Brown, Memphis, Tennessee.

Bicycle reflections are a good subject for drawings, especially since there is usually one around to look at.
Student work by Michael Adkins, Abilene, Texas.

Summary

This chapter has introduced you to a wide range of drawing skills and possibilities for compositional exploration. You have learned to successfully incorporate perspective into your drawings. You have also gained experience in working with objects found in nature. This investigation has given you a chance to confront various textures, shapes and structures that nature so richly provides.

By building upon these experiences you have learned how to approach drawing landscapes and our urban environment.

As an artist, you need to challenge yourself constantly to grow and explore new directions in drawing. Working with a diverse range of subject matter will increase your ability to think visually. Handling a variety of subject mater, techniques and compositions will promote your drawing skills.

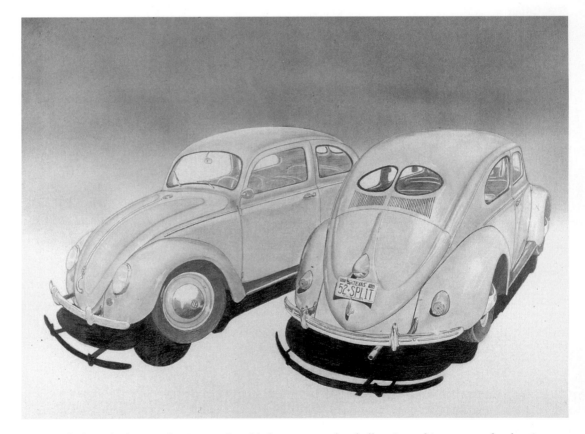

Cars, with their shadows, reflections and molded curves, can be challenging subject matter for drawings. Try contrasting a clean vehicle with a dusty or muddy one, or imagine the view from above or from underneath. What personalities do cars have? Student work by Humberto Pina, Goodrich, Texas.

Activities

Shifting Intensity

Draw a small landscape with a clear foreground, middleground and background. In this first drawing, use value contrasts to emphasize the foreground. Draw the same landscape two more times, emphasizing middleground in the second drawing and background in the third. Compare the three drawings. Which is most effective? Can you say why?

Analyzing Landscapes

Find a variety of landscape paintings, drawings and photographs from magazines, newspapers and other sources (cards or postcards from museums, advertising supplements, old books that can be cut up). Try to find as many as twelve different examples. Bring them into class and discuss them with your classmates. Which landscapes show romantic views of nature? Which show nature realistically? When people appear in them, are they shown large, as if they are important, or very small in relation to natural forms? How many different styles of landscape could you find?

Cars With Attitudes

Contour drawings of cars can be used as the basis for a series of drawings and abstractions.

First, make a contour drawing of a car. Color the drawing with felt-tip pens, colored pencils or watercolors. Now think carefully about the car. Is it fast, slow, hot, a wreck, stodgy? Write a description of the car. What is its attitude?

Draw and paint the car again, but change it to show its atttitude. Exaggerate features, show several sides or views at the same time. Distort it. Abstract it so that it is recognizable as a car, but not completely realistic.

In a third drawing, just show the mood of the car. The drawing should be nonobjective, so the viewer should not actually be able to see a car in the drawing. Think: What kinds of lines would you use to show speed? What lines would suggest a junkyard car? An old, beaten-up truck?

Creating Texture with Colored Pencils

Use colored pencils to create texture in a landscape or cityscape. Colored pencils allow you to "layer" colors to produce complex blendings. Experiment with letting the pencil strokes show, instead of

Student work by Stephen Doyle.

blending the soft colors together to create a smooth surface. Explore the uses of value and shading as you create texture.

A Furnished Room

Use a large sheet of drawing paper and a pencil. Using two vanishing points, draw a room that is open to the viewer. Furnish it with at least ten objects that are also drawn in perspective. This room may be a kitchen, a spaceship, your dream bedroom, an office or a living room. Some ideas for objects are furniture such as beds, chairs, tables, televisions and bookshelves. You may add windows, rugs, books, wall posters— whatever you'd like to see in a room.

Usually this project works best if you draw a transparent box very lightly first. Plan your furnishings first on tracing paper.

Ant's View

On a piece of illustration board, with pen and ink or marker, draw a room from an ant's view. This room might be the artroom, the cafeteria or the gymnasium. Get down low on the floor with a viewfinder to find an interesting composition. Think like an ant. What looks big? What is little? What is dangerous? With a pencil, plan out your composition on paper first. If you go to another part of the school, you might photograph your view, to help you when you cannot get to that spot.

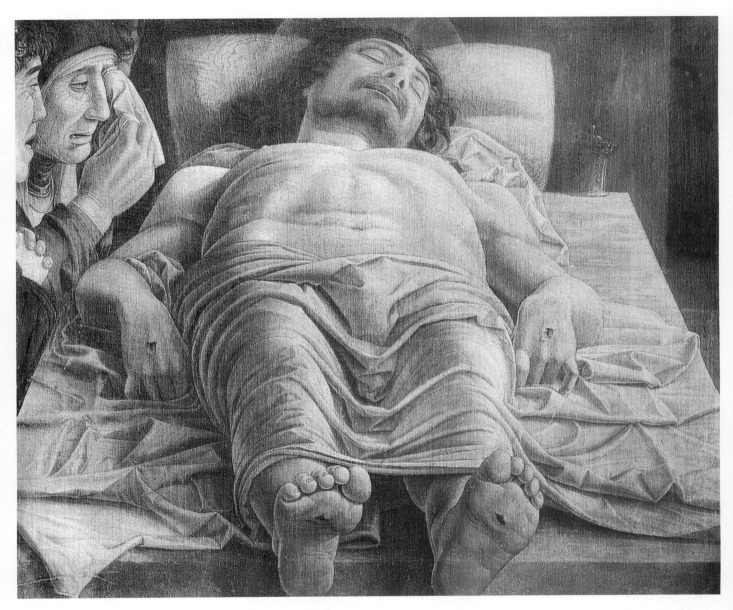

Foreshortening, discussed in Chapter 4, is an important skill to master in figure drawing. Try to see the shapes of the body as *shapes*, rather than as familiar forms like arms and legs. Can you imagine why the artist wanted to portray his subject from this angle? Mantegna, *The Dead Christ*. Courtesy Art Resource/NY.

5 Anatomy and the Figure

This chapter introduces you to drawing figures and portraits. Drawing the human form is one of the most interesting and challenging tasks for an artist. Before you can draw a figure, you need an understanding of the structure of the human skeleton. You also need

an understanding of proportions of the human form. In exercises that isolate specific body parts, you will learn the overall proportions of the human figure as well as sharpen your observational and drawing skills.

Human beings, of course, are more than just skeletons. Learning to capture the characteristics and emotions of a figure requires skill in observation and interpretation. In gesture drawing, you will learn how to draw quickly, with just a few lines, to capture a figure's general characteristics, form, weight and movement.

Contour drawing is a method that allows you to use line to explore both the outside and inside edges of a form. Several methods of contour drawing are presented in this chapter.

Once you have learned the basics of contour drawing, you will learn how line, stroke and tone can be used to draw a figure meaningfully and with speed.

Finally, you will learn to put all of the skills taught in this chapter together to draw portraits and figurative compositions. You will also learn how to arrange a figure within a composition.

Vocabulary
gesture drawing
contour drawing
proportions
outline

Key Chapter Points

- An understanding of the human skeleton and anatomy is the starting point for drawing a figure.
- Gesture drawing is a method of drawing simple lines to capture a figure and pose quickly.
- Contour drawing defines the edges of a form to suggest three dimensions.

- The human figure is proportional.
- A portrait captures both likeness and emotions.
- Placement of a figure and its relationship to other objects in the drawing must be carefully considered in developing the composition.

Anatomy

The human figure is probably the most complex subject on earth to draw. Although the human body is complex and has an awesome range of edges, curves and mass, do you think it is necessarily more *difficult* to draw than other subjects? Perhaps drawing the human form simply requires keener observation and more perseverance.

The body is built on a skeleton, making the skeleton the logical beginning point to explore. Without a clear understanding of the structure of the skeleton, you will have problems in drawing the body correctly.

The drawings on the next few pages illustrate the skeleton. Using light pencil lines, lightly sketch one entire composition on a large sheet of brown wrapping paper. Draw the entire skeleton—skull, vertebrae, rib cage, pelvis—down to the ankles. Take time to get the proportions correct.

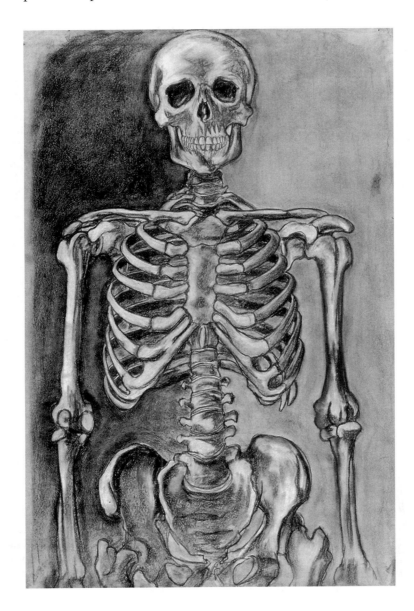

Student work by Humberto Pina, Goodrich, Texas.

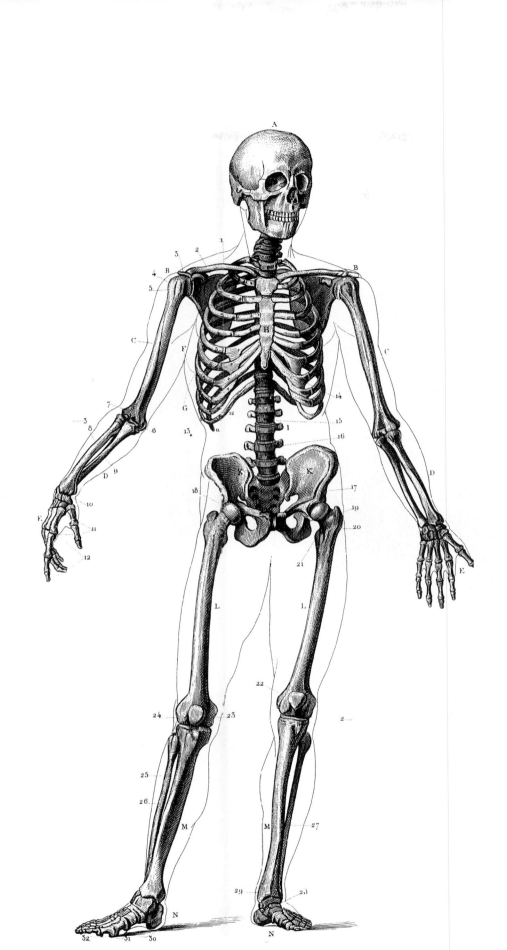

What is your body made of?
How do your bones fit together
and move? A careful look at
what's beneath your skin will
help you draw what's visible
from the outside.

From the side you can
see how full and curved
the rib cage is, and how
the spine curves gently
as it moves from skull to
pelvis.

From the back you'll
notice the large plates
that form the shoulder
blades, and the bumpy
joints of elbows, shoul-
ders and spine.

When you are satisfied with the whole image, use black charcoal and white chalk to develop the sketch. Develop sharp edges and high contrast on the bones that are closest to you. Use gray on bones that are farther away. Using a wide range of value and a variety of edges will give the skeleton a good sense of space and depth. You will also be creating a stronger sense of structure in your composition.

The skull is another good area to practice drawing. Use marks to develop and carve out the structure of the skull. Vary the edges to add interest. This practice will be of great benefit when you begin to draw figures and portraits.

THINK ABOUT IT
To better understand an object, you can observe it, describe it or illustrate it. Using all three methods may bring the best results.

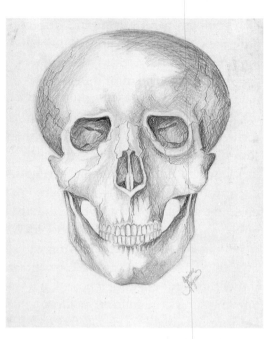

Student work by Geinene Haynes, Nashville, Tennessee.

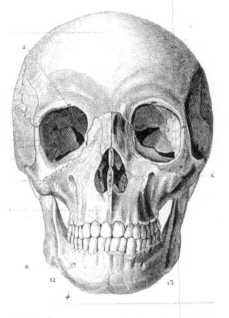

Notice how many teeth show in a skull, as opposed to a face covered with skin.

Gesture Drawing

Can you convey movement in a drawing? Suppose you wanted to draw someone jumping or running. How would you capture the movement of the figure? A quick sketch, or gesture drawing, can capture and express the sense of movement. Gesture drawing can do more than show movement. The goal of gesture drawing is to capture the figure's weight, mass and movement with a few lines. The drawings should contain a great deal of information with just a few sketchy lines.

Do not confuse gesture drawing with outlining or contour drawings. An outline shows the outer edges of a pose. Contour drawing shows the fullness of a form. Gesture drawing, however, refers to quickly drawn lines that define the basic characteristics of a pose. Use the following suggestions to experiment with gesture drawing. Try to complete your drawing in one or two minutes.

1. Don't try to be totally accurate. Just try to capture the overall sense of movement of the pose.

2. Draw quickly without first thinking how to draw. Just do it.

3. Don't deal only with edges of the figure. Work inside and outside the edges of the figure with rhythmic lines.

4. Look for lines that convey the weight of the figure.

5. Try to express the feeling of the pose.

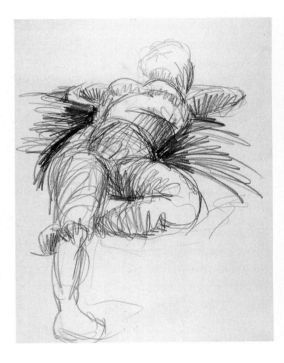

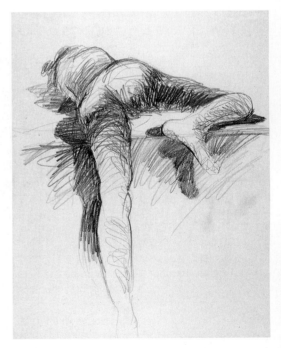

Gesture drawings use loose, casual strokes to capture a pose or an attitude. They're not intended to be realistic or completely accurate, but they should give the viewer a sense of what you see. Try to reveal movement or the amount of tension the body shows.

Newsprint Tablets

Newsprint tablets provide an economical paper for quick sketches and studies. Newsprint comes in smooth and slightly rough (toothed) textures. The newsprint with a tooth is better for charcoals, pastels and chalks. Carbon pencil does not usually make a very dark mark on newsprint. Felt-tip markers work well on newsprint, although they sometimes bleed through the paper. If this happens, tear a sheet from the tablet and use it as a blotter under each page as you draw.

(lower sheet, counter-clockwise) thick, medium-hard vine charcoal; ebony pencil; Marks-A-Lot wide permanent marker

(top sheet, clockwise) Sharpie medium-width marker; charcoal pencil; thin, medium-hard vine charcoal; compressed charcoal square; round compressed charcoal stick; fine-tip marker; black conté crayon; burnt sienna pastel; sanguine conté crayon

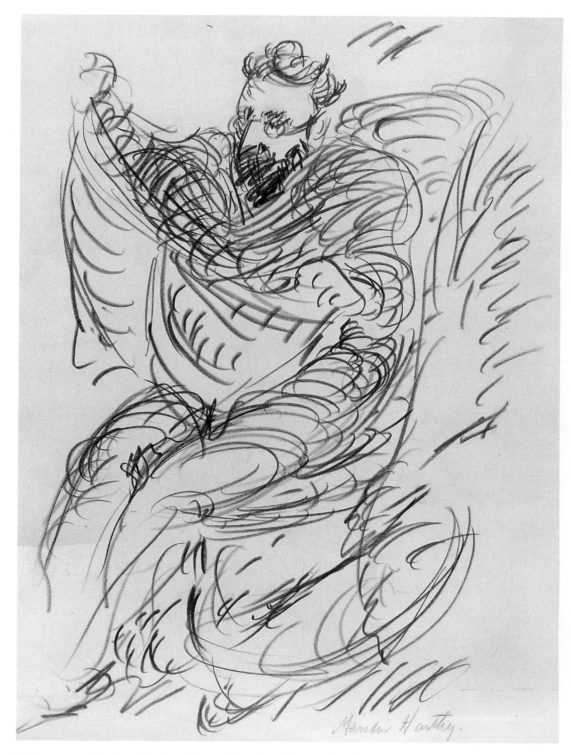

This man may be in a chair, but he's anything but still. How has the artist caught the feeling of energy that seems to surround this person? Follow a few of the lines from where they begin to where they end. What shapes do most of them make? Marsden Hartley, *Man in a Chair*. Pencil on paper, 12" x 8 7/8" (30 x 23 cm). Los Angeles County Museum of Art, Gift of Frank Perls.

Adding Interest to Gesture Drawings

To build complexity and add interest in a gesture drawing, use line, stroke and tone. Line defines edges. Do you want sharply defined edges or soft edges? Use line to give sensitivity to the edges.

The use of stroke adds strength and weight to the gesture pose. Develop a system of markings to indicate stress and add variety.

Tone can translate large areas of mass. *Tone*, or broad areas of value, captures the volume of a figure or object. In gesture drawing, tones of light and dark can add drama and heighten features.

Developing a marking system of line, stroke and tone will increase your visual vocabulary. This combination of marks will also increase your ability to develop various relationships within a composition. Such a system will be very useful to build beyond the structure of a *contour drawing*.

This diagram shows one way of adjusting proportions when dealing with a figure that is not simply standing facing the viewer. Drawing lines such as these may help you maintain the proper proportions when drawing posed figures.

Lesley Dill, *Blue Circulatory System*, 1993. Wire and paper, 72" x 33" x 1" (183 x 84 x 2.5 cm). Courtesy Bernard Toale Gallery.

Contour Drawing

Contour drawing captures the illusion of volume and space. Unlike outlines, which merely define a shape without suggesting depth, contour lines define the edges within a form. These lines create the appearance of three dimensions. Contour lines may be outlined, repeated, over-lapped and sometimes broken.

Contour lines are very descriptive. They can vary in weight and thickness and express qualities, such as softness, crispness and boldness. They can also describe textural edges of a form.

Drawing a figure using contour lines demands strong concentration. Draw lines as if you were touching the edges of the subject. Practice will greatly improve the quality of your contour drawing. Here are several methods to help you.

Blind contour Do a contour drawing without looking at the paper. Move your pencil as your eye scans the edges of the figure. Try not to peek at your paper. Don't worry about results. Just focus on drawing what you see.

Emphasizing weight Have a model pose sitting or lying down. Accent the areas of pressure with heavy dark lines. Vary the speed and value of the lines to capture the strength of the pose. Where is the weight the strongest? What edges should be emphasized?

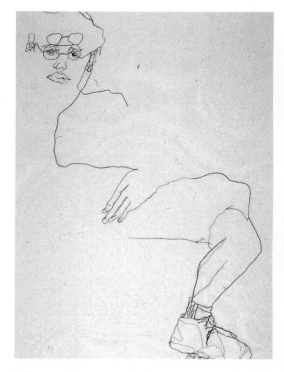

What you leave out of a drawing can reveal almost as much as what you put in. Can you find some lines that create three-dimensionality here? Student work by Julie Haruki, Honolulu, Hawaii.

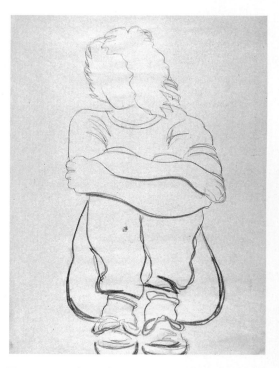

To give visual weight to a contour drawing, dark-en some of the lines. Consider first what you'd like to emphasize, and why. What is emphasized in this contour drawing?

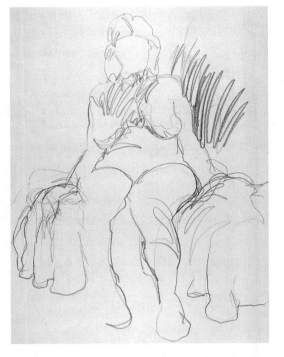

Student work by Alan Levy, Abilene, Texas.

Without faces, without clear details of any kind, contour drawings can still reveal mood and suggest personality.

Inside and out Have a model pose with arms or legs crossed. Draw the pose, using only certain edges inside and outside the figure. Do not draw an outline around the total form. Record only what is necessary to capture the gestural qualities of the pose.

Reverse Do a contour drawing of a figure in a comfortable pose. Draw on one side of the paper. Then have the model take the same pose in the reverse direction. Do a second drawing on the other half of the paper. You can allow some areas of the figures to overlap in both drawings. The reverse images will create interesting compositions and help you develop hand-eye coordination.

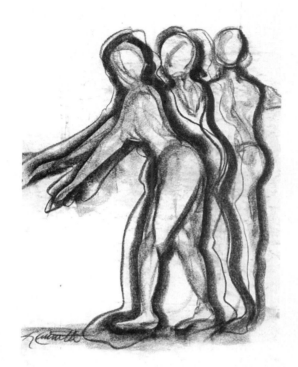

Shifting contours Have a model choose a pose that can be easily shifted to another position. Capture the pose in the first contour drawing. Then have the model change position slightly. Draw a second contour drawing on top of the first. If you like, repeat the process to enhance the sense of movement in the poses.

THINK ABOUT IT
Contour drawing strengthens your ability to focus on a subject. At the same time that you identify the form of your subject, you are analyzing and interpreting it as well.

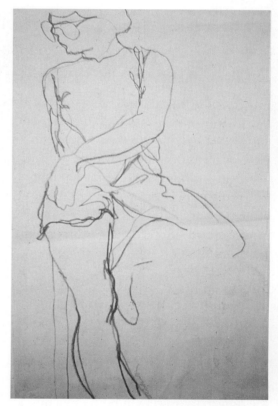

Above left, and above: Cartoonists often show arms and legs making many movements at once, to suggest haste or confusion. As you work on shifting contour drawings like these, think of when you might want to create that sort of movement.

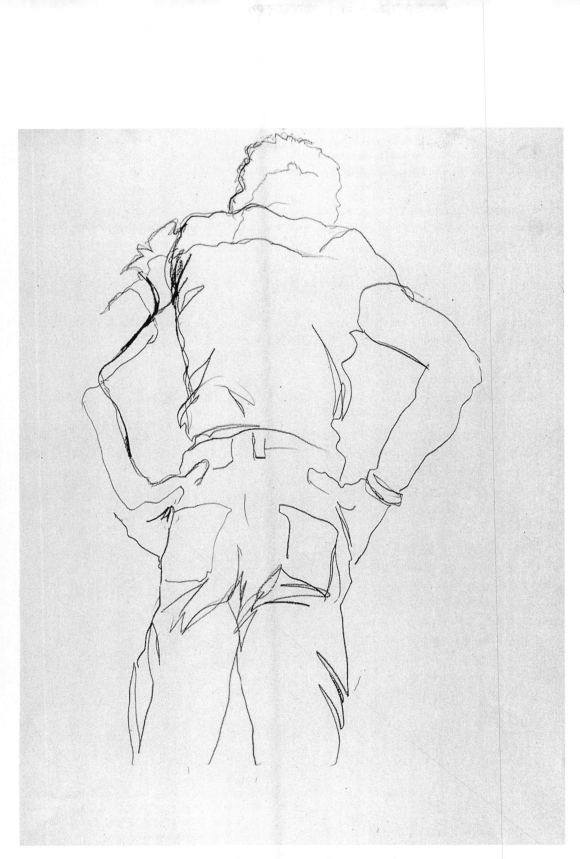

With practice, your contour drawings can begin to capture the essence of a person at a particular moment.

Full Figure Drawing

Learning how to draw the full figure quickly takes time and practice. You must learn how to draw the figure frontally as well as at different angles. There are several ways to approach full figure drawing.

Draw the figure by filling in all of the positive space within the figure with charcoal. Imagine that your charcoal stick is bouncing around the inside edges of the figure. Make marks that reflect the direction of the body mass and the movement of the pose. Draw the whole pose as though you were drawing a silhouette. Don't bother with details.

When you have gained confidence in using positive space to draw the figure, reverse the process and work with negative space. Work with the outside edges of the figure instead of the inside edges. Fill in all the negative space with black strokes and tone. Make the outside edges descriptive.

After you have practiced working with positive and negative space separately, combine these techniques into one drawing. Draw the figure from the hips up by drawing the negative space. Draw the figure from the waist down by filling in the positive space. This method allows you to begin fusing lights and darks within a composition, which will help give the composition unity.

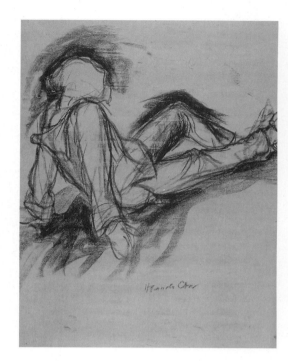

Draw the figure from many different angles. Try to feel the weight of the model's upper body as it presses on her arms. How has that weight affected her shoulders? Her neck? Student work by Hannah Cofer, Knoxville, Tennessee.

Proportion

Proportion is a comparative relationship between the parts of the human form. For example, there is a relationship between the size of the head and the body.

Leonardo da Vinci divided the figure into eight parts. He found that the measurement of a person's head multiplied eight times equals their height. If a person spreads out his or her arms horizontally, the measurement from fingertip to fingertip will equal the person's height.

Another way to establish correct proportions in full figure drawing is to draw a vertical line up through the figure. This line can serve as a reference point. Use the line to show the relationship between parts and the whole figure.

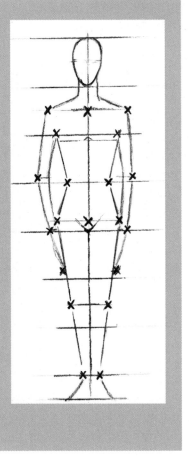

Concentrate at first on the body's forms and overall shapes, not on small details. Leave facial features out at first, or suggest them only with areas of tone. Student work by Gina Miller, Abilene, Texas.

To explore lights and darks within a composition, have a model pose under strong lighting. Use lights to create dynamic shadows inside and outside the figure. Draw the figure by laying in large areas of darks. Work with both positive and negative space. Can you find a relationship between the lights and the darks? How does the figure relate to the whole composition? How does working with positive and negative space help you locate the figure within the composition?

THINK ABOUT IT
Drawing the full figure is a form of problem solving. Each question you ask yourself at the different stages of the drawing process allows you to explore possibilities and solutions.

After you have drawn the figure with large areas of tone, use lines and strokes to emphasize the edges of the figure. Adding thin and thick lines will give detail and strength to the drawing, as well as help you relate the figure to negative space.

Bend your fingers. Clench your fist. Where do the wrinkles appear? Student work by Gina Miller, Abilene, Texas.

Hands and Feet Concentrate on specific areas of the body, particularly the hands and feet. Hands are complex and challenging to draw. Look at your own hands. Feel the thickness at the base of your hand. What happens when you bend your fingers? Practice drawing hands at various angles and from different viewpoints. You can experiment with using a minimum of lines or overlapping lines. As the edges of the form diminish, so should the weight and strength of the lines.

Work with the feet in the same manner. Explore the variety of curves, muscle padding, and bone structure. Do feet offer some problems in foreshortening? How can you draw a foot that is projecting toward you while keeping the proportions correct? Experiment with contour lines and draw exactly what you see.

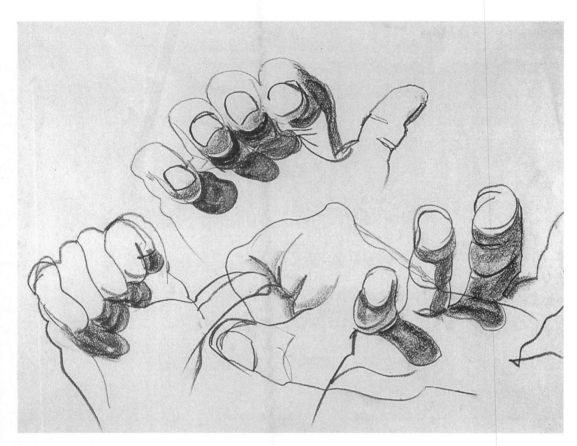

Shine a bright light on your hands. Use tone to create shadow areas.

Use overlapping and transparency to explore the hand's many forms.

Combining your studies of hands can produce some interesting results. Student work by George Flores, El Paso, Texas.

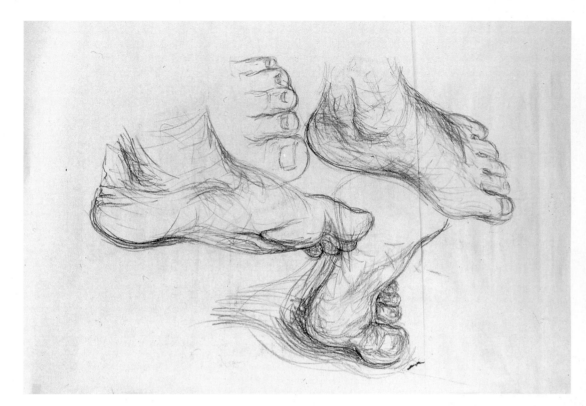

Just as you did with hands, draw feet in as many positions as you can.

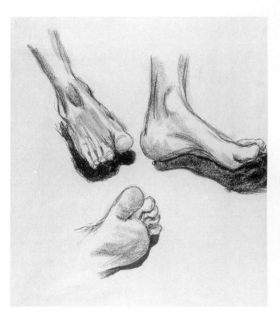

Notice the use of highlights here. Where is the light coming from?

Feet, Hands, Ears, Eyes, Nose and Mouth

Hands and feet are often considered "difficult" parts to draw. The key to drawing areas like hands and feet is to look for the relationship between the overall structure and its parts. How does each part relate to the whole? First look at each part separately; then examine how each part relates to the other parts. For example, where is the hand in relation to the elbow? How long is the hand in relation to the face? Relating one part to another helps give you an overall sense of direction and unity in your drawing.

Hands and feet and facial features have variations in edges. Observe closely how edges change from sharp to round, smooth to crisp. Varying the edges of the forms will help define the areas and add strength to the drawing.

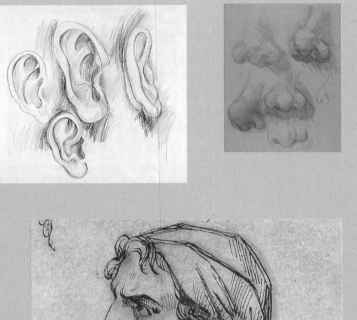

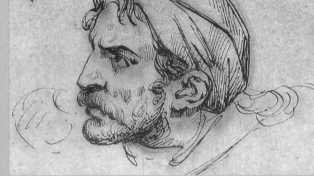

Theodore Gericault, *Three Sailors' Heads* (detail), ca. 1818. Pen and iron gall over pencil on brown wove paper, 8" x 10" (21 x 26 cm). The Baltimore Museum of Art: Fanny B. Thalheimer Bequest Fund.

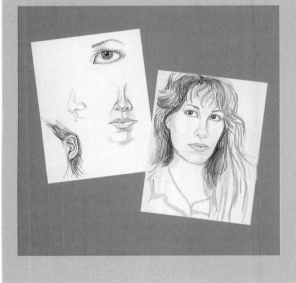

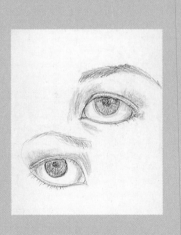

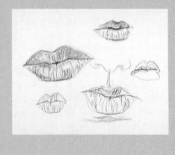

Face A good way to approach the features of the face is to use a mirror and explore your own face. First look for relationships between the parts. Study relationships between areas such as your nose and your eyes. Where is your nose in relation to your eyes? Where is your chin in relation to your forehead?

Try isolating each feature. Draw just your nose or one eye. Can you express more than just an exact likeness of each feature? Can the shape of your mouth convey a feeling?

Gradually expand your skills by drawing your whole face. Try drawing your face at different angles and with different light sources.

THINK ABOUT IT
Drawing a self-portrait is an exercise in reflective thinking. Who are you? What are you thinking and feeling?

Proportions of the Head

The proportions of the human head do not vary from person to person. Although each person looks different from another, the placement of features remains constant.

The eyes are located halfway between the chin and the top of the head.

The human head is essentially an oval. The face can be divided into thirds. A third of the face is located from the nostrils to the chin. Another third is located between the nostrils and the eyebrows. The last third is from the eyebrows to the hairline.

Once you establish the general proportions of the face, you can develop the facial features in greater detail.

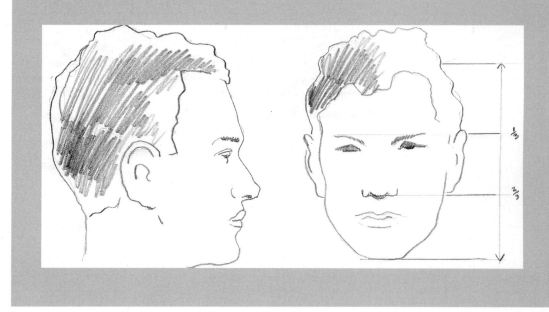

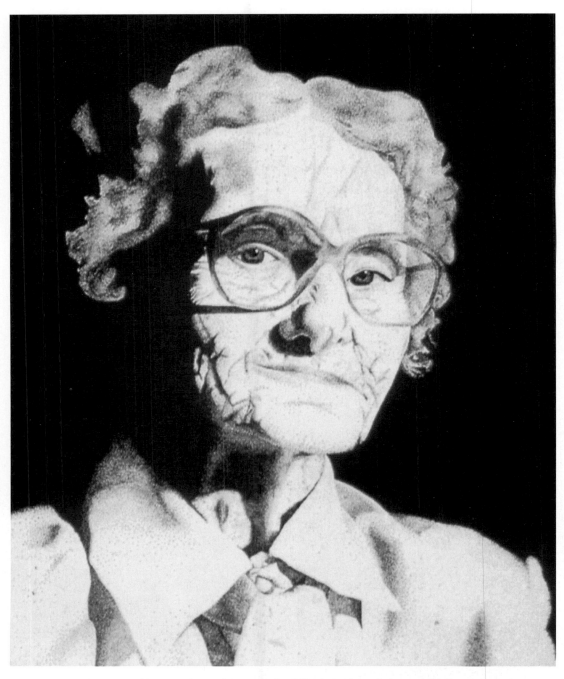

The faces of babies and older people can be especially difficult to draw, because of differences in skin tone and changes in general proportions. Notice how sensitively this artist has used darks and lights to suggest personality as well as likeness. Student work by Kathy Ballsrud, Monticello, Illinois.

Portraits

Portraits have been described as windows to people's personalities. Is a successful portrait an exact likeness of a person? Or is it more important to express the qualities that sets the person apart from other people? Portraits can express far more than just a person's likeness, which is why they are so challenging.

In drawing a portrait, the artist must be sensitive to the model's mood and personality and look for ways to communicate them. Is the model relaxed or tense? Can the pose capture that quality?

Alice Neel translated her model's personality and mannerisms into an expressive drawing. How is her drawing a direct visual translation of the model? How is it an emotional response to the model? Because Neel conveys more than just a likeness of the model, her portraits have a strong sense of originality.

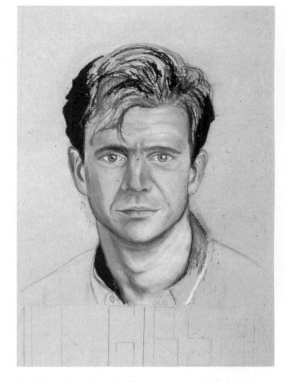

Realistic detail in the face contrasts with looser, darker lines in the hair and shirt. Student work by Juleen Generelli, Worcester, Massachusetts.

Speaking of Art...

In 1530 during a political upheaval in Florence, Michelangelo hid in a small, secret room in the basement of San Lorenzo. It could only be entered by a trapdoor. In 1975, large figure drawings or cartoons by Michelangelo were found on the walls of this crypt. They were drawn with charcoal and red earth pigment. Some of the drawing overlapped, probably because he lacked space or light.

What clues has the artist given you about what this person is like? Alice Neel, *Adrienne Rich*, 1973. Ink heightened with Chinese white on paper, 30 3/8" x 22 7/8" (77 x 58 cm). Courtesy Robert Miller Gallery. Photograph: Zindman/Fremont.

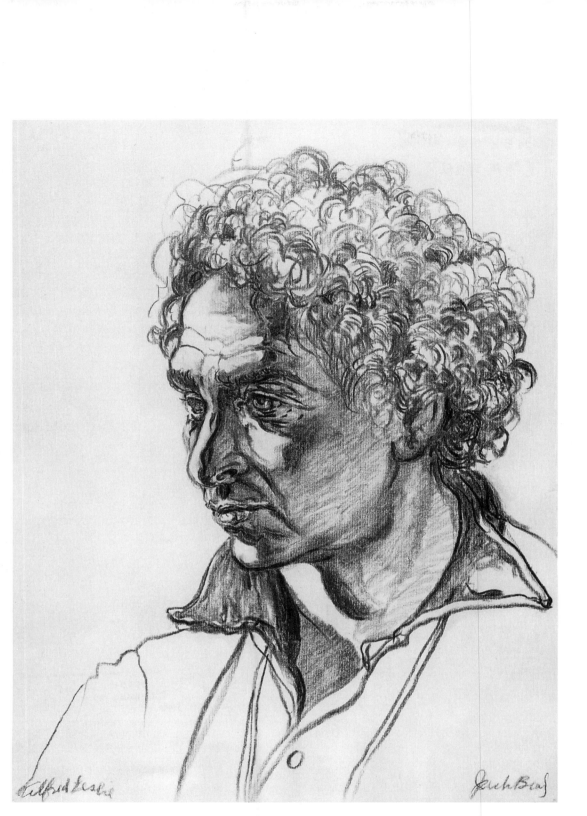

Use of line, stroke and tone is clearly evident in this portrait. Can you see how the many dark areas and strong lines make the work forceful? Jack Beal, *Alfred Leslie*, 1976. Charcoal on paper, 25 1/2" x 19 5/8" (65 x 50 cm). Courtsey Frumkin/Adams Gallery. Photograph: eeva-inkeri.

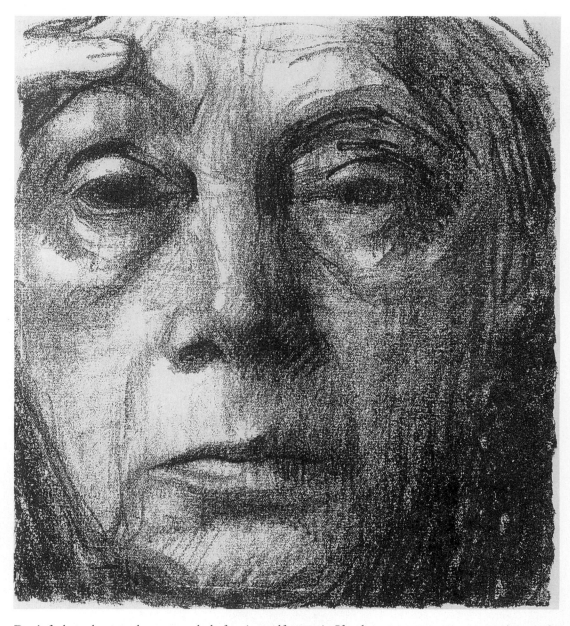

Don't feel you have to show your whole face in a self-portrait. If a close-up seems more appropriate, try it. Käthe Kollwitz, *Self Portrait*, 1934. Lithograph. National Gallery of Art, Washington, DC. Rosenwald Collection.

Self-portraits Self-portraits are a good way to explore portraiture. By using mirrors and photographs, you can draw yourself at your own pace. But more importantly, you can reach down deep inside and translate your feelings and emotions into a drawing. Drawing a self-portrait allows you to draw what you see outwardly while conveying what you feel inwardly. This is a rare opportunity, so be creative and express yourself!

Here are a few suggestions to help you develop a self-portrait.

1. Search for a comfortable pose—one that expresses your personality.

2. Consider the lighting, background and clothing or props you want to include.

3. Set up mirrors so that you can see yourself easily as you draw.

4. Select the proper medium that expresses the subject matter.

5. Use a marking system and colors that reflect the content of the subject matter.

6. Don't be afraid to let your feelings show. Your self-portrait should be a strong image that reflects not only your image but also what lies within.

The expression on your face is important in a self-portrait—it sets the tone for the whole work. Here, the angle of the head, slightly pouting mouth and defiant eyes help suggest suspicion or resentment. Student work by Tony Board, Greenwood, Indiana.

Working in the style of a famous artist is good practice. By trying to recreate the techniques of others, you discover techniques of your own. Pat Steir, *Self After Rembrandt*, 1985. Hardground, 26" x 20" (66 x 51 cm). Courtesy of the artist.

Figurative Compositions

Before you draw a figure, you need to plan your composition. How will you position the figure to create interest? What relationship do you want to establish between the figure and the background environment? Planning the composition is the first step in drawing a figure.

How the figure is placed is a fundamental concern in developing the composition. For example, you don't want to leave large areas of the paper blank. Nor do you want to have half your composition running off the page. Using a system of organizational line drawing is one approach to locating the figure properly. This system is essentially a latticework of gesture lines that are continuous and overlapping. They serve as a framework in which the figure and surrounding shapes are located.

Alberto Giacometti, *The Artist's Mother Sitting, I*, 1964. Lithograph. © Sotheby Park-Bernet. Art Resource, NY.

What questions are raised by the division of space in this work? Does the background suggest two sides of the woman's personality? A dark past and a bright future? Paula Modersohn-Becker, *Portrait of a Peasant Woman*, 1900. Charcoal on buff wove paper, 17" x 25" (43.3 x 63.9 cm). The Art Institute of Chicago, Gift of the Donnelly Family, 1978.26.

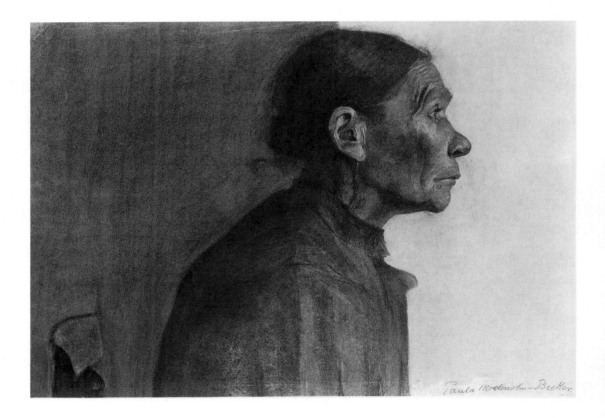

Gathering Information

Philip Pearlstein once remarked that in developing his figurative work he uses three different systems to gather information. First he records the composition by doing quick sketches that capture the gestural qualities of the pose. Then he freezes the image in a photograph, retaining the lighting and values in the composition. This is an important step in Pearlstein's work because he often uses multiple light sources. Finally he observes and works directly with the model. His three-step systematic approach provides him with unique aspects of visual information.

How has composition helped create a focus in this work? Philip Pearlstein, *Model in Plum-Colored Kimono on Stool (both legs up)*, 1978. Watercolor 59 5/8 x 40 1/4 " (151 x 102 cm). Courtesy Frumkin/Adams Gallery. Photograph: eeva-inkeri.

What do gestures and facial expressions tell you about these two people? How has the artist used lines for emphasis and to unify the composition? Sharaku, *Attori*. Scala/Art Resource.

Casual lines echo the casual pose of the model in this ink and chalk composition. Student work by Erica Cho, Ardmore, Pennsylvania.

Using organizational lines allows you to correct mistakes or reevaluate relationships between forms. By gradually building up lines as points of reference, you can develop compositional relationships and images with meaningful proportions.

Alberto Giacometti's drawings often display a latticework of lines that surrounds the figure in space. His drawings are a natural extension of his sculptures.

Here are some suggestions for using a system of organizational lines.

1. Draw vertical and horizontal lines that roughly indicate where the figure and objects will be placed.

2. Develop these lines to establish the height and width of the figure and objects.

3. Draw through the objects to develop the correct proportions.

4. Extend the lines beyond the objects into negative space.

5. Stand back from the work and reevaluate the positioning of the figure and objects in relation to the overall composition. Make any corrections.

Once you have located the forms in space correctly, you can develop the drawing. You do not have to erase the organizational lines.

This artist's use of contrast between dark and light areas, and his variation of line width, creates emphasis in certain spots. Can you find them? What is being emphasized? Alfred Leslie, *Artist in the Studio*, 1979. Graphite on paper, 80" x 60" (203 x 152 cm), 4 sheets. Courtsey Frumkin/Adams Gallery. Photograph: eeva-inkeri.

Look carefully at these two faces. What besides size tells you that one is an adult and the other is a child? Sidney Goodman, *Sidney Goodman Holding Maia*. Charcoal and pastel, 44 1/4" x 52" (112 x 132 cm). Courtesy Terry Dintenfass Gallery.

Which parts of this drawing are realistic? Which are more stylized? *Miniature showing Riza-i Abibasi Painting a European.* Persian. Courtesy Princeton University Libraries.

Speaking of Art...

As a teenager, Michelangelo and other artist apprentices were copying Masaccio's paintings in the church of the Carmine. Michelangelo began teasing Pietro Torrigiano, a hot-tempered young man. Torrigiano lost his temper and punched Michelangelo in the nose, breaking it. "I felt bone and cartilage crush like a biscuit, so that fellow will carry my signature until he dies," said Torrigiano. And Michelangelo did. In his self-portraits, even as an old man, he shows himself with a broken nose.

Soft shadows and gentle, flowing lines contribute to the relaxed mood of this drawing. Can you identify where the artist has used foreshortening? Diego Rivera, *Sleeping Woman,* 1921. Crayon, 23" x 18" (58 x 46 cm). Fogg Art Museum, Harvard University. Bequest of Meta and Paul J. Sachs.

Even the simplest, most familiar scenes can become effective figure drawings. Student work by Christopher Jenkins, Clinton, Mississippi.

Summary

In this chapter, you learned several approaches to drawing the human figure. You explored the structure of the human skeleton and proportions of the human figure. Practice in gesture drawing has developed your ability to capture the movement of a pose and the basic characteristics of a figure. Contour drawing has taught you how to observe closely the edges inside and outside a form. You are learning how to be more expressive and descriptive in your use of line. Drawing the full figure has presented you with challenges in positioning a figure within a composition. And in drawing portraits, you are learning how to convey feelings and emotions.

Drawing the human figure is an ongoing learning process. Figure drawing requires a great deal of time and persistence. Artists like Wayne Thiebaud still spend a number of hours each week studying the figure and developing drawing skills.

The human figure is quite complex and demands a lot of respect in recording it. For any artist, and particularly the beginning drawing student, reaching the point where you are no longer intimidated by drawing the figure is a major accomplishment.

Student work by Chris Pritchett, Milwaukee, Wisconsin.

Humor can add personality and life to any portrait. Student work by Michelle Bodie, St, John, Indiana.

Activities

Mirror and Photograph Self-Portraits

Draw two self-portraits. In one, draw yourself by using a mirror. In the other, draw from a photograph of yourself. Compare the two drawings. Which is stiffer or flatter? Which is more lifelike? In which was it easier to show volume?

A Historical Self-Portrait

Select a portrait painting or drawing from a previous century. Use it to create a self-portrait. Pose in the same position; try to show the same expression; draw the same clothing. Note the style the artist used: is it realistic or somewhat abstract? How is it different from your own style?

Crayon Resist Gesture Drawings

Use several different colored crayons on manila paper to make gesture drawings of people. Paint over these with a contrasting watercolor. Traditionally black is used for this resist technique, but any color may be used.

Matisse Collages

Make gesture drawings of figures on several colors of construction paper. After studying Matisse's cut paper collages, cut out the gesture drawings. Turn them over so the drawn lines are not showing. Arrange them on construction paper. Try breaking up the background and creating a rhythm with construction paper shapes. Glue it all down.

Wire Gesture Sculpture

Turn a gesture drawing into a wire sculpture. Copy one of your gesture drawings with bendable wire such as aluminum sculpture wire. Begin with about four feet of wire; more may be added to the sculpture. With a staple gun, attach your finished wire figure to a wooden base. Both wire and base may be painted.

Drawing the Figure on a Grid

With your classmates, enlarge an illustration of a figure to larger-than-life proportions. For example, an 8" x 12" illustration could be enlarged to six times its size. Section the enlargement into six-inch squares and number each square on the back.

You and your classmates will each receive one six-inch square and the corresponding two-inch square of the original illustration. Divide your six-inch square into nine smaller squares. Divide the two-inch square into four smaller squares.

Grid a six-inch square of illustration board. Now draw your section of the figure in this grid. Try to match the line, color and value of the original illustration as closely as possible. When you have all finished, join the large squares together on the backs with tape. How successful were you in completing the figure? Share what you learned about scale and the details of human anatomy.

Student work by Stephen Doyle.

A Self-Portrait with Pointillism

Georges Seurat used a method called pointillism, in which he applied small dots of color to a surface so that from a distance they blend together.

Create a self-portrait using the same technique. Begin by drawing a pencil sketch of your head. Take time to measure correct proportions of each part.

When you are satisfied with your sketch, use a fine-point pen to create a pointillist drawing. Use tiny dots to create value, shading and contour.

The Figure and Elements of Design

An easy way to learn to draw the full figure is by drawing the figure from a back view. Drawing a figure from the back minimizes details, stresses shape and contour, and eliminates the face. To make your composition interesting and exciting, emphasize an element or principle of design. Minimize the importance of the figure.

Drawings that make strong statements often combine images in unusual ways. What do you think this combination of images means? Student work by Christopher Ward, Libertyville, Illinois.

6 Stimulating Creativity

Creativity is not something that can be found in a book or learned in a few easy steps. However, you can develop your creativity through a variety of learning experiences.

This chapter investigates various ways to stimulate creativity. Multicultural experiences can help you explore the artwork of different cultures and open you to new ideas. Graffiti drawing can help you develop spontaneity in your drawings. New

technology offers another medium for expression. You will learn how to incorporate photocopied and computer-generated images into your compositions.

Interpreting subject matter from a variety of points of view is another way to stimulate your creativity. Placing an inani-

mate object in a setting in which it does not belong can help you see the object in a different way. Thinking of an object in terms of a metaphor is another way to make an image strong and vivid. Metaphors are dramatic and forceful comparisons that help us see something more clearly and often in a new way.

Key Chapter Points

- Art forms from different cultures are a source of new ideas.
- Drawing and painting can be fused in a composition.
- Photocopied and computer-generated images can be used in a composition.
- Placing an object in an unexpected setting can give life to the object.
- A metaphor can be used as the foundation of a composition.

Boogie Woogie is a musical style with a fast, irregular beat. Imagine the squares in this composition as musical notes. Can you see how they jump around the image? Piet Mondrian, *Broadway Boogie Woogie*, 1942. Oil on canvas, 50" x 50" (127 x 127 cm). The Museum of Modern Art, New York. Given anonymously.

A good artist is always learning and growing. Looking, listening, reading and being open to all aspects of life can broaden your experiences. Everything you experience becomes a part of you and can be reflected in your artwork.

For example, Piet Mondrian became interested late in his life in jazz and the syncopated rhythm called boogie woogie. Mondrian found in New York City the same vitality and energy that he heard in jazz. *Broadway Boogie Woogie*, painted in 1942, is radically different from Mondrian's earlier black-and-white grid paintings. It shows how Mondrian applied his feelings about jazz to look at New York in a new way. In doing so, he created a new direction in his art.

The purpose of creativity is to produce unexpected, effective results. The broader your range of experiences and the more willing you are to take new directions in your artwork, the more creative you will be.

THINK ABOUT IT
According to Picasso, creative thinking can be thinking a thought no one else has come up with. According to Andy Warhol, it can be putting things together in a new way.

Use the exercises on the following pages to expand your creativity. They offer different approaches to drawing.

Thinking about an unusual perspective can help you generate creative ideas. Notice this artist's use of atmospheric perspective to help give the composition focus. Student work by Ben MacNeil, Raleigh, North Carolina.

Giving Life to Inanimate Objects

Suppose you created a composition by placing an ordinary household item, like a hand mixer, in an unusual setting, like a garden. Such an arrangement challenges you (and the viewer) to look at both the object and the environment in a new way. Drawing an object from a different point of view can help you give life to the object.

Create your own composition. You may want to combine several unrelated objects into one composition. Experiment with different combinations of media, such as watercolors, ink, oil pastels and colored pencils. Use media that will enhance the qualities of the subject matter.

Hair takes on a strange life of its own in this highly detailed work. Is it just a girl on a swing—or is the house on fire? Student work by Mason Doran, Livonia, New York.

Seeing a crystal goblet by itself in a surreal setting raises immediate questions. Is the goblet a symbol for something else? What is it sitting in, and why? Works that are visual puzzles can make you question your own assumptions and look more closely. Student work by Michael Lowrance, Temple, Texas.

Color

The use of color can give life to a drawing. Color can accent elements and reinforce relationships in a composition. Colors can establish the mood of a work. Exploring color in your work can stimulate your creativity and technical ability. Color gives you the option to emphasize areas, create moods and incorporate a wider range of materials into your work. Color pencils, pastels, crayons, color inks and magic markers are just a few of the materials that you can use to develop color in your drawings.

You can blend pastel with a finger or tissue to create soft edges and mix colors. In spite of the softness of the medium, pastel colors can be quite vivid. Student work by Stephen Beal, Dorchester, Massachusetts.

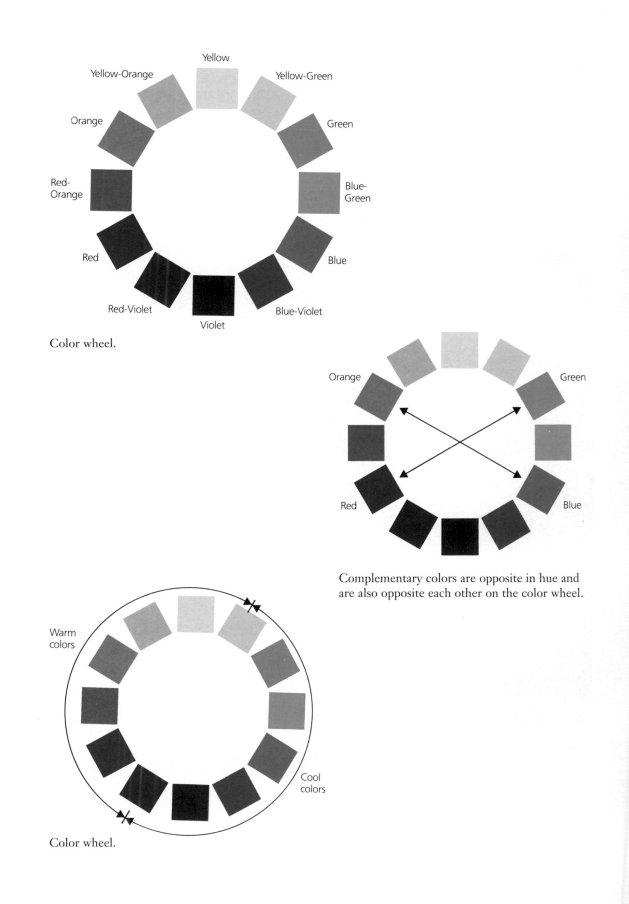

Color wheel.

Complementary colors are opposite in hue and are also opposite each other on the color wheel.

Color wheel.

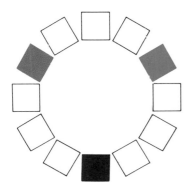

Triad scheme.

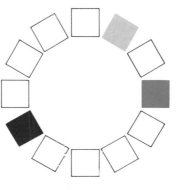

Split complementary scheme.

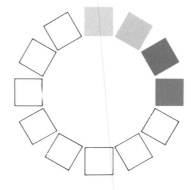

Analogous scheme.

Mixing a color with its complement can produce
a neutral gray.

Value scale of red. What color should be added to make a tint
of red?

A saturation or intensity scale.

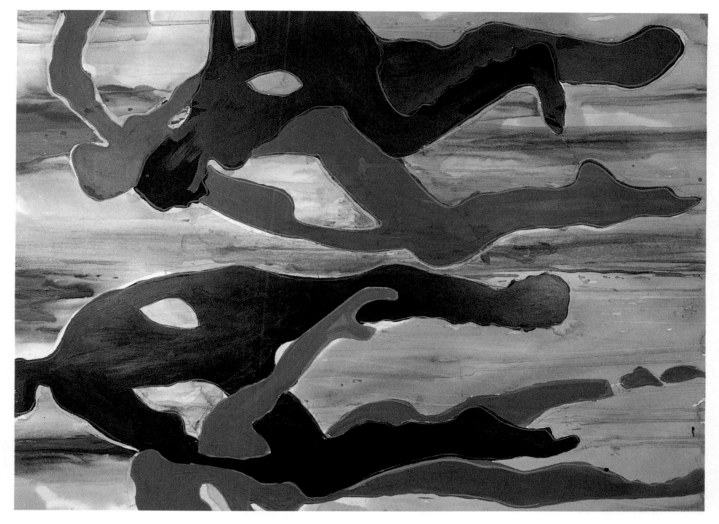

Shades of blue help give this composition its underwater feel. What other elements help suggest water and swimming? Student work by Holly Hall, Ocean Springs, Mississippi.

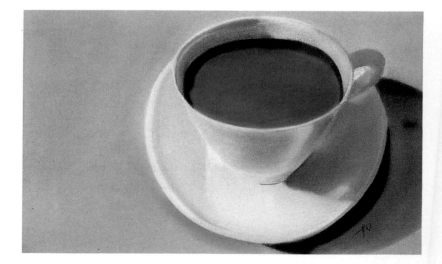

Experiment with your uses of color. Coffee doesn't have to be brown, shadows don't have to be gray. Surprising colors catch the viewer's eye. Student work by Hoang Nguyen, Bondurant, Iowa.

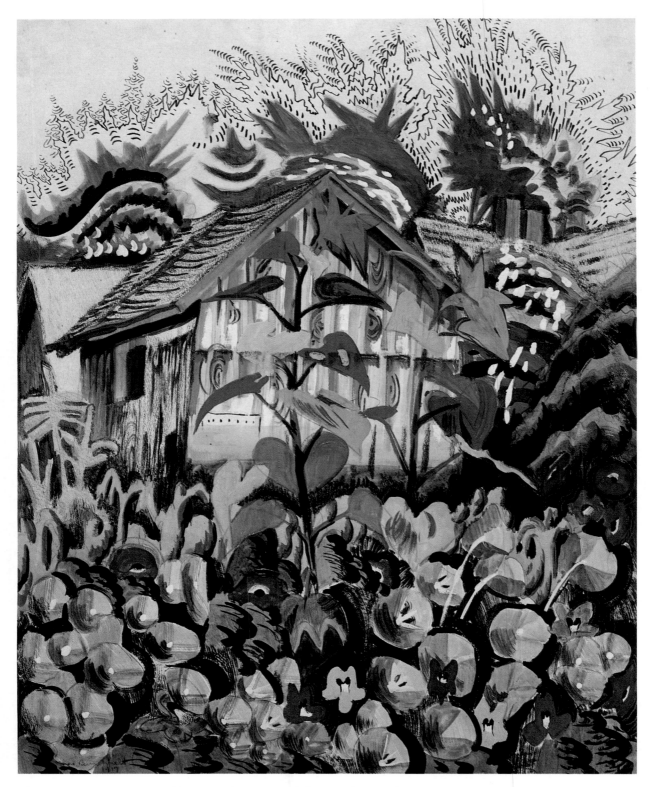

Plants seem to jump, wave and leap into the air around the quiet barn in this mixed media work. Where has the artist used line to emphasize that effect? How do you think he feels about the natural world? Charles Burchfield, *Nasturtiums and the Barn*, 1917. Watercolor, charcoal, gouache, wash, crayon, ink, pencil on paper, 22" x 18" (56 x 46 cm). McNay Art Institute, San Antonio, Texas.

Color Materials

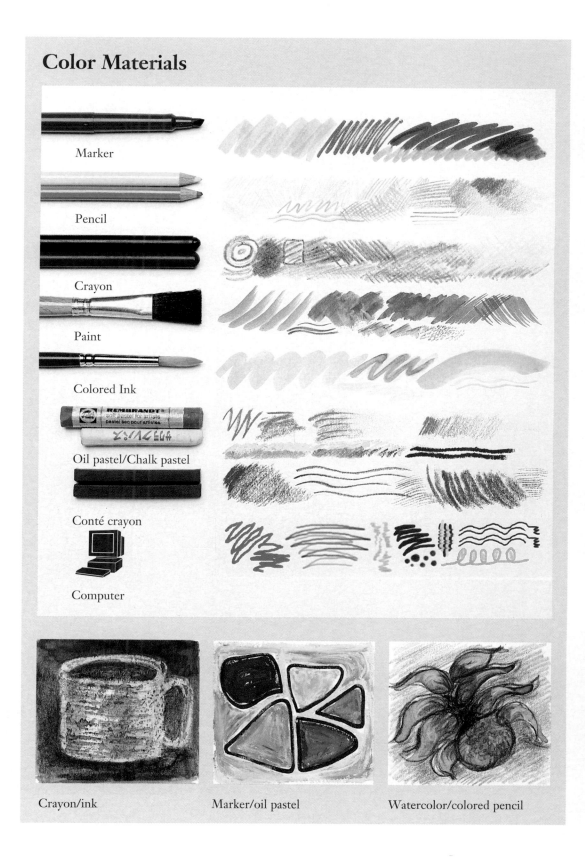

Marker

Pencil

Crayon

Paint

Colored Ink

Oil pastel/Chalk pastel

Conté crayon

Computer

Crayon/ink

Marker/oil pastel

Watercolor/colored pencil

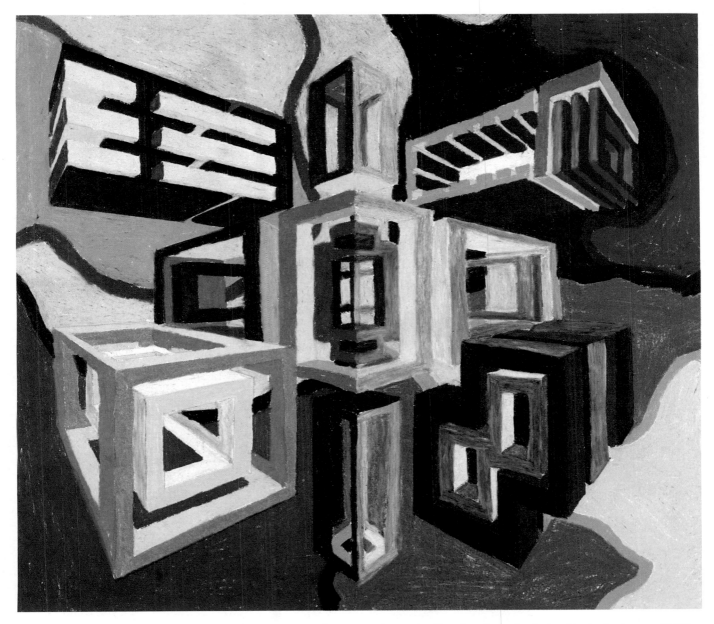

Vivid color adds a new dimension to a nonobjective two-point perspective study. How has the artist dealt with the background? What effect does this have on the foreground shapes? Student work by Eduardo Ramirez, El Paso, Texas.

Do you think the use of color enhances these portraits? Why or why not? Student work by Dianna Carlin, Bloomfield Hills, Michigan.

Cartoons are drawings, too. How do cartoonists show action and movement? How has this artist created a colorful, action-packed composition? Student work by Jarrett J. Krosoczka, Worcester, Massachusetts.

How has this artist made the fish stand out plainly from its background? How has the use of color helped him do this? Student work by Shannon Boles, Pensacola, Florida.

The color of mellow sunlight is caught here. What gives the work its unity? Student work by Kim Canette, Ocean Springs, Mississippi.

Color has always had symbolic qualities for people. We talk of having the blues, of being green with envy, of writing purple prose. A self-portrait could be your chance to use color symbolically to express the kind of person you think you are. What do you think this artist was saying about himself? Dennis Bayuzick, *Mirror, Mirror*, 1990. Oil on canvas, 18" x 24" (46 x 61 cm). Courtesy of the artist.

Would you call this work realistic or abstract? Why? Student work by Matt Levar, North Olmsted, Ohio.

The lush colors and soft textures of a garden in summer are sensitively rendered here in pastel. Student work by Mark Grimm, Lititz, Pennsylvania.

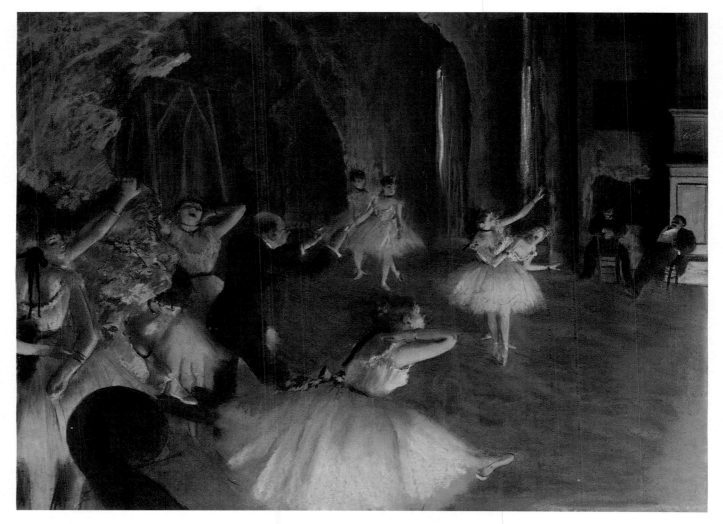

This work, shown in black and white on page 37, is a pastel drawing. How has the artist used light to create drama and interest? Where do you see the most detail? Can you tell the color of the paper the artist worked on? Hilaire Germain Edgar Degas, *The Rehearsal on the Stage*. Pastel over brush-and-ink drawing on paper, 21" x 28 1/2" (53.3 x 72.3 cm). The Metropolitan Museum of Art, Bequest of Mrs. H. O. Havemeyer, 1929. The H. O. Havemeyer Collection. (29.100.39)

Illuminated manuscripts were books of devotion that celebrated pastimes and the everyday lives of peasants. Animals were often featured in humorous scenes in the margins. *Hours of the Duchess of Burgundy*, ca. 1450 (ms. 76/1362), folio with miniature of St. Mark. Chantilly, Musée Condé. Courtesy Giraudon/Art Resource, NY.

As you gain confidence in drawing the skull, try to express your feelings about the images that its shapes and forms bring to your mind. Student work by Brent Coffman, Lexington, Tennessee.

Do you see a familiar shape here? Can you see how the artist has used it to create a repeated pattern? Does color create a mood in the work? Dana Chipman Laman, *Old Mail*. Mixed media, 28" x 39" (71 x 99 cm). Courtesy of the artist.

Notice especially the many repeated patterns in this ancient work,. Carpet page from the Book of Durrow, mid-seventh century, folio 192. Dublin, Trinity College. Courtesy Bridgeman/Art Resource.

Developing Multicultural Experiences

People in different cultures throughout the world have unique ways of expressing their values and beliefs in their artwork. Studying past and present cultures can enrich your visual vocabulary and expand your points of view.

Picasso's work is an excellent example of cross-cultural influence. Picasso used the simplified lines and forms he saw in African masks to create works such as *Mother and Child*. Picasso used African art to stimulate his growth as an artist.

The best way to approach multicultural studies is to review artwork created by different civilizations all over the world. What are the differences between art from Western civilizations and art from the Far East? How do the structures found in Egypt compare to those of the Mayans or Aztecs? What are the differences and similarities between carvings of the Northwest Coast Indians and carvings by the natives of New Guinea?

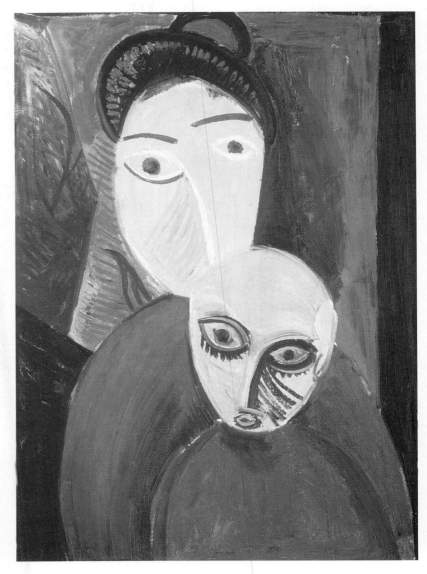

Can you see any relationships between Picasso's painting, above, and the African mask at left? Notice eyebrows, facial markings, mouths. What do you think interested Picasso about masks? Above: Pablo Picasso, *Mother and Child*, 1907. Oil on canvas. Courtesy SPADEM. Left: Mask, Gabon. Paris, Musée des Arts Africains et Oceaniens. Giraudon/Art Resource, NY.

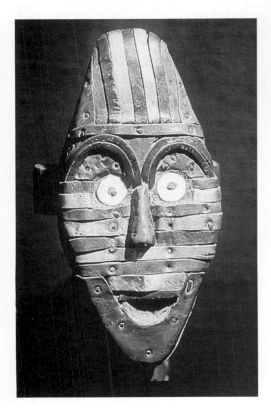

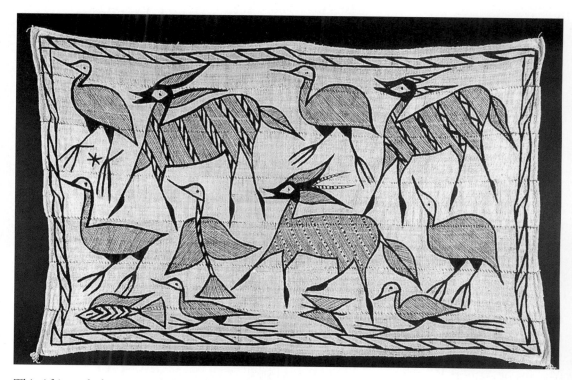

This African cloth uses simple lines and patterns to depict animals and birds. How is movement suggested? French West Africa, painting. Mud on cloth, 20th century. Courtesy Karen Durlach.

THINK ABOUT IT
Transferring knowledge from one area to another is the real test of true learning!

This exercise gives you an opportunity to explore new approaches to making marks.

1. Select images, symbols or lettering from a culture that interests you.

2. Draw the ones you select on a sheet of poster board. Then, cut them out and glue them to a sheet of illustration board.

3. Lay a sheet of durable lightweight paper on top of the image. Then, create a rubbing by drawing layers of lines over the image.

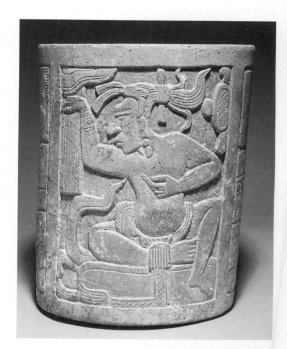

Exaggeration and simplification give this carved vase great presence. Do you think the carving tells a story? Mayan carved vase, late Classic period, ca. 550–950 AD. Private collection. Art Resource, NY.

What ceremonies have you been part of? What objects or clothing do you use in those ceremonies? Ceremonial Board, New Guinea, Middle Sepik River, Sawos. Wood, 74 1/4" (189 cm) high. The Metropolitan Museum of Art, The Michael C. Rockefeller Memorial Collection, Gift of Nelson A. Rockefeller, 1969.

Many cultures use images from nature to express ideas. What might nature have meant to this artist? Head plaque with frog totems, Northwest Coast of America, Tsimshian, Skeena River. Wood, abalone shell. Museum of Man, Ottawa. Courtesy Werner Forman Archive. Art Resource, NY.

Egyptian art often includes gods shown as animals (notice the bird's head at extreme right). Can you imagine the story this wall relief tells? *Temple of Suchos and Haroeris. Horus consigning to Pharaoh Energetos II his sword, behind the Pharaoh his sister and wife Cleopatra.* Kom Ombo, Egypt. Foto/Marburg/Art Resource, NY.

Rubbings

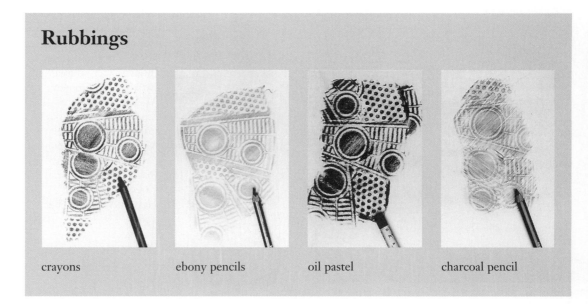

crayons ebony pencils oil pastel charcoal pencil

Even a simple rubbing can have visual mystery.

This artist used crayon, salt and watercolor with torn paper to suggest Native American rock art. What symbols has she chosen to use? What might the torn paper mean? Student work by Nikki Kelsey, Temple, Texas.

Rubbing techniques and drawn in lines were used to create this energetic composition. Can you see influences from other cultures here? Student work by Ha Young Lee, São Paulo, Brazil.

Spontaneity through Graffiti

Graffiti drawing offers you a creative outlet for free and spontaneous drawing. What do you think of when you hear the word graffiti? Did you know that graffiti can be found in galleries and museums and not just on public buildings? Graffiti drawing is loose and unstructured. It is energetic and can be visually powerful.

Explore using different types of media to create your own graffiti drawing. What feelings do you want it to express?

1. Lay in large areas of spontaneous marks, movements, symbols, images and lettering.

2. Gradually build up these marks in layers, emphasizing dominant shapes.

3. Use a variety of edges on the shapes.

4. Develop and vary the qualities expressed by the lines.

5. Work to develop a wide range of surfaces.

6. Include a broad range of values. Make one color dominant.

THINK ABOUT IT
Did you find that you came up with new ideas as you were drawing? Often, the best ideas come during the process of drawing.

Layers of active lines and shapes give this graffiti drawing great energy—and echo the movement and visual chaos of many large cities. Los Four (Carlos David Almaraz, Gilbert Lujan, Roberto de la Rocha, Frank Romero), *Group Mural*, 1973. Acrylic spray paint on canvas, 9' x 22' (3 x 7.1 m). Los Angeles County Museum of Art, lent by the artists.

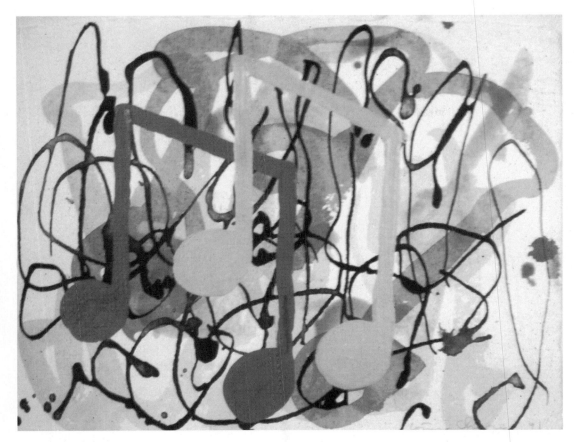

Try to imagine the music this artist might have been listening to as she created this work. What mood has the artist created? Louisa Chase, *Untitled*, 1991. Ink and acrylic on paper, 10" x 13" (25.4 x 33 cm). Courtesy of the artist.

Have you ever been tempted to write in your school books? Think about why or why not. Then take a look at this work, done by students from The Bronx (See also page 176). Tim Rollins + K. O. S., *Study for Amerika X*, 1988. Watercolor and bistre on book pages on linen, 24" x 42" (61 x 107 cm). Courtesy Art and Knowledge Workshop. Photograph: Ken Schles.

Tim Rollins + K. O. S.

In 1981, a young artist named Tim Rollins began to teach art at one of the special education schools in the South Bronx of New York. Rollins often read literary classics to his students. One day Rollins noticed a student was drawing right on the pages of his book. Angry at first, Rollins became astonished as he looked closely at the image the student had drawn. The student had captured the essence of the novel in his drawing. This incident lead to the creation of a new kind of teaching. Rollins called it K. O. S. (Kids of Survival) and the Art and Knowledge Workshop.

What Tim Rollins and his students are creating does not fit into any familiar art category. It is a unique type of collaboration between an artist–teacher and students–artists. The role of the teacher is to select a piece of literature that students will transform into images. K. O. S. students read the text aloud and then work together to decide how to represent it visually. They draw their images on the pages of the text. Then, using a slow process of selection, they select images to place on a piece of canvas as the finished work.

The *Amerika* series was inspired by a famous scene from a novel by Franz Kafka. Students were told to use their imagination. The variety of images that emerged was stupendous. Students represented themselves as golden trumpets, and included letters, body parts, animals and baseball bats in the final panel.

Tim Rollins + K. O. S., *Amerika—For the People of Bathgate*, 1988. Mural, 55' x 36' (18 x 12 m), Central Elementary School 4, Bronx, New York. Executed by Jerry Johnson. Photograph © Peter Bellamy, 1988.

The art produced by K. O. S. has universal appeal. Paintings from the Art and Knowledge Workshop have been exhibited all over the world. The thought-provoking methods used by Tim Rollins have resulted in artwork that is stylistically unique. Through the creation of this art, students from the South Bronx have learned about the world beyond their boundaries and have taught the world about the South Bronx.

Fusion of Drawing and Painting

Have you ever found that you can apply skills that you have learned in one subject area to another? The skills and techniques you have learned in drawing can be applied to paintings. The fusion of drawing and painting can help you plan a composition.

In this exercise, you will be *drawing in* a chair set up at an interesting angle and *painting out* the ground.

1. Prime a sheet of illustration board with a light gray or off-colored pastel.

2. Using graphite pencils and sticks, sketch the chair and the shadows by drawing through the object to find the correct proportions.

3. Layer the lines to explore positive and negative space. Draw the lines in directions that "carve out" the space in the still life.

4. Paint out unnecessary lines and clean up the ground. This layer of paint will clarify the image and give it more life. Using a rag to partially remove some areas of paint will add motion and expression to the chair.

5. To give added strength to the composition, try painting in highlights found in the ground or the chair.

6. Draw in extreme darks and add fine line highlights with white chalk.

Active lines throughout this composition seem to lift the chair off the ground. What other techniques has the artist used to give the chair life and presence? Author, *Chair*, 1993.

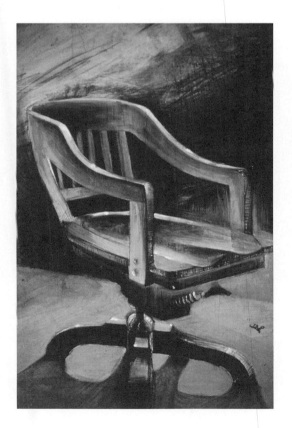

Can you give a chair personality? Mystery? Humor? Do you have a favorite chair? Try drawing it for this exercise. Student work by John Chapman, Weatherford, Texas.

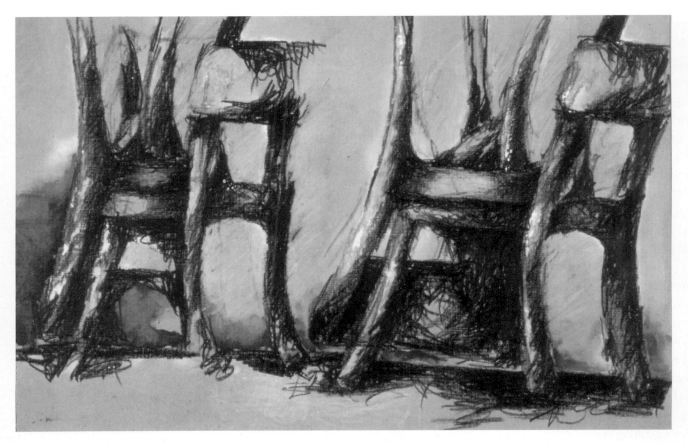

Using many kinds of line, deep shadows and an interesting color of paper can help enliven any composition. And when you really examine them, you may find that chairs aren't as ordinary as you'd thought. Student work by Minn Lee, Charlotte, North Carolina.

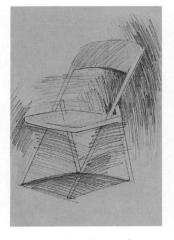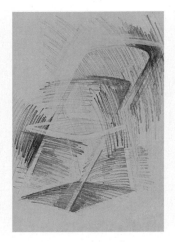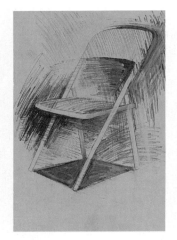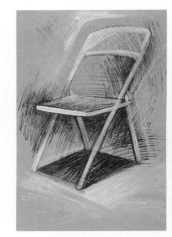

Sketching the planes of space in the chair.

Redefining the chair by painting out unwanted areas.

Sharpening up the chair by adding accent lines.

Laying in the highlights.

Papers

Almost any kind of paper can be used for drawing. The least expensive papers are made from wood pulp and produced by machine or molds. High-quality papers are made with a great deal of care and have a high-rag content, which makes them expensive. High-quality papers are easily identified by a watermark or relief stamp of the manufacturer's name. Paper surfaces range from smooth to very coarse with many gradations in between. Smooth paper, also called hot-press or plate-finish, is especially good for pen and pencil drawings. Fine- or medium-grained papers (cold-press or kid-finish) are suitable for graphite pencils or sticks, wax or colored pencils, pastels, colored chalks and wash. The coarsest-grained paper is usually used for watercolor.

While inexpensive papers are excellent for experimenting with media and techniques, they become brittle and yellow with age. High-quality papers are best for works to be included in a portfolio or those expected to last for a long time. Because of their rag content, high-quality papers will not become brittle or yellow with age. They are exciting to use because their surfaces have great tactile appeal.

Materials Used
(left to right)
1. Drawing ink applied with bamboo brush
2. Conté crayon
3. China pencil
4. Graphite pencil, unwrapped
5. Technical-drawing pen

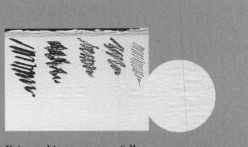

Printmaking paper, 118 lb.

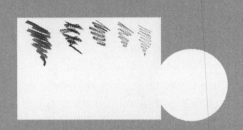

Hot-press illustration board, #172

Cold-press illustration board, #80

Bristol board, 100 lb., kid-finish

Bristol paper, 1 ply, plate-finish

Using Photocopied Images

Photocopiers can help artists visualize information in different ways. For example, photocopied images can translate photographs or drawings into simplified shapes. Contrasts in values can be seen more clearly. Images produced by a photocopier can show exciting dot patterns. What are some ways that artists can use this visual information?

Chuck Close has successfully used various forms of technology to enhance his approaches to art. Close's portraits are actually paintings of photographs of people. Photographic techniques have allowed him to develop ultra-realistic images. He has even explored using his fingerprints and a stamp pad to create his portraits.

Try this exercise to explore how you can use photocopied images in your own drawing.

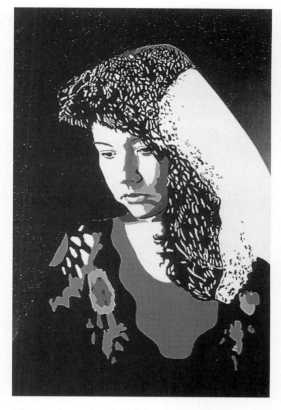

This work was inspired by an image that was photocopied many times to remove some middle values. Student work by Alicia Santana, Queens, New York.

1. Select a photograph or one of your own drawings.

2. Photocopy the image several times, changing the scale on each copy.

3. Plan a composition and environment that can include the photocopied images.

4. Glue some of the images onto the composition. Draw some of the other images, trying to make them look as close to the photocopied image as possible.

5. Complete the drawing so that the photocopied images cannot be distinguished from the drawn images.

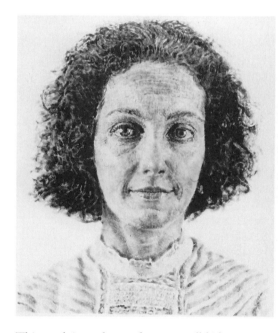

This work is made up of many small kidney shapes stamped or pressed onto a surface. What overall effect has the artist created here? Would you like to have your own portrait done this way? Chuck Close, *Emily*, 1986. Oil-based ink on mylar, 47" x 38 1/4" (119 x 97 cm). Courtesy The Pace Gallery.

Using Computer-generated Images

Computers are used in countless ways in almost every area of our society, including art. A computer can be a powerful tool for an artist. The computer in art can function as a designing tool and as a drawing instrument. The artist can alter forms by distorting, enlarging, compressing or cropping the image using lines, dots and value shapes. Images can be easily manipulated to be larger, upside down or placed to the left or right, allowing the artist to fully explore compositional possibilities.

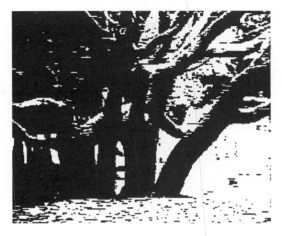

A computer image was used as the basis for this ink drawing of oak trees. Why might the artist have wanted to digitize natural forms? Student work by Holly Hall, Ocean Springs, Mississippi.

Computers allow you to combine images and create effects that might be difficult, time-consuming or impossible using conventional means. And they offer *millions* of available colors. Joan Truckenbrod, *Take Control*, 1991. Cibachrome print, 25" x 30" (64 x 76 cm). Courtesy The Williams Gallery, Princeton, New Jersey.

This digitized image was used as the basis for the final work, below.

Holly Hall's work shows some of the ways a computer can be used to create artwork. Here is how Holly produced a digital painted image:

1. The image of David was digitized with a video camera and DCTV Software and saved to a floppy disk.

2. The image of eyes was also digitized and saved to a floppy disk.

3. The image of David was loaded in DCTV paint mode to a blank page screen.

4. The image of eyes was loaded to a spare page.

5. A rub-through tool was used to rub

A digitized image of Michelangelo's *David* was inserted into the original image. The artist used a rub-through tool on the paint software to create mottled areas of color and to expose parts of the *David* image. This produced a kind of computer collage. Student work by Holly Hall, Ocean Springs, Mississippi.

Sharp edges and airbrush-like effects are possible with computers. This work combines hard and soft edges smoothly, creating a scene that looks somehow more real than reality. Wynne Ragland, *#84*, 1992. Topas software on an IBM PC 486, 32" x 47" (81 x 119 cm). Courtesy The Williams Gallery, Princeton, New Jersey.

This artist uses computer line as he might use a pencil or magic marker—a hard line separates the figure from its background. The artist has created his own software and a "drawing machine." Harold Cohen, *Aaron with Decorative Panel*, 1992. Computer generated drawing, 72" x 54" (183 x 137 cm). Courtesy The Williams Gallery, Princeton, New Jersey.

the image of David from the blank page to the spare page, so that both images showed through the monitor screen.

6. The final image was printed on a color printer.

THINK ABOUT IT
Computer-generated images force you to think in new ways. It is difficult not to ask how the image was made, altered or enhanced. What did you think when you saw the illustrations?

Have you ever made paper sculpture? Origami?
Try drawing a three-dimensional form on the
computer. How will you make areas close to you
come forward, and those farther away recede?
How will you create sharp edges, shadows and
form? This computer work is a stereopair: viewed
through a stereoscope, the image appears three-
dimensional. Steward Dickson, *Enneper's Surface*,
1992. Courtesy The Williams Gallery, Princeton,
New Jersey.

Would you have guessed that this work was made
on a computer? Probably not—many of this
artist's works are handcolored with pastel or
watercolor, and so appear very like paintings.
Barbara Nessim, *Blind Companions*, 1992.
Courtesy The Williams Gallery, Princeton, New
Jersey.

Using Metaphors

One way to describe something is to compare it to something else. What do you picture when you hear the expression, "A mighty fortress is our God"? Comparisons like metaphors and similes help us see something vividly and often in a new way. They surprise us and make an immediate impression. A metaphor states that one thing is another. A simile describes one thing as being like another.

Comparisons are like small puzzles that allow us to say a lot in just a few words. "Wet almond-trees, in the rain,/Like iron sticking grimly out of earth." Can you picture the landscape that D. H. Lawrence created with this simile?

Boots seem to be more than simply footwear here—what metaphor do you think the artist is suggesting? Or is he just exploring shapes in space? Student work by Boris Zakic, Yugoslavia.

Is there meaning in scissors and forks flying through the air? Where are they going? What will it look like when they land? Student work by Lissa di Pretorio, Lincoln, Nebraska.

Can a bird be a metaphor for life? Read the poem below. How does the poet use comparisons to paint a picture with words?

DREAMS

Hold fast to dreams
For if dreams die
Life is a broken-winged bird
That cannot fly.

Hold fast to dreams
For when dreams go
Life is a barren field
Frozen with snow.

*Langston Hughes**

Like writers, artists use metaphors to create images. What metaphor did Linda Murray use in her painting *The Urban Forest Lines?* (See page 188.)

*From *The Dream Keeper and Other Poems,* by Langston Hughes. Copyright 1932 by Alfred A. Knopf, Inc. and renewed 1960 by Langston Hughes. Reprinted by permission of the publisher.

Perhaps you can think of a metaphor for yourself or your personality. Are you a sheep, a cloud, a river? Are your thoughts caged and restless, like these birds? Do you have someone living in your head? Rafal Olbinski, *Memoirs from Easthampton*, 1993. Pencil, 18" x 24" (46 x 61 cm). Courtesy of the artist.

Is there someone you know who seems to be good at things that you aren't, and thinks you're good at things that he or she isn't? How might you express that in a drawing? This artist hints at such an idea in a strange but compelling work. Maurits Cornelius Escher, *Bond of Union*, 1956. Lithograph. Art Resource, NY.

This artist often thinks of city life in terms of shopping carts. Why do you think she thinks that way? What is it about shopping carts that interests her, visually or otherwise? When you think of cities and the lives inside them, what do you think of? Linda Murray, *The Urban Forest Lines*, 1992. Acrylic on canvas, 40" x 48 1/2" (102 x 123 cm). Courtesy of the artist.

Can you see how thinking in terms of metaphors can stimulate your creativity? Metaphors can help you describe and analyze a drawing. Metaphors can also be used as the foundation of a drawing. Suppose you want to express your feelings about someone or something in a drawing. How can thinking of a metaphor for your subject help you be more expressive in your drawing?

Do you ever think abstractly—that is, do shapes and colors come to your mind that don't look like anything around you? Try putting them down on paper. They can become a kind of image diary for you to draw from. Student work by Ben MacNeill, Raleigh, North Carolina.

Summary

How do these lines "feel"? Why? What do you think the artist is trying to suggest? Roman Verostko, *Diamond Lake Apocalypse*, 1992. Ink plotter on archival paper, 22" x 24" (56 x 61 cm). Courtesy The Williams Gallery, Princeton, New Jersey.

This chapter has given you the opportunity to explore some unconventional drawing techniques to help you think more creatively. The more willing you are to take new directions in art, the more you will grow as an artist. Artists, like any other professionals, must continually break new ground in communicating and expressing their feelings. Drawing is a vehicle for self-expression, which is a truly rewarding and fulfilling experience. Understanding how drawing can help you express yourself is a very important concept to learn.

Imagine famous faces digitized: Mona Lisa, Abe Lincoln, John F. Kennedy, Henry VIII. What effect does digitizing have on a face? Look at this image closely. How close can you get before it stops being recognizable? David Udovic, *Einstein*, 1985. Ciba-painting, 8" x 7 1/2" (20 x 19 cm). Courtesy The Williams Gallery, Princeton, New Jersey.

Activities

Loosening Up
Choose one of the following topics:
- turning into an insect
- withering or shrinking
- turning into a monster
- seeing an object coming alive

Begin drawing. At five-minute intervals, exchange papers with a classmate. Continue the drawing of your classmate.

Complex Geometric Forms with Cutouts
Create a simple two-point perspective drawing of a box. When you are comfortable with two-point perspective, draw several more modules, interconnecting them in an architectural design. Within each module, create a negative space by drawing a partial cutout. When you have drawn your three-dimensional construction, complete the composition by using shading and color.

Multiculturalism and Style
Does culture affect style? Choose a culture you would like to research. Is there a particular type of art that is produced by members of that culture? Compare the artwork of two or more artists from that culture. Do the artists have similar styles? What are the characteristics and differences in their styles? Write a short essay, identifying the culture and how it might be reflected in the work of the artists.

Scale Change
Look at the art of Escher, Magritte and the Surrealists. Notice how Magritte particularly changed the scale of objects. Then create a drawing in which the scale of objects is changed. To get a feel for this, put human-sized objects in a dollhouse.

Student work by Danny Nguyen.

Drawing with Mixed Media
Select a multicultural theme for a drawing. Then use at least two mixed media techniques. Explore mixing wet and dry materials together. Take advantage of the possibilities that each medium offers.

Danny Nguyen wanted to combine themes of his native home of Korea, his dream to be an architect and his new permanent home in America. He chose an abstract style to tie these three areas together. He began with colored pencils, then added watercolor washes, weaving the media back and forth.

Drawing to Make a Statement
Think of a current topic or issue in the news. Where do you stand on the issue? How can you use art to express your opinion or feelings? Explore your personal response to the issue by completing a drawing. Include a figure in your drawing.

When commercial airlines decided to ban smoking, Curtis Fesser developed a creative figure drawing to show how a smoker might feel about the ban. He used ebony pencil on drawing paper.

Student work by Curtis Fesser.

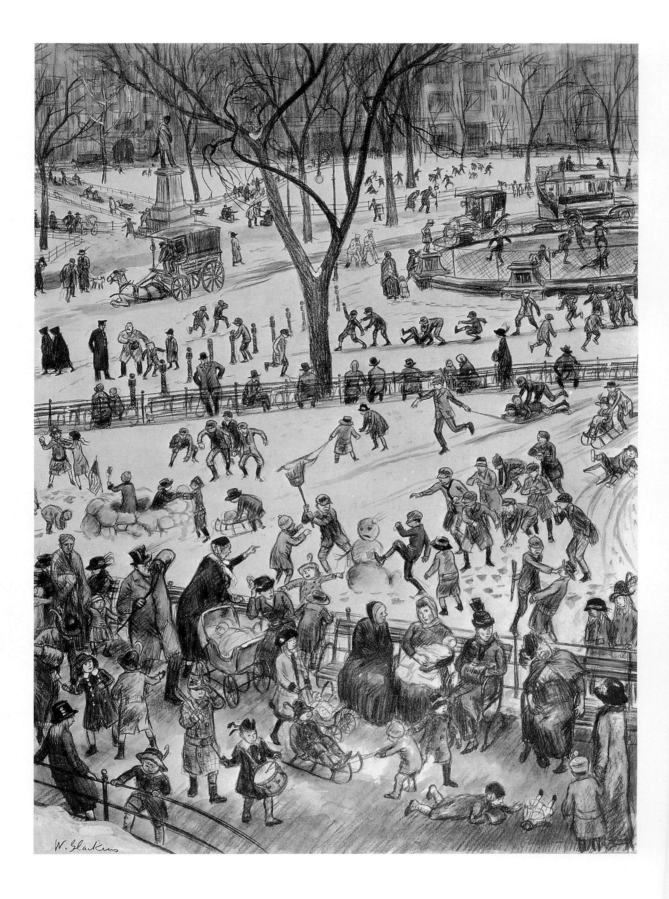

Part 3
Past and Present

William Glackens, *Washington Square*, 1913. Pencil and wash touched with white over blue crayon outlines, 24 5/8" x 18 1/4" (63 x 46 cm). Collection, The Museum of Modern Art, New York (Gift of Mrs. John D. Rockefeller, Jr.).

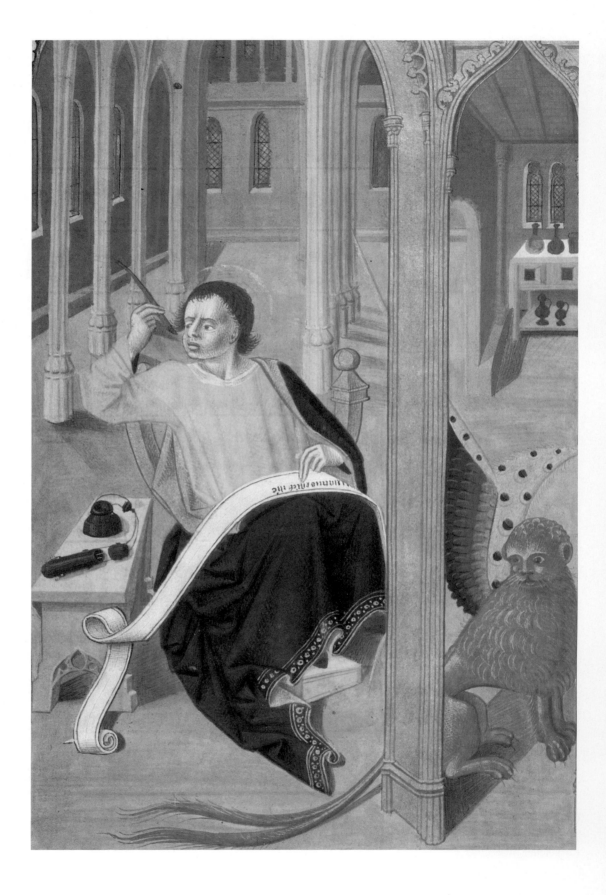

7 The Past

Art is a record of human existence. Art tells a story of the progress of humanity and culture. As a culture or a nation changes, so too does its art. It is important to understand how world events, cultural values and technology have shaped the history of art.

Art history is a vital part of objective art criticism. To truly understand a work of art, you need an understanding of the period and place in which it was produced.

There are many advantages to studying art history. Discovering the value of art history is to discover what other artists themselves have discovered and to experience what they experienced. Art is a place where minds shake hands.

Key Chapter Points

- Drawing has evolved over the centuries.
- Roman, Greek and Egyptian art have influenced European and American art.
- Egyptian drawings were flat. Figures were drawn according to a strict formula.
- Greek art was expressive. Figures were drawn with accurate proportions and idealized form.

- Asian art emphasizes nature in simple yet sensitive works.
- Renaissance artists developed linear perspective and dramatic lighting.
- Impressionism enphasized the effects of light on color.
- Abstract art uses simplified shapes and geometric forms to represent figures and objects. It is often non-objective.

Hours of the Duchess of Burgundy (detail), ca. 1450 (ms. 76/1362), folio with miniature of St. Mark. Musée Conde, Chantilly, France. Giraudon/Art Resource, NY.

Cave Drawings

The story of drawing begins deep within the Altimira caves not far from Santilla, Spain. Why does it begin here? Because scholars believe that the prehistoric cave drawings found on the walls of these caves are the first important works of art. The drawings of animals found here are skillfully executed pictures of bison, deer, boar and other animals. The pictures were probably a part of some magical ceremony. The ceilings of some of the caves are so low that viewers must wriggle on their stomachs in order to reach the drawings.

The works are marvelously executed and preserved. The drawings, deep within the cave, have been protected from rain, wind and other elements that would have eroded them. The works of art are believed to have been done between the years of 15,000 to 10,000 BC. However, it is amazing to note that the skill behind these works often surpasses the quality of drawings done thousands of years later. The origin of these drawings still remains a mystery.

THINK ABOUT IT
Like many kinds of art, cave paintings can be examined for their meaning and artistic quality, as well as for what they tell us about the people who drew them.

Speaking of Art ...

Although no one really knows why these earliest drawings were made, Joseph Campbell suggests that they may have been used in initiation rites of young hunters. Some of the drawings have pits in them from being struck with spears.

Room of the Bisons. Tate Gallery, London/Art Resource, NY.

Egyptian Art

The drawings of the Egyptian empire were a part of a mystical religion. The artwork found within the walls of the great pyramids of Egypt was of great religious importance. The Egyptians believed that after death the body of a pharaoh lived within the walls of his tomb or pyramid. Tombs were often robbed and the bodies damaged or destroyed. To make sure that the soul of the deceased had a body to live in, artists painted human figures. The artwork could then become the dwelling place of the spirit or soul of the pharaoh.

Because the images in the drawings served a purpose in maintaining the eternal happiness of the soul of the deceased, they were drawn according to a strict formula. Any departure from the formula could have harmed the soul. The more important figures were larger. Artists drew figures in profile but with the eyes facing front. Artists did not express personal ideas in their drawings. There is little suggestion of depth in the drawings. Nor did Egyptian artists use shading. Their drawings were arranged in panels, as present-day comic books are arranged.

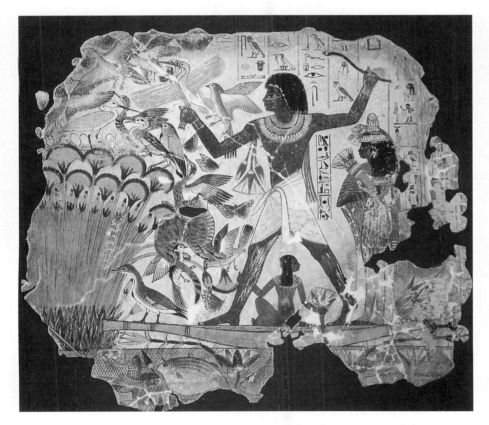

Fowling the Marshes, wall painting, ca. 1400 BC. Reproduced by Courtesy of the Trustees of the British Museum.

Greek and Roman Art

The art of ancient Greece was utilitarian, but it was also done to replicate beauty and idealized form. The Greek period from about 480 to 323 BC was known as the Classical Period. The art of this period is noted for its beauty, order, symmetry and balance. Greek figurative drawings and sculptures in this period are noted for their accurate proportions, movements and posture. Drawing was expressive and reflected the artist's personal interpretation. The Greeks decorated their pottery with geometric designs and accurate depiction of human figures. Greek depiction and draftsmanship were unrivaled by any previous civilization.

The Romans, who were more concerned about commerce and engineering, made few progressive contributions to art. Roman artworks were often copies of Greek art. Roman artists, like the Greeks, never discovered the value of linear perspective. Therefore, many of their drawings appear flat and lack a sense of depth or space. Roman painters relied upon aerial perspective and architectural structures to suggest depth in their drawings.

Arch angel. Greek. Reproduced by Courtesy of the Trustees of the British Museum.

Lady playing the cithara, wall painting, Roman, 100 BC. Courtesy The Metropolitan Museum of Art, Rogers Fund, 1903.

Asian Art

China is thought by many to be the oldest surviving civilization in the world. Its artwork has influenced the art of many other cultures, including Japan, Korea, India and Southeast Asia.

Early Chinese art centered on animals and people in everyday life. Later, its art reflected the spiritual ideas of Buddhism: people became small compared to their natural environment, and more connected to the past and their ancestors.

The rabbit shown here is part of a hanging scroll, painted in ink on silk during the Sung dynasty, sometime after 960 AD. Art was valued at this time in China: people in cities were becoming more wealthy, and they had begun collecting art of the past and present. Notice the contrast of soft and hard edges in the scroll, and the sensitive portrayal of the rabbit. What does it tell you about the artist's feeling about nature?

Japanese art is generally subtle, but simple in form and design, and often concerned with nature. During some periods in history, Japan was isolated from other cultures; at other times China, Korea and Europe provided artistic and cultural

Hanging scroll, Sung. Ink and color on silk. National Palace Museum, Taiwan, Republic of China.

influences. The animal caricatures seen below—like the rabbit, part of a scroll—were drawn in ink and were meant to be humorous. They form a kind of Japanese comic strip: their use of satire and cartoon-like style predates Western cartoons and comics by six hundred years! You'll notice that the lines that form benches and tables here go back in space, but do not move any closer together, as they would using one-point perspective.

Animal caricatures, detail of a horizontal scroll attributed to Toba Sojo. Later Heian period, ca. late 12th century. Ink on paper, approximately 12" (30 cm) high. Kozan-ji.

Renaissance Art

Little happened to enliven the progression of art from the Greek period until the Italian Renaissance. People in the medieval period were more concerned with labor and preparing themselves for the afterlife than with making progress in the world in which they lived. The art of the medieval period that preceded the Renaissance was characteristically iconographic and flat. The figures found in medieval paintings appear molded from a cookie cutter. With the spread of Christianity, artists focused on God, not humans and the natural world. They did not depict the human form realistically.

Leonardo da Vinci, *Caricature grottesche*. Windsor Castle, Windsor, Great Britain. Art Resource, NY.

Jean Pucelle, *Breviaro di Belleville*. Bibliotheque Nationale, Paris, France. Courtesy Scala/Art Resource, NY.

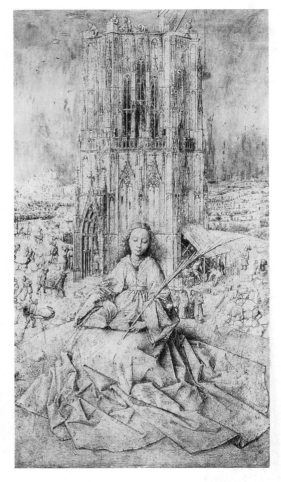

Jan van Eyck, *St. Borboini*. Courtesy
Girdaudon/Art Resource, NY.

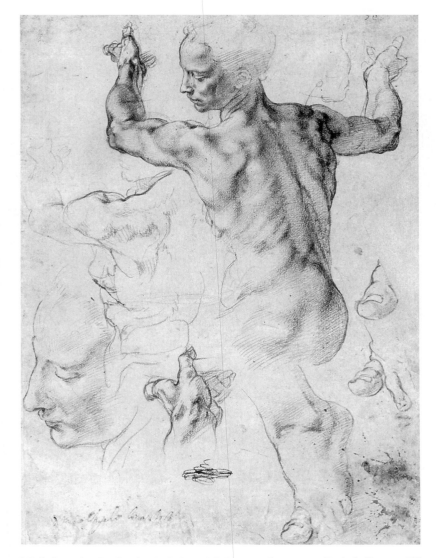

Michelangelo, *Studies for the Libyan Sibyl*, 15–16th century. Red chalk, 11 3/8"
x 8 3/8" (28.9 x 21.3 cm). Courtesy The Metropolitan Museum of Art,
Purchase, 1924, Joseph Pulitzer Bequest. (24.197.2)

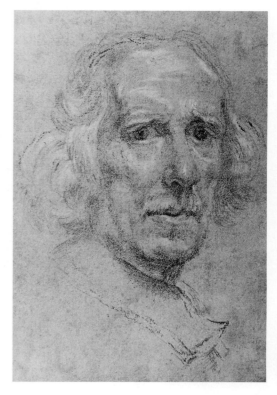

Gian Lorenzo Bernini, *Self-Portrait*, 1665.
Windsor Castle, Windsor, Great Britain. Art
Resource, NY.

Albrecht Durer, *The piece of turf*, 1503. Watercolor and gouache on paper, 16"
x 12" (41 x 31.5 cm). Vienna, Albertina.

Beginning in the ninth century, how-
ever, artistic monks in northern Europe
developed the art of drawing illuminated
manuscripts. They depicted realistic
human forms and used line and shape to
create intricate graphic decorations.

The Renaissance began in Italy during
the fifteenth century. Artists began to
study Classical themes of the Greeks for
inspiration. In addition, they also studied
anatomy. These studies paid off in the
accuracy of their figure drawings.
Renaissance artists developed pictorial
skills in perspective.

Leonardo da Vinci is noted for study-
ing science and anatomy. Leonardo want-
ed to scientifically study every facet of a
subject before he attempted to draw it,
which limited his output of artwork.
However, he did systematically discover
many aspects of linear perspective. He
kept detailed sketchbooks and notebooks
that include reminders of subjects that
interested him.

Michelangelo (see page 201) was the most productive artist of the Renaissance era. He painted the ceiling of the Sistine Chapel. His drawings contain a freshness that had never been seen in the history of art. His figurative drawings and paintings have a sense of depth and perspective. He was one of the first artists to effectively use a series of lights and darks to create realistic depth and form. The figures are twisted and foreshortened at interesting angles that make them appear lifelike. He always worked from detailed drawings and sketches, which he often burned to keep his technique a secret.

Antoine Watteau, *Study of a Tree in a Landscape*. Red chalk, 17 1/4" x 12 1/4" (43.8 x 31.1 cm). Courtesy Norton Simon, Inc. Museum of Art.

Raphael, *Coronation of St. Nicholas*. Charcoal with white highlights. Musée des Beaux-Arts, Lille, France. Giraudon/Art Resource, NY.

Nineteenth Century Art

The art of the nineteenth century developed in several important movements. The movement of Realism and its concern with realistic draftsmanship gave way to the Impressionist movement and its fascination with color and light. The work of Manet served as a bridge between the art of the Realists and the Impressionists. His style and concerns were somewhere in between the artists of the previous centuries and what was about to take place in Impressionism.

The best-known Impressionist work was painted by Claude Monet. Monet worked outside. His primary interest was in the shift of light and color upon natural surfaces. He painted many subjects several times under different lighting conditions.

Edouard Manet, *Gare Saint-Lazare*, 1873. Oil on canvas, 36 3/4" x 45 1/8" (93.3 x 114.6 cm). Courtesy National Gallery of Art. Gift of Horace Havemeyer in memory of his mother Louisine W. Havemeyer.

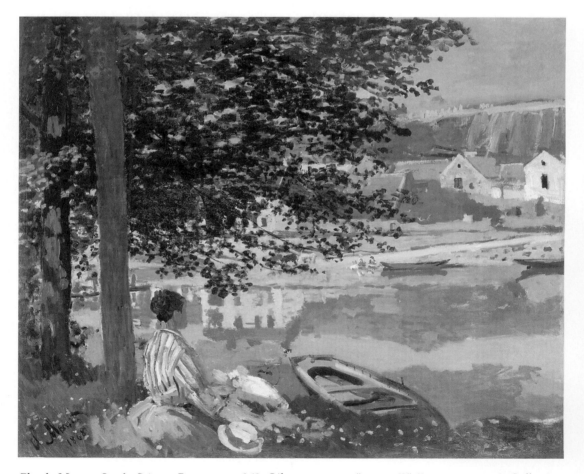

Claude Monet, *On the Seine at Bennecourt*, 1868. Oil on canvas, 32" x 39 5/8" (81.5 x 100.7 cm). Collection of Mr. and Mrs. Potter Palmer, 1922.427. Photograph ©1993, The Art Institute of Chicago, All Rights Reserved.

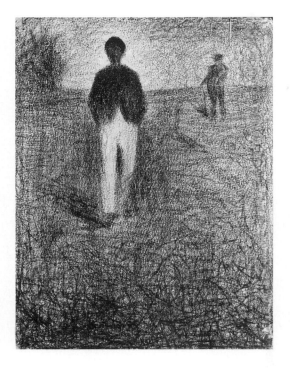

Georges Seurat, *Two Men Walking in a Field*, ca. 1882–84. Conté crayon on laid paper, 12 1/2" x 9 1/2" (31.8 x 24.3 cm). Courtesy The Baltimore Museum of Art. The Cone Collection, formed by Dr. Claribel Cone and Miss Etta Cone of Baltimore, Maryland.

Impressionism opened the doors for exploration of new subject matter in art. The century closed with the innovative work of one of the greatest artists ever to live, Vincent van Gogh (see page 206). His work was more about the overall impression of nature and how nature affects the body and soul. Van Gogh's work contains the Impressionist concern for color along with a new concern for the transcendent energy that nature emits to the soul. To experience a van Gogh painting is to get swept away in a vast current fueled by the energy of nature itself. His colors are exaggerated, and his figures contain a lifelike motion.

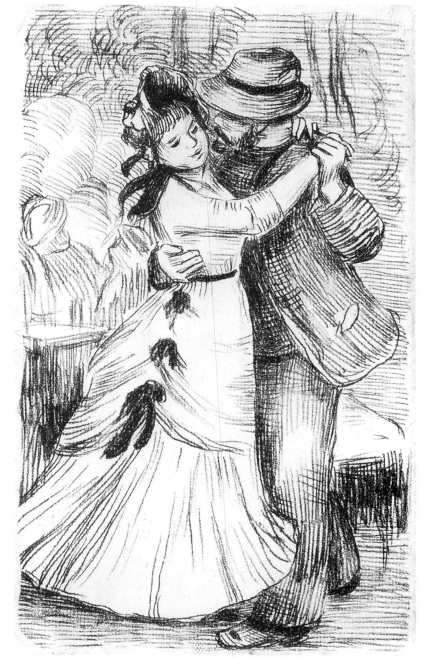

Pierre Auguste Renoir, *Dance in the Country*, 1890. Soft ground etching. Art Resource, NY.

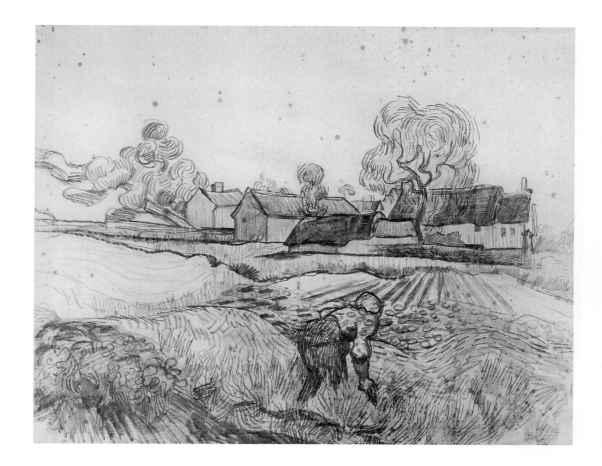

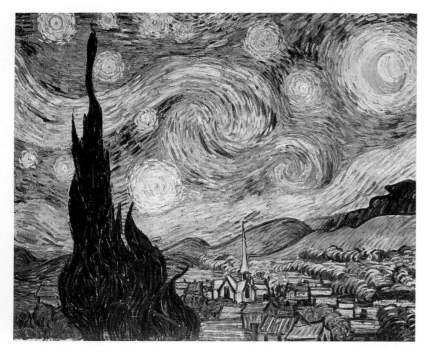

Vincent van Gogh, *Father Eloi's Farm*. Musée
d'Orsay, Paris, France. Giraudon/Art Resource.

Vincent van Gogh, *The Starry Night*, 1889. Oil on
canvas, 29" x 36 1/4" (73.7 x 92.1 cm). The
Museum of Modern Art, NY. Acquired through
the Lillie P. Bliss Bequest.

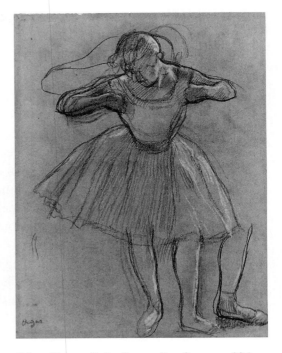

Edgar Degas, *Ballet Dancer Standing*, ca. 1886–90.
Black crayon heightened with white and pink
chalk on gray-brown wove paper, 11 15/16" x
9 1/2" (30.4 x 24. cm). Courtesy The Baltimore
Museum of Art. The Cone Collection, formed by
Dr. Claribel Cone and Miss Etta Cone of
Baltimore, Maryland.

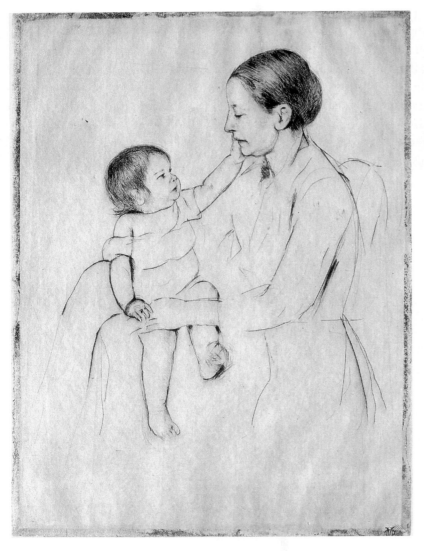

Mary Cassatt, *The Caress*, 1891. Dry-point. Courtesy The Metropolitan
Museum of Art, Gift of Arthur Sachs, 1916.

The Early Twentieth Century

The increasingly abstracted work of artists like van Gogh opened up new possibilities for the artists of the early twentieth century. The Spanish artist Pablo Picasso was perhaps the first artist to explore the idea that the canvas was a two-dimensional illusion depicting a three-dimensional reality. Subsequently, Picasso pioneered an approach to painting known as Cubism. His early work consisted of flat planes that at best slightly resembled the subject being depicted. The early work was extremely geometric and reduced painting to a series of flat, geometric planes. The work suggests that all of the angles of a subject are being depicted at once.

THINK ABOUT IT
Studying works by Picasso helps you learn to think abstractly. You develop your skill in moving from the specific to the idea.

In the middle of the twentieth century, art took another giant step. The place was America, and the time was after World War II. The movement was called Abstract Expressionism, and it emerged from both New York and the writings of critic Clement Greenburg. It was influenced by Cubism, but in the 1940s it became a more abstract and painterly approach to picture making. It was incredibly abstract, and its primary concern was form and depth within the parameters of the rectangular frame of the canvas.

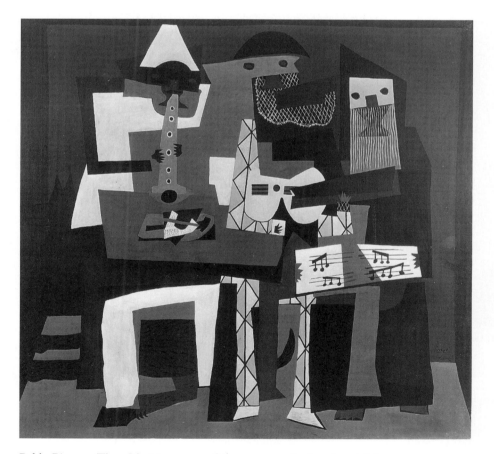

Pablo Picasso, *Three Musicians*, 1921. Oil on canvas, 6' 7" x 7' 3 3/4" (200.7 x 222.9 cm). Courtesy The Museum of Modern Art, NY. Mrs. Simon Guggenheim Fund.

Pablo Picasso, *Torso in the classical style* (an exercise done by Picasso when he was a student). Charcoal and black pencil. Courtesy Musée Picasso.

The most legendary of this movement's painters was New York artist Jackson Pollock. Pollock dripped and splattered paint on large sheets of canvas stretched across his studio floor. At first glance the work seems haphazard and primitive. However, the work exhibits many random properties inherent to nature. Other remarkable artists of this movement include Willem de Kooning, a more figurative artist, and Mark Rothko, an artist whose colorful rectangles emit a sense of mystic spirituality.

THINK ABOUT IT
Each time you analyze, interpret and evaluate an artwork, you are exercising your critical thinking skills.

Marcel Duchamp, *Virgin*, 1912. Graphite, 16 7/8" x 8 2/3" (42.8 x 22 cm). Courtesy Philadelphia Museum of Art: A.E. Gallatin Collection.

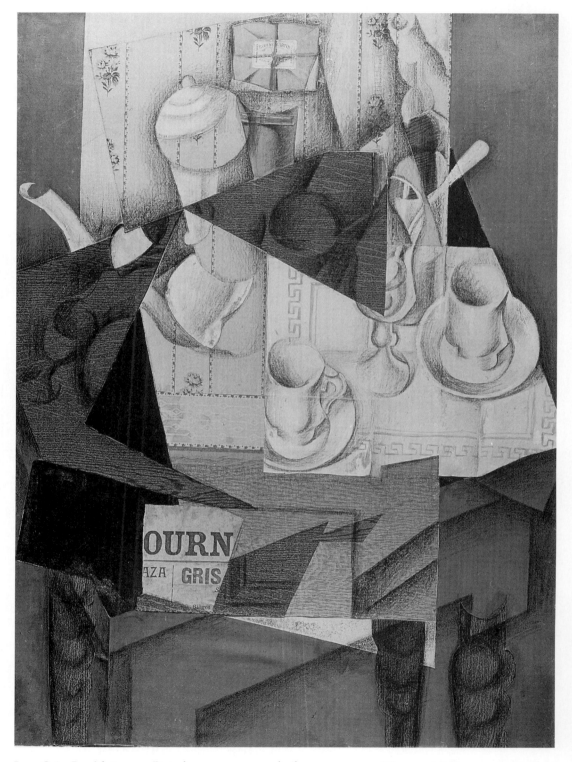

Juan Gris, *Breakfast*, 1914. Pasted paper, crayon and oil on canvas, 31 7/8" x 23 1/2" (80.9 x 59.7 cm). Collection, The Museum of Modern Art, NY. Acquired through the Lillie P. Bliss Bequest.

Jean Arp, *Automatic Drawing*, 1916. Brush and ink on gray paper, 16 3/4" x 21 1/4" (42.5 x 54 cm). Collection, The Museum of Modern Art, NY. Given anonymously.

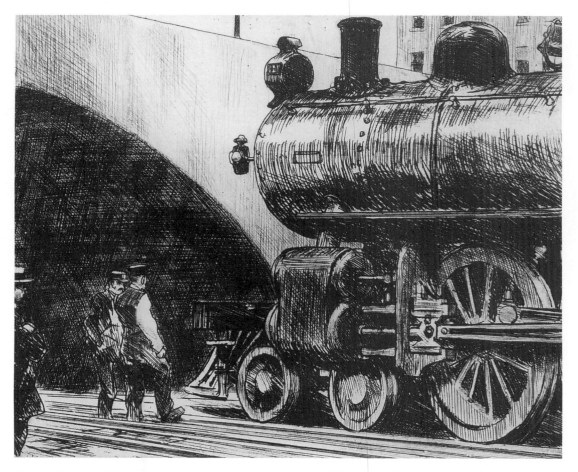

Edward Hopper, *The Locomotive*, 1922. Etching on paper, 7 7/8" x 9 13/16" (20 x 25 cm). Collection of The Whitney Museum of American Art, NY.

Paul Klee, *Portrait of Flechtheim*, 1928. Pen and ink, 11 3/8" x 9 1/4" (28.9 x 23.5 cm).

Giorgio de Chirico, *Metamorphosis*, 1929. Lithograph. © Sotheby Parke-Bernet. Agent: Editorial Photocolor Archives.

Jackson Pollock, *Echo (Number 25)*, 1951. Enamel on unprimed canvas, 7' 7 7/8" x 7' 2" (233.4 x 218.4 cm). Courtesy The Museum of Modern Art, NY. Acquired through the Lilie P. Bliss Bequest and Mr. and Mrs. David Rockefeller Fund.

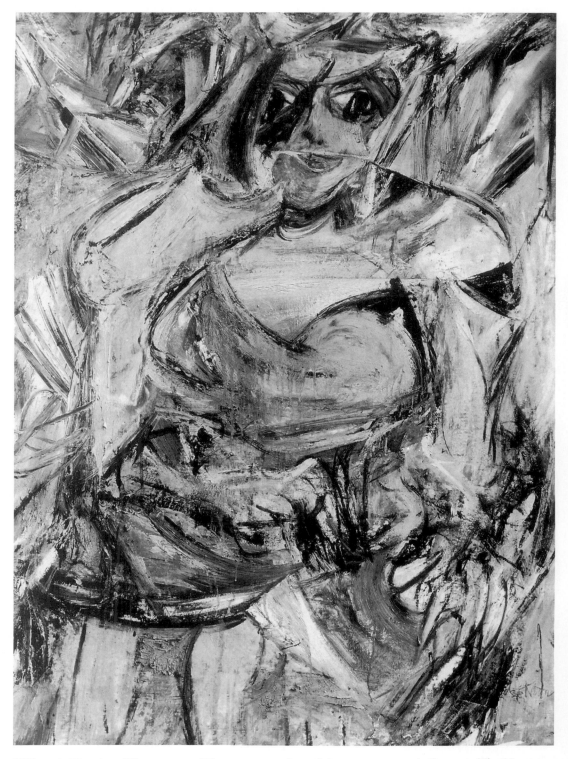

Willem de Kooning, *Woman*, 1952. Oil on canvas, 59" x 43" (149.9 x 109.2 cm). Courtesy The Museum of Modern Art, NY. Gift of Mrs. D. Rockefeller III.

Mark Rothko, *Ochre and Red on Red*, 1954.
92 5/8" x 63 3/4" (235.3 x 161.9 cm). Courtesy
The Phillips Collection, Washington, DC.

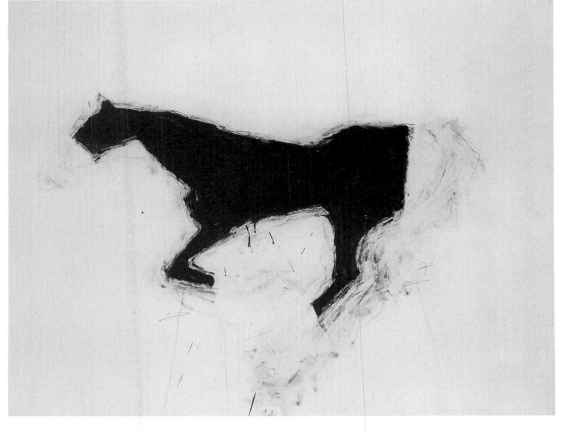

Susan Rothenberg, *Untitled Drawing, No. 44*, 1977. Synthetic polymer paint and tempera on paper, 18 1/2"
x 10 1/8" (98 x 127 cm). The Museum of Modern Art, New York. Gift of Mrs. Gilbert W. Chapman.

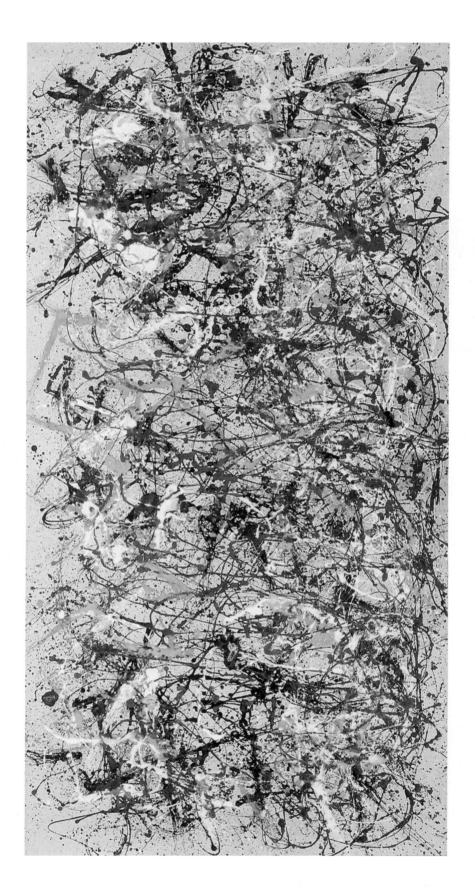

8 The Present

Each new movement in art is built upon the art created in previous decades. The art of today has been heavily influenced by the art of the past thirty years. Contemporary art serves as a point of departure for developing artists. As a developing artist yourself, you should use works of art as an artistic resource to learn about new techniques, trends and media.

There is another important reason for exploring contemporary art history. Much contemporary art is concerned with social issues. Art has always had a relevancy to the times in which people live, but this is particularly true of contemporary art. In our time, art has become an important means of communication.

This chapter covers eight movements and trends in contemporary art. As you read about each one, consider the relevancy of the art to your own life. How have these artists influenced your definition of art?

Key Chapter Points

- Artists in the twentieth century have developed new art movements and forms of expression.
- Pop Art features everyday objects and satirizes popular culture.
- Minimalism reduces the subject to simplified geometric forms and lines.
- Photo-Realism incorporates the technology of photography.
- Abstraction is nonrepresentational art.
- Post-Modernism is an era of openness to new subject matter and techniques.

Jackson Pollock, *Autumn Rhythm*. Oil on canvas, 105" x 207" (266.7 x 525.8 cm). Courtesy The Metropolitan Museum of Art, George A. Hearn Fund, 1957. (57.92)

Pop Art

*Artists: Andy Warhol, Jasper Johns,
Roy Lichtenstein and Wayne Thiebaud*

The Pop Art movement emerged from
the 1960s and satirized "popular" culture.
The Pop movement was also a reaction
to the art of the 1950s Abstract
Expressionism. The content of Pop Art,
unlike Abstract Expressionist paintings by
Jackson Pollock, included recognizable
subjects, such as American flags, cartoon
characters, commercial objects, comic
book replicas and the human figure.

No artist in the history of art had a
more unceasing sense of humor than did
Andy Warhol. His tedious reproductions
of cultural heroes are humorous both in
their monotony and their sheer vulgarity.
The work is effective, but to see one of
his portraits of Marilyn Monroe or Elvis
Presley is to see them all. Warhol's work
is about molding, casting, and then,
senselessly reproducing. Trends in culture
and art are similar. Trends emerge, repro-
duce, disappear and emerge again.
Warhol's work comments on culture and
serves as an ironic social commentary.

The subject matter in many works of
Pop Art often includes the mundane or
the overlooked. This is especially the case
in the work of Jasper Johns. The
American flags and targets that Jasper
Johns drew are removed from their famil-
iar contexts. The artwork is seldom what
it seems. The targets are not designed to
be shot at and the flag is not a patriotic
banner. The targets and flags should be
examined as works of art. Johns exploits

Jasper Johns, *Target with Four Faces*, 1955. Assemblage: encaustic and collage
on canvas with objects, 26" x 26" (66 x 66 cm) surmounted by four tinted
plaster faces in wood box with hinged front. Box, closed, 3 3/4" x 26" x 3 1/2"
(9.5 x 66 x 8.9 cm). Overall dimensions with box open, 33 5/8" x 26" x 3"
(85.3 x 66 x 7.6 cm). Courtesy The Museum of Modern Art. Gift of Mr. and
Mrs. Robert C. Scull.

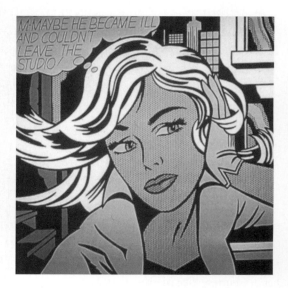

Roy Lichtenstein, *M–Maybe*, 1965. Oil and
magna on canvas, 60" x 60" (152.4 x 152.4 cm).
Photograph courtesy Leo Castelli Photo
Archives.

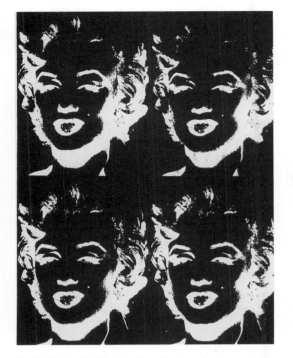

Andy Warhol, *Marilyn*. Synthetic polymer paint and silkscreen ink on canvas. 36" x 28" (91.4 x 71.1 cm). Courtesy The Andy Warhol Foundation.

California artist Wayne Thiebaud is an unrivaled draftsman of Pop Art. Thiebaud draws with extremely confident and precise pencil marks. His paintings and drawings of subjects, such as ice cream cones and pies, are often so lusciously executed that the subjects appear edible. Thiebaud is also a dynamic draftsman of landscape. His landscapes contain an interesting sense of design and light. The light and shadows in the works suggest landscapes that were inspired by a sunrise or sunset. The suburban California landscapes are often drawn at dynamic angles that make the composition interesting.

the flat subjects by making interesting pencil marks and lines that make for a visually intriguing drawing. His drawings are not about the finished product or subject. The drawings exhibit the process of discovery by drawing and then looking. The human touch of the artist is evident. The works breathe life from the subject that comes from the work of art, not the subject matter.

The cartoon drawings of Roy Lichtenstein appear to be dramatically different from the works of Jasper Johns. However, a similar idea is behind them both. Lichtenstein's work transforms a mundane subject into art. The subject matter exists, but only as a prop for producing an elaborate design. Lichtenstein draws intriguing forms that overlap and suggest the illusion of visual depth. His combinations of interesting lines, dots and patterns give his drawings a sophisticated sense of design. He uses a rich sense of color (usually primary) that gives the work a plastic, Pop quality typical of cartoon drawings.

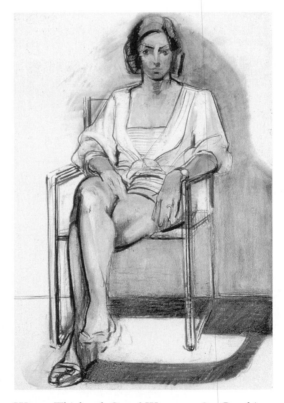

Wayne Thiebaud, *Seated Woman*, 1985. Graphite, 23 1/8" x 29" (58.7 x 73.7 cm). Courtesy Rutgers Barclay Galleries.

Minimalism

Artists: Brice Marden and Agnes Martin

Minimalism is an art movement that began in the 1960s. In this movement, artwork was reduced to minimal colors and simple geometric forms, lines and textures. Sculpture, a medium of pure, reduced form, was very appropriate for this movement. Important Minimalist sculptors include Donald Judd, Dan Flavin and Richard Serra.

However, this movement produced two outstanding draftspeople in Brice Marden and Agnes Martin. They both employ the reductive use of form. Any subject other than form is removed from their work. The work of the Minimalist painters and sculptors was criticized as being an end to art because Minimalism was an art of pure form. Critics suggested that this implied that art had taken its full course. Painting and sculpture had progressed from realism to abstraction, from abstraction to nonrepresentational abstraction, and finally, to minimalism. In a sense, art had played itself to an end.

Museums and galleries played a crucial role in the acceptance of Minimalist artworks. A series of boxlike sculptures by Donald Judd are only boxes—until they are placed in a museum. In that context, they become art.

Richard Serra, *Untitled*, 1971. Charcoal on paper, 26 1/2" x 40" (67.3 x 101.6 cm). Courtesy of the artist. Photograph by Eric Pollitzer.

Richard Serra, *To Encircle Base Plate Hexagram, Right Angles Inverted*. Steel, 26' diameter (792.5 cm), 8" rim (20.3 cm). Installed 183rd and Webster Street, Bronx, NY. Collection of Ronald Greenberg, St. Louis.

Dan Flavin, *Untitled (Monument for V. Tatlin)*, 1975–1. Cool white, fluorescent light 10' high (304.8 cm). Photograph courtesy Leo Castelli Photo Archives.

Agnes Martin, *Untitled #8*, 1975. Acrylic, pencil and Shiva gesso on canvas, 6' x 6' (182.9 x 182.9 cm). Courtesy The Pace Gallery. Photograph by Albert Mozell.

Photo-Realism/Super-Realism

Artists: Robert Cottingham, Chuck Close and Ralph Goings

Pop Art introduced the common objects of a culture as appropriate subject matter for art. Pop Art exploited reality, but a new movement would emerge out of the late 1960s that would exploit the commonplace one step further. The movement is Photo-Realism or Super-Realism. Photo-Realism is a fitting name for the movement. Painting and drawing in this particular movement contains all the qualities of photography.

Photo-Realism is a method of painting almost photographically. The artists associated with this movement work from the information of photographs. Photo-Realists Chuck Close and Ralph Goings work from smaller photographs and enlarge the works to large-scale, realistic paintings. The technology of the photograph became reproduced by the brush of an artist and on a larger scale. In what sense are these works more "real" than anything supplied by the Realism of the past?

The large-scale portraits of Chuck Close are not about the beauty of the human condition; rather, his work concentrates on the harsh reality of being a human being. His portraits are never commissioned and the portraits never lie or flatter. The works are close-up glimpses of the human psyche exposed by the large-scale reproduction of the photographic image. The works are technical studies of his medium. He paints them in many different techniques, usually a square block at a time. His earlier work employed a minimal amount of pigment that produces a maximum amount of realistic visual effect.

THINK ABOUT IT
Consider this statement: "We shape our tools, and afterwards our tools shape us." How do the tools that artists use today reflect and shape the times in which we live?

Robert Cottingham, the most formally accomplished draftsman of the Photo-Realist movement, focuses on urban architecture and its reflective surfaces. His compositions are cropped in such a manner that design becomes a focus of the work. The angles in the paintings enhance the composition and design.

Robert Cottingham, *Newberry*, 1974. Oil on canvas, 78" x 78" (198 x 198 cm). Courtesy of the artist. Photograph by Eric Pollitzer.

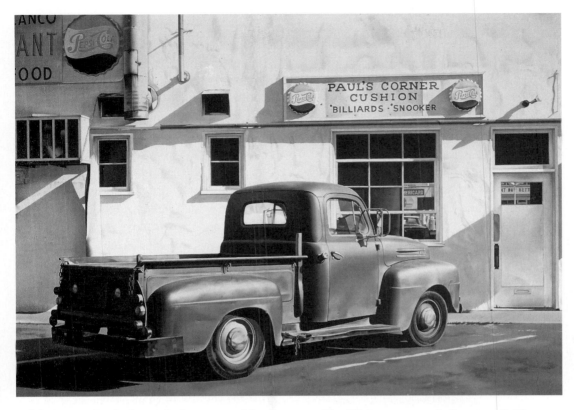

Ralph Goings, *Paul's Corner Cushion*, 1970. Oil on canvas, 48" x 68" (122 x 173 cm). Courtesy O. K. Harris Works of Art, NY.

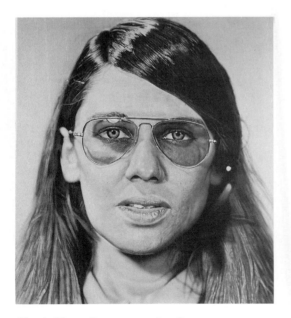

Chuck Close, *Susan*, 1971. Acrylic on canvas, 100" x 90" (254 x 228.6 cm). Courtesy The Pace Gallery.

Ralph Goings brings a different twist to the tediousness of Photo-Realism. Although his paintings are formal studies not altogether different from Cottingham's, Goings's work focuses more on the suburban elements of landscape and the rigid discipline of the still life. One of Goings's favorite and most typical subjects is the interior of the American diner. He prefers to draw ketchup bottles, napkin holders and scenes typical of a working-class diner. However, he approaches such mundane subjects with a keen sense for perfection.

Contemporary Abstraction

Artists: Ray Frost Fleming, Ted Rose, Howard Hodgkin and James Havard

Abstraction became less relevant with the emergence of Pop Art and Photo-Realism. However, there are many innovative abstract artists producing relevant artwork today.

In looking at abstract or nonrepresentational painting, examine the surface of the painting and the painting's sense of illusionistic space or depth. Good design is not enough to make an abstract painting successful. Without space and depth, an abstract painting is "static" or motionless.

Ray Fleming's work employs the collaging and overlapping of different shapes in order to achieve a sense of three-dimensional space. The shapes are not static, but appear to be in motion.

The paintings of Ted Rose utilize tones of color and texture to suggest illusionistic depth. Rose prefers to have the brightest colors and the richest textures appear to be in front of the simple backgrounds, which have muted gray tones of color. Rose also employs the use of collaged shapes in his paintings to enhance the sense of depth and design.

Howard Hodgkin employs the illusionist device of overlapping segments of

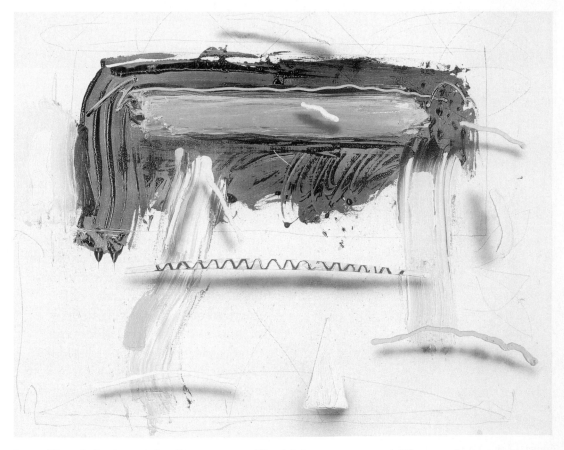

James Havard, *Zuni*, 1976. Acrylic on canvas, 48" x 60" (121.9 x 152.4 cm). Photograph courtesy Louis K. Meisel Gallery, NY.

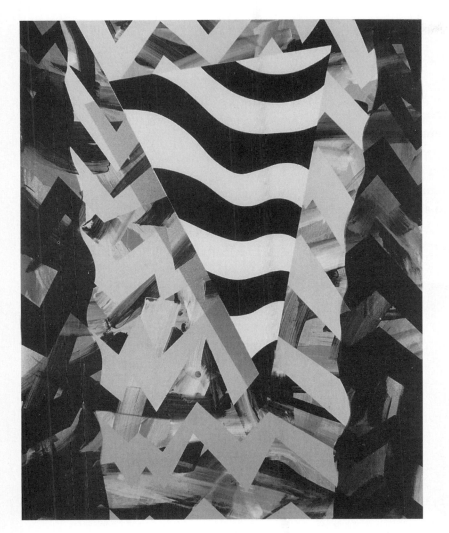

Ted Rose, *New York Wedge*. Acrylic transfer, 38"x 48" (97 x 122cm).

troweled paint. The warm (yellow and red) colors appear to float over the rest of the cooler colors. Often in Hodgkin's paintings, the brushwork and troweled paint overlap onto the ornate frame to make the picture less confined and more interesting.

James Havard, an abstract-illusionist painter, often employs line and shadow to give his works the illusion of three-dimensional space. The images in his paintings appear interesting because they seem to float above the picture plane.

Howard Hodgkin, *Down in the Valley*, 1985–88. Oil on wood, 29" x 36" (73.67 x 91.4 cm). Courtesy Knoedler & Company, NY.

Post-Modernism

New Subject Matter

*Artists: Martin Maddox and
Carlo Maria Mariani*

The period of time that encompasses the last quarter of the twentieth century is known as the era of Post-Modernism. The term suggests that the Modern era of the early three-quarters of the twentieth century has ended and that the end of the twentieth century is no longer a part of the Modern era. The Modern period has been characterized by its many different styles and artistic movements. What started with the Cubist paintings of Picasso progressed to the drips and splatters of Jackson Pollock and ended with the Minimalist sculptures of Donald Judd. However, with the increasing irrelevancy of Modernism and Abstraction there came a need for new subject matter. Hence, the art of the Post-Modern era is open to many new approaches to creating art.

The Post-Modernist era is an era of openness to new subject matter and techniques. The era has witnessed a rebirth in classical architecture and neo-classical figurative paintings. This is evident in the works of Post-Modern artists like Martin Maddox and Carlo Maria Mariani. Their works contain Classical and Neo-Classical themes.

THINK ABOUT IT
Synthesizing means fitting together different combinations to form a whole. By using ideas and styles from other centuries, artists find new ways to express meaning.

Carlo Maria Mariani, *April*, 1988. Oil on canvas, 90 1/2" x 70 3/4" (229.9 x 179.7 cm). Courtesy of the artist.

Social and Political Themes

*Artists: Barbara Kruger
and Robert Longo*

Artists in the 1980s like no other era in art produced art with overt references to social and political issues. Artists of this era have approached political and social commentary in numerous ways.

Barbara Kruger creates installations and billboards for social and political commentary. A visual image is often accompanied with a simple sentence or group of words that relate the image with an idea. The work is commanding and designed to communicate a message that can be easily and quickly understood. The work often evokes a sense of guilt that probes the viewer's conscience for a prolonged period of time. Her work often contains a sense of screaming helplessness, as if the art is the only truthful source of social commentary.

Robert Longo's work effectively utilizes the discipline of drawing to reproduce reality and create social commentary. His series of work titled *Men in Cities* is a social commentary on urban life. The works depict urban professionals dancing in urban nightclubs. At close examination, the figures seem to be in awkward positions. They appear to be stumbling or freefalling and out of control. The work captures a disturbing sense that the figures are caught in a senseless and self-destructive social ritual.

Barbara Kruger, *Untitled (Questions)*, 1990. Enamel on aluminum, 186" x 254" (472.4 x 645.2 cm). Courtesy Mary Boone Gallery, NY. Photograph by Zindman/Fremont.

Robert Longo, *Untitled*, 1980. Oil, paintstick and graphite on paper, 3 panels, each 60" x 40" (152 x 102 cm). Photograph courtesy Metro Pictures, New York. Collection of Charles Saatchi.

Irony and Humor

Artists: Susan Coe, Peter Saul,
Gilbert & George and Robert Arneson

Humor and irony in art have been used throughout history, and serve as vital elements for communicating thought, emotion and reaction to the problems of everyday life.

Humor tends to translate human messages into light-hearted visual images that help people laugh at themselves or at familiar situations. Irony usually expresses a meaning that is the exact opposite of what is expected. Works that contain humor and irony are often quite powerful and make you think. They generally offer several possible meanings, challenging viewers both visually and intellectually. Artists Susan Coe (see page 232) and Red Grooms are artists who often use irony and humor in their works.

Robert Arneson, *Elvis (#1)*, 1978. Ink, conté, pencil on paper, 40" x 31" (101.6 x 78.7 cm). Courtesy Frumkin/Adams Gallery, NY.

Peter Saul, *New York Painter*, 1987. Oil and acrylic on canvas, 72" x 108" (182.9 x 274.3 cm). Courtesy Frumkin/Adams Gallery, NY. Photograph by eeva–inkeri.

WE FEEL BRIEFLY, BUT SERIOUSLY, FOR OUR FELLOW ARTIST MEN

'THE GENERAL JUNGLE'

Gilbert and George, *The General Jungle*, 1971. Charcoal on paper, 8' x 7' (243.8 x 213.4 cm). Courtesy Sonnabend Gallery, NY.

Another trend in art that emerged in the Post-Modern era is art that makes fun of art. This is apparent in the works of Peter Saul, Gilbert & George and Robert Arneson. Their art shows influences of art movements through the centuries. By placing modern art within an historical framework, artists of the Post-Modern era carry on a conversation with art itself and with the artists who have influenced it so far.

Sue Coe, *No Job*, 1992. Graphite, crayon, gouache and ink on Strathmore Bristol board, 29 1/8" x 23 1/8" (74 x 58.7 cm). Courtesy The Galerie St. Etienne.

Narrative Content

Artists: Eric Fischl, Ed Ruscha and Larry Rivers

Narrative painting emerged during the 1980s. The narrative that accompanies the image serves as an in-depth explanation for the work itself. These works suggest that visual images alone are not enough to communicate visual perceptions. Post-Modernism, at this point, is concerned with the role of both language and the visual image to communicate.

However, not all narrative work requires words. The artwork of Eric Fischl is narrative, but it needs no words to tell the story. Fischl's work is a twofold narrative. On one level, Fischl is describing real-life situations in suburbia, but on another level, Fischl is exorcising his own and our self-consciousness about being ordinary and vulnerable human beings. He uses nudity in most of his paintings to force the viewer to recognize his or her sense of self-consciousness.

Ruscha employs the illusive device of cliché to set the mood in his paintings. The work itself contains a commercial graphics quality that becomes a part of making the work a visual and literal cliché.

Larry Rivers, *Dreyfus*. Graphite on paper. Courtesy of the artist.

Perhaps one of the most talented and accomplished narrative artists creating innovative work today is New York artist Larry Rivers. Rivers's work often contains autobiographical references, and is honest and confessional. His work often contains mixed media, collage, found objects and is often done in relief. A characteristic of Rivers's work that sets his work apart from others' is his austere sense of gesture. His paintings seldom contain the elements of figurative realism, but his sense of gesture is poignant and precise.

Six Artists Speak

W. Perry Barton

For me, there is something about the relationship between paper and the way it responds to the touch of the brush and charcoal stick that keeps pulling me back to drawing. In my drawings, the images are figurative, which immediately invokes a narrative and familiarity. I try to keep both these elements in an uneasy balance. I believe that the viewer must be engaged to complete the picture. So each story is incomplete and eventually totally different. The nature of black and white is quite helpful here. If the figure is familiar, the familiarity is kept at bay by the black-and-whiteness of it.

And yes, there is also humor in my drawings. Art can be funny and serious at the same time. So here we have figurative–narrative–kept at a distance–funny–serious drawing.

W. Perry Barton, *Cruising Through Toy Town*, 1990. Charcoal and acrylic on paper, 42" x 58" (106.7 x 147.3 cm). Courtesy of the artist.

Joanna L. Kao, *Two Generations*. Monotype, 22" x 27" (55.9 x 68.6 cm). Courtesy of the artist.

Joanna L. Kao

My art is concerned with cultural and racial identity. The child of Chinese immigrants, I knew only one other Chinese person in school, my sister. I felt disconnected from the world because I looked different from everyone else. Yet even within our family, cultural and generational gaps separated us from our parents.

When I finally traveled to China as an adult with my parents, I found I was an outsider there too. I took pride in my Chinese heritage, which connected me to my parents, but I did not know the language or culture that accompanied this heritage.

Art is one of the means by which I can explore how I am different and where I fit in. I have been working on a series of monotype prints concerned with images from the histories of my parents and from my childhood. Through these images, I seek to explore the interactions that have shaped my family and myself.

Yetti Frenkel

Ordinary characters from everyday life, like the people one might see on the subway, in school yards or at shopping malls, populate my paintings. I am fascinated by the unspoken dialogue between people, the language of posture and expression, and by the small moments of drama in daily life. The challenge by a bully, the weariness of a commuter, the joyous abandon in an unguarded moment— these moments are the main focus of my work. My work is political in that it portrays contemporary problems and attitudes; if I have a social agenda, it is to create a feeling of empathy in the viewer and a feeling of connectedness to the community.

My most recent exhibit was shown at the Lynn Historical Society in Lynn, Massachusetts. This exhibit portrayed the children of the city of Lynn and was the culmination of two years of painting and drawing people from the community.

Yetti Frenkel, *Recess*, 1991. Conté, 40" x 60" (101.6 x 152.4 cm). Courtesy of the artist.

Susan Avishai

In my series of colored pencil drawings, my subject is fabric affected by form, which I use as a metaphor for any covering that can both hide and reveal what is underneath. By eliminating the head and hands, I focus more on the elements of picture-making rather than storytelling. Human expression is still implied by the stance of the figure, the choice of clothing, the "body language," but it is no longer predominant. I'd like to feel I could convey the smell of freshly ironed cotton or the coarseness of linen. I have turned up the volume by adding color. It feels heady and full of possibilities; I'm like a cook discovering spices.

Scale is important in my new work. I have come in close to the subject, presenting it right up to the picture plane and often eliminating the background altogether. The size lets the viewer become more bound up in the image.

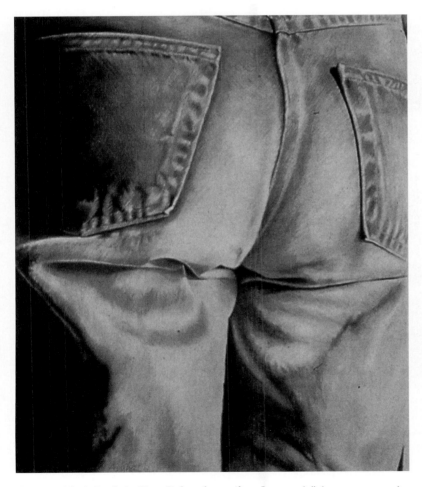

Susan Avishai, *Study in Blue*. Colored pencil, 12" x 13 1/2" (30.5 x 34.3 cm). Courtesy of the artist.

Tom Riesing

Most of my recent work has used the Alcoa Highway Bridge as its main subject matter. As a form, the bridge fits nicely with the way I think about the interaction of structure and space. I like the way this bridge both frames and mimics the landscape and how it changes as you move around it. It can go from dense and impenetrable to open and ethereal, or from towering (even heroic) when seen from below to almost inconsequential when seen from above.

These drawings are done on paper treated with powdered charcoal. The image is produced exclusively by erasing the black surface. This erasing technique allows me to work reductively and create light at the same time. The powdered charcoal I use is not very dark; I have a very narrow range of value to work with. In the finished piece, there is a lot less shown than is actually perceived by the viewer.

Thomas Riesing, *Ford Tri–Motor*, 1989. Charcoal on paper, 42 1/2" x 62" (108 x 157.5 cm). Courtesy of the artist.

Marcia Goldenstein, *Reversal*. Acrylic, watercolor, xerox and pencil. Courtesy of the artist.

Marcia Goldenstein

My mixed media pieces are motivated by the rich tradition of landscape painting. The variety of materials enables me to analyze both the historical significance of landscape painting and my personal response to unique places. Having grown up on the Great Plains in Nebraska, I found my understanding of landscape challenged when I moved to East Tennessee. The emphasis of the landscape shifted from sky to foliage; from horizontal to diagonal; from distant panorama to more intimate spaces.

There are so many ways in which a sense of place can be experienced— through panoramas, intimate close-ups, maps, photographs and historical references. In my works, the shifts in focus, perspective, scale and visual language are overlaid and combined to create a composite of various levels of reality and personal responses to a particular time and place.

Glossary

abstraction Simplification and/or alteration of forms, derived from actual observation or experience to present the essence of the objects, people or places.

aesthetics Artistic qualities of forms, and what's beautiful in a work of art.

aggressive line A line that is strongly emphasized.

ambiguous space The spatial relationships between the positive and negative space are not clearly defined.

analogous colors Colors that are adjacent to one another on the color wheel.

analytical line A line that establishes objects in relation to one another and to the space they occupy.

anatomy The study of the parts of the human body.

atmospheric perspective or **aerial perspective** A means to achieve the illusion of space, based on the observation that the value and value contrasts of objects decrease as the objects recede into the distance.

avant garde Term used to describe the work that is in the newest form of visual expression.

background The area of a picture that appears farthest away in a three-dimensional illusion.

balance Principle of art that arranges elements in a work of art so that they seem to be "weighted" evenly throughout.

base line The imaginary line on which an object lies.

biomorphic shape Irregular shape that resembles the curves found in live organisms.

blind contour Line drawing in which the artist never looks at the paper. This method helps the artist develop a feel for space and form. It also improves eye-hand coordination.

broad strokes Wide drawn markings achieved by using the sides of drawing media, such as charcoal, graphite, pastels, etc.

caricature Drawing that exaggerates prominent features or characteristics of the subject.

cartoon A comic drawing that simplifies or exaggerates a person or event.

cast shadows The shadow cast by a form onto a nearby surface.

chiaroscuro In drawing or painting, the use of strong contrast between light and dark, and the gradual transition of values, producing the effect of modeling.

chromatic Relating to colors.

collage A work of art in which materials, such as paper, cloth or found materials, are glued onto a surface.

color An element of art that refers to the character of a surface, derived from the response of vision to the light reflected from that surface.

color tonality A particular selection and arrangement of color schemes, involving hue, value and intensity relationships.

color triad A group of three colors spaced equally apart on the color wheel.

color wheel The circular arrangements of hues based on a color theory.

complementary colors Hues that are directly opposite each other on the color wheel. Intense color effects are achieved through the placement of complementary colors next to each other.

composition The organization or arrangement of visual elements, such as lines, spaces, tones and colors, in a work of art.

constricted line An aggressively stated line that creates a feeling of tension.

content The essential meaning, significance or aesthetic value of an art form, that includes emotional, intellectual, symbolic, thematic and narrative connotations.

contrast Extreme differences in colors, values, textures and other elements.

contour The outer edges of any three-dimensional form that is defined by line.

contour drawing A line drawing that defines the outer and inner shapes of forms.

contour line In drawing, the line of varying thickness, tone and speed, that follows and emphasizes the contour of three-dimensional forms.

convergence In the system of linear perspective, the point at which parallel lines meet, or converge, as they recede.

cropping Masking unnecessary areas of a picture to create an interesting composition.

cross-contour lines Contour lines that intersect one another at oblique angles. Cross-contour line emphasizes the volume of an object.

cross-hatching The overlapping of hatched or parallel lines to create value.

Cubism A style of art that uses two-dimensional geometric shapes to depict three-dimensional organic forms.

curvilinear Stresses the use of curved lines.

Dada An anti-art movement that resulted from the social, political and psychological effects of World War I.

design The overall conception of a work of art.

diminution The phenomenon of objects farther away appearing smaller in linear perspective.

distortion To deform or change something from its normal shape to another, less realistic shape.

diptych A work of art in two sections or parts.

dominance Effect created by making certain elements appear more important than others in a composition.

drawing style A particular way of drawing that defines the artist's own style or a specific period of time.

elements of design The basic components used by the artist to create works of art. Shape, value, texture, line and color are elements of design.

elevation A drawing that contains images on a vertical plane without depth or perspective.

ellipse A circle seen from an oblique angle, creating an elongated shape.

elongated Stretched out in length.

emotionalism Theory of art that judges the expressive qualities of a work of art.

emphasis Principle of art by which the artist combines contrasting sizes, shapes, colors or other elements to place greater attention on certain areas in a work of art.

exaggeration Enlargements or distortions of elements in a work of art.

Expressionism A movement in art of the early twentieth century that began in Germany. Also used to describe all art that communicates strong emotional and personal feelings.

eye level An imaginary horizontal line that is even with the height of your eyes.

Fauvism An art movement that began in France about 1905, that featured a strong, emotional use of color and decorative qualities.

figure The human form or any recognizable object or nonrepresentational shape.

fixative A chemical that is sprayed over a two-dimensional work of art to prevent smearing and to make art media, such as charcoal, graphite or pastels, adhere to the paper.

found objects Any natural or human-made objects found and used by an artist in a work of art.

foreground Area of a picture that appears nearest to the viewer.

foreshortening A technique used to show the proportions of an object in a space, and distinguish the foreground and background of a picture plane.

form A three-dimensional shape that encloses space.

formalism A theory that judges a work of art by its organization of the elements of art.

format The overall shape and size of the surface of a work of art and the position it occupies in relation to the viewer.

Futurism A twentieth century submovement within Cubism. The imagery is based on an interest in time, motion and rhythm, in response to the machinery and human activities of modern times.

gallery An enterprise where art is exhibited and sold.

gestural drawing A quick drawing that captures the gestures and movements of the body.

graphic artist An artist who designs, illustrates and creates any kind of art for printed reproduction.

ground Any surface on which a picture is drawn or painted, such as canvas, paper, cardboard, etc.

hard copy Printed computer image.

hard edge Crisp, clean edges achieved through the use of flat, even values or colors.

harmony Principle of art that stresses the related qualities of all parts of a composition.

hatching A technique in which lines or strokes are placed parallel to each other; used to create gray tones.

highlight The area on a form that reflects the most light.

horizon line The line at which sky and earth meet.

hue The characteristic or quality identified by the name of a color.

implied line Line that is suggested by a change in color or value.

Impressionism Late nineteenth-century movement in which artists recorded the immediate effect produced by light.

incised line A line cut into a surface with a sharp tool.

intensity The saturation, strength or purity of a color. A brilliant color is of high intensity; a dull color, of low intensity.

interpenetration The movement created by shapes or objects breaking through each other.

layering A technique in which art media are used over one another.

line An element of art that is a continuous mark made by a tool as it is drawn across a surface.

linear perspective Technique used to create the illusion of depth on a two-dimensional plane.

local color The natural color of an object as it appears to the naked eye.

logo A design that symbolizes or represents a company or individual.

lyrical line A decorative line that is gracefully ornate.

manipulation To model; to shape.

manuscript illumination The decorative drawings and paintings of handwritten books in the Middle Ages.

mass The illusion of weight or density of an object.

mechanical drawing A drawing made by using compasses or other drafting tools.

media Materials or tools used to create a work of art.

middleground The intermediate zone of space, between foreground and background, in a work of art.

mixed media A combination of media, such as ink and watercolor, to create a work of art.

modeling The use of light and dark values to create form.

monochromatic A color scheme of one color plus black and white.

motif The repetition of visual elements, or combination of elements, that dominate and help unify a work of art.

movement Principle of art that uses elements to create the illusion of action.

multiple perspective Different illusions of space used in one drawing.

museum A place where art is collected for public viewing.

narrative art A form of art that tells a story.

negative space The area surrounding positive shapes.

neutrals White, gray or black. Neutrals result when there is no reflection of any single wavelength of light, but rather all of them at once.

nonobjective Artwork without recognizable natural objects. The images are products of the artist's imagination.

one-point perspective Perspective in which all parallel lines converge at a single point on the horizon line.

opaque The quality of a material that does not let light pass through.

optical color Color seen when modified by the quality of available light.

organic Free, irregular form that resembles living things.

organizational line Line that gives structure to a drawing.

outline Line of uniform thickness around the outer edge of a form, to show its overall shape.

overlapping Placing one object in front of another, to create depth in a work of art.

pattern An arranged repetition of forms or design, or a combination of both.

perspective A technique used to create the illusion of three-dimensional space and objects on the two-dimensional surface of a picture plane.

perspective drawing A drawing on a two-dimensional surface that gives the illusion of three-dimensional space and objects.

picture plane The actual two-dimensional surface on which a drawing is made.

pigment Finely powdered coloring material used in paints and drawing media.

portfolio A collection of an artist's work for presentation.

portrait A picture that features a person or group.

positive-negative reversal The perception of shapes in a work of art that alternate between positive and negative identities.

positive shape The shape of an object that is the subject in a work of art.

primary colors Red, blue and yellow; colors that cannot be created by mixing together other pigments.

primitive art Visual art that uses imagery of folk art, and is characterized by an emphasis on form and expression. Often appears child-like.

principles of art The means by which the visual elements are organized and integrated into a unified arrangement. They include balance, harmony, emphasis, movement, rhythm, unity and variety.

proportion Relationship of elements to one another and to the whole artwork in terms of their properties of quantity, size and degree of emphasis.

realism The representation of actual places, people or objects according to their appearance in visible nature. The nineteenth-century Realism was a style of art that interpreted the subject matter of every-day life, and the meanings beneath surface appearances.

relief The raised parts of a surface background.

repetition The use of the same visual elements over and over in a composition. Repetition may produce the dominance of one visual idea, harmony, unity or a rhythmic movement.

representational drawing A drawing of objects, people or places that looks very much like what one sees.

rhythm Principle of art that uses repetition of visual elements in a work of art, to create a feeling of movement.

rubbing A technique of reproducing textures by placing paper over the textured surface, and rubbing the paper with a drawing medium.

saturation Intensity of a color.

scale The relative size or weight of an object compared to a constant size or weight.

secondary color The colors that result from the mixture of two primary colors; orange, green and purple are secondary colors.

shading Using art media to create darkened areas (shadows) that give the illusion of space and depth.

shallow space A space with limited depth.

shape An element of art that is two-dimensional, and encloses space. Shape can be divided into two categories: geometric shape and organic shape.

simulated (visual) texture The imitation of a texture implied in an artwork.

simultaneous contrast Intensified contrast that results whenever two different color tones or two contrasting values come into contact.

sketch A quick drawing that may be a reference for later work.

sketchbook A drawing notebook in which artists record things they see or imagine.

space An element of art that is the area around and within an object. **spatial gesture** The implication of gestural movement by an imagined connection of objects distributed in space.

spectrum The complete range of color presented in a beam of light.

still life An arrangement of non-moving objects that are subject matter for a work of art.

stippling A technique that uses patterns of dots to create values and value gradation.

structure The constructive elements of a work of art; the foundation of a composition.

style The unique character contained in a work of art, period of time or geographical location. Style also means an artist's expressive use of media to give works individual character.

subjective Personal or individual viewpoint through which the artist is free to change, or modify characteristics of a natural form, emphasizing personal emotions.

subjective colors Colors selected by the artist that have no connection with object reality.

subject matter Things represented in a work of art.

subject meaning The content derived from subject matter in a work of art.

symbol An image that stands for something more than its own literal meaning.

symmetrical balance Balance created through the duplication of an image, or of an element on either side of a composition divided in half.

tactile A quality perceived through the sense of touch.

technique The method, skill or system of working with tools and materials.

tertiary colors Colors created by mixing primary and secondary colors.

texture An element of art that refers to the tactile quality of a surface.

three-dimensional shape A shape that has height, width and depth.

thumbnail sketches Small, quick sketches that record ideas and information for a final work of art.

tone In visual arts, the lightness and darkness of a color.

tooth The texture of a sheet of paper.

translucent Quality of any material that allows some light to pass through.

trompe-l'oeil The French term for trick-the-eye. It is an illusionistic technique in which nature is copied so realistically that the subject can be mistaken for a natural form.

two-dimensional shape An area defined by length and width.

unity A principle of design that relates to a work of art whose many different parts seem to connect well to one another.

value An element of art that refers to the relative darkness or lightness of an area.

value gradation The gradual change from dark to light areas. It creates the illusion of three dimensions on a flat surface.

Bibliography

value scale The range from white through gray to black, modified gradually.

vanishing point In linear perspective, the point on the horizon line at which all the receding parallel lines converge.

variety The use of many different elements in a composition.

viewfinder A device that works as a "window" through which subject matter is pictured. It gives the artist an idea of proportion, layout, and is excellent for cropping.

visual elements The means by which artists convey their ideas and feelings. Visual elements are color, line, shape, texture and value.

visual environment All the natural or human-made things that surround you.

volume The quality of a three-dimensional object that occupies a certain amount of space.

wash The application of ink or paint thinned with water to the drawing surface.

wash drawing Drawing in which washes of thinned ink or paint are used.

working drawings The study drawings for a final work of art.

Betty, Claudia, and Teel Sale. *Drawing: A Contemporary Approach*. Orlando: Harcourt Brace Jovanovich, 1992.

Blake, Wendon (drawings by Ferdinand Petri). *Starting to Draw*. New York: Watson-Guptill Publications, 1981.

Borgeson, Bet. *Color Drawing Workshop*. New York: Watson-Guptill Publications, 1984.

———. *The Colored Pencil*. New York: Watson-Guptill Publications, 1983.

Brommer, Gerald F. and Joseph Gatto. *Careers in Art: An Illustrated Guide*. Worcester, MA: Davis Publications, Inc., 1984.

Brommer, Gerald F. *Exploring Drawing*. Worcester, MA: Davis Publications, Inc., 1988.

Calle, Paul. *The Pencil*. Westport, CT: North Light Publishers, 1974.

Chaet, Bernard. *The Art of Drawing*. 2nd ed. New York: Holt, Rinehart & Winston, 1978.

Doyle, Michael. *Color Drawing: A Marker-Colored Pencil Approach*. New York: Van Nostrand Reinhold, 1981.

Edwards, Betty. *Drawing on the Right Side of the Brain*. Los Angeles: J. P. Tarcher, Inc., 1979.

———. *Drawing on the Artist Within*. New York: Simon and Schuster, 1986.

Enstice, Wayne, and Melody Peters. *Drawing: Space, Form and Expression*. Englewood Cliffs, NJ: Prentice-Hall, Inc., 1990.

Gatto, Joseph. *Drawing Media and Techniques*. Worcester, MA: Davis Publications, Inc., 1986.

Goldstein, Nathan. *The Art of Responsive Drawing*. Englewood Cliffs, NJ: Prentice-Hall, Inc., 1973.

———. *Figure Drawing*. Englewood Cliffs, NJ: Prentice-Hall, Inc., 1981.

Graves, Douglas R. *Drawing Portraits*. New York: Watson-Guptill Publishers, 1983.

Hanks, Kurt, and Belliston, Larry. *Draw! A Visual Approach to Thinking, Learning and Communicating*. Los Altos, California: William Kaufmann, Inc., 1977.

———. *Rapid Viz: A New Method for the Rapid Visualization of Ideas*. Los Altos, CA: William Kaufmann Inc., 1980.

Holden, Donald. *Art Career Guide*. New York: Watson-Guptill Publications, 1983.

James, Jane H. *Perpective Drawing*. Englewood Cliffs, NJ: Prentice-Hall, Inc., 1981.

Kaupelis, Robert. *Learning to Draw: A Creative Approach to Drawing*. New York: Watson-Guptill Publications, 1983.

Larson, Karl V. *See & Draw*. Worcester, MA: Davis Publications, Inc., 1993.

Mayer, Ralph. *The Artist's Handbook of Materials and Techniques*. New York: The Viking Penguin Press, Inc., 1991.

Mendelowitz, Daniel M., and Duane A. Wakeham. *A Guide to Drawing*. 4th ed. New York: Holt, Rihehart & Winston, Inc., 1988.

Mugnaini, Joseph. *Expressive Drawing: A Schematic Approach*. Worcester, MA: Davis Publications, Inc., 1988.

———. *The Hidden Elements of Drawing*. New York: Van Nostrand Reinhold Company, 1974.

Parramón, J. M. *The Big Book of Drawing: The history, study, materials, techniques, subjects, theory, and practice of artistic drawing*. New York: Watson-Guptill Publications, 1987.

Presnall, Terry R. *Illustration and Drawing: Styles and Techniques*. Cincinnati: North Light Books, 1987.

Roukes, Nicholas, *Art Synectics*. Calgary, Alberta: Juniro Arts Publications, and Worcester, MA: Davis Publications, Inc., 1982.

———. *Design Synectics*. Worcester, MA: Davis Publications, Inc,. 1988.

Russo, Alexander. *The Challenge of Drawing: An Introduction*. Englewood Cliffs, NJ: Prentice-Hall, Inc., 1987.

Sarnoff, Bob. *Cartoons and Comics: Ideas and Techniques*. Worcester, MA: Davis Publications, Inc., 1988.

Shadrin, Richard L. *Design and Drawing: An Applied Approach*. Worcester, MA: Davis Publications, Inc., 1993.

Sheaks, Barclay. *Drawing Figures and Faces*. Worcester, MA: Davis Publications, Inc., 1986.

Smagula, Howard J. *Creative Drawing*. Carmel, IN: Brown and Benchmark, 1993.

Smith, Ray. *How to Draw and Paint What You See*. New York: Alfred A. Knopf, 1984.

Winter, Roger. *On Drawing*. San Diego: Collegiate Press, 1991.

Index

Acknowledgments

There are many whom I wish to thank for their part in this book.

First there is my family, Kathy, Mason and Anna, who have given freely of their time and provided constant support. I would like to thank my parents, Wally and Billie Rose, who have been a constant source of encouragement to me.

I would also like to thank my students for their time, labor and encouragement. These students include Todd Walker for his work on chapters seven and eight, Gina Miller, for her research throughout the book, and Ha Young Lee, for her assistance on writing the glossary. Sarah Romeo provided much needed assistance throughout the book as my secretary.

This book certainly would not have been possible without the foundation that was laid over the years by such professors as Lee Forest, Jim McMurray, Carl Sublett, Tom Riesing, Jim Myford and Pat Pinson.

I would like to thank the following people for their encouragement and helpful suggestions; Don Umphrey, Arthur Williams, and Talle Johnson.

The driving force for the vision and development of the text belonged to Wyatt Wade and Claire Golding of Davis Publications. I would like to thank the following people who work for or are associated with Davis Publications; Nancy Burnett, Holly Hanson, Douglass Scott, Ewa Jurkowska and Janet Stone.

My sincere appreciation goes to all my students over the years who have provided me with a source of inspiration and a wealth of learning experiences.

— *Ted Rose*

Davis Publications, Inc. would like to thank Susan Ebersole and Diane McNutt of Scholastic, Inc. for their invaluable assistance in obtaining student work. Scholastic awards photographs appear on pages 13, 25, 32, 33, 35, 41, 43, 44, 50, 53, 70, 84, 85, 93, 100, 101, 104, 105, 124, 135, 139, 142, 145, 146, 148, 150, 151, 153, 156, 163, 164, 178, 189.

We would also like to thank Sally Bales and Donald Dodd for contributing student work.